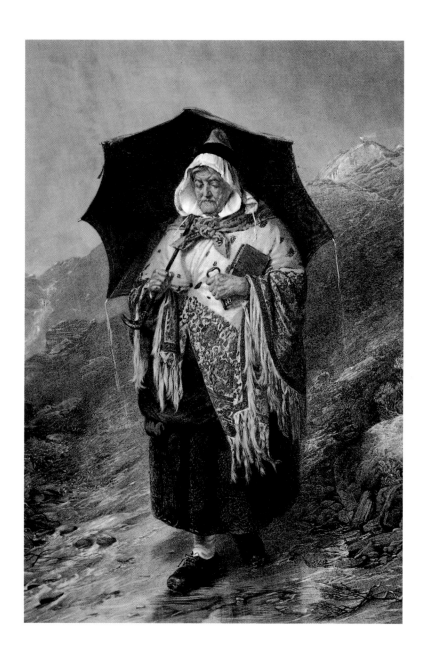

W. H. Simmons, *The Sabbath Day*, 1877.

Lorenzo Lorenzi

Witches

Exploring the Iconography of
the Sorceress and Enchantress

Translated by *Ursula Creagh*

Centro Di

Copyright © 2005 Centro Di
della Edifimi srl, Firenze
edizioni@centrodi.it
www.centrodi.it
ISBN 88-7038-430-6

Printing
Petruzzi Stampa, Città di Castello (PG), November 2005

Translation
Ursula Creagh

Design and layout
Manola Miniati (Centro Di)

Text editing
Alberto Bartolomeo (Centro Di)

Contents

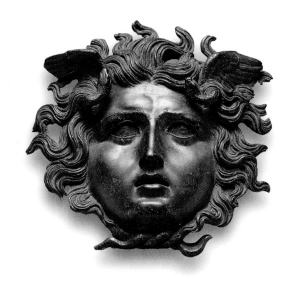

1. Head of Medusa from Este, bronze plaque, I century A. D.,
Museo nazionale atestino, Este.

Introduction

The aim of this work is to present a concise analysis of the iconographic evolution of the witch over an extensive period of European culture: from the days of Classical Greece to the Romantic age. Since the subject has always aroused wide cultural interest the study includes some of the most famous images in the history of European art. Many works depicting witches draw their references from major literary works such as earlier poems and treatises and these, in turn, reflect archetypal images in painting, sculpture and wood-carving, often of a strongly symbolic or allegorical significance. Indeed, this subject is open to many forms of interpretation, including those of a philosophical, iconological and psychoanalytic nature since it emerges that even in a study involving general questions of aesthetics and taste we discover that the historical background hinges on the differing forms of presentation which reflect the changing pattern of political and religious events.

One result to emerge from our study concerns the dual character of the witch and of her disquieting image. The witch has regularly been portrayed according to two iconographic extremes, both of great visual impact. Her representation swings between the hideous and the sublime, between the engaging and the troubling, between the charmingly seductive and the alarmingly menacing. As demi-goddess, *mater matuta*, artificer, disrupter of the male hierarchy of power, she attracted widespread interest as a woman seeking to assert her feminine being by using all the tools at her disposal, her psychic powers and her charm and beauty, the latter being the vehicle for conveying her sexuality. In this volume we trace these elements in art, in the human fruits of spiritualised material (Hegel), chiefly painting and sculpture, and thus in man's finest achievements. It has emerged that images of the witch also encapsulate primitive aspects of the Natural and the Ideal manipulating the object, the world, and drawing strength from nature (the object itself) through the exercise of the intellect.

Interdisciplinary studies of some works have revealed a parallel pattern of idea and form, fused together into a single entity. The history of Western art shows the recurring theme of this merging of beauty and horror, of charm and grace and of terrifying hideous images, a twofold image which proved highly successful. This work is not intended as a dissertation on the finer points of iconography. Instead, the study is focused on a reasoned and accurate evaluation of the major characteristics of a figure whose significance is lost in the mists of time, the practitioner of the occult, the witch, a character who has existed in various guises since the dawn of civilization.

While deferring all analyses and results to the respective chapters which interpret our findings and give them a historical perspective, we would like to explain the chief the-

sis of this book. In *Witches, Exploring the Iconography of the Sorceress and Enchantress* we hope to demonstrate the existence of two aesthetics for a single being, oscillating between the power of beauty and the power which is exercised by the spirit or soul (the psyche): beauty and soul being concepts which concern man's most profound and mysterious dimension.

The Gorgon is a mask, an image from Greek culture with a human face but the spirit of a demon. In the *Iliad* Homer sets an image of the Gorgon on Agamemnon's shield and in the centre of the aegis which covers Athena's breast. Although described as female in form, the figure is attributed with various anomalies including glaring eyes, claws, protruding pendulous tongue and a head sprouting poisonous snakes. In mythology the three Gorgons had an apotropaic significance: they warded off misfortune and frightened the enemy. The first to bear this name was Medusa, the original

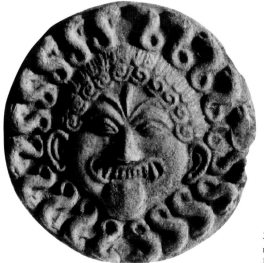

2. Antefix with Gorgon's mask from Lavallo, Museo nazionale, Melfi.

Gorgon and the only mortal, and she was later joined by two similar embodiments of her image, Stheno and Euryale, the supernal immortals. Euryale personified sexual perversion and Stheno social perversion, while Medusa, the principal of these three forces, represented spiritual and progressive strength subverted into vain stagnation. The mortal Medusa had a gloomy life and her death was even more macabre. As a beautiful young girl she was surprised by Athena when coupling with Poseidon in the temple and the enraged goddess transformed her into a monster with eyes of fire, long pendulous tongue and enormous sharpened claws, while a mass of writhing snakes sprang from her head like hairs. On Poseidon's orders Perseus slew her while she slept, cutting off her head and placing it in his shoulder-bag. With the aid of his wondrous winged sandals Perseus took flight and on his way homeward some drops of blood unhappily dripped from the bag as he flew over the Libyan coastline: those which fell on land pro-

duced poisonous vipers and those falling into the sea turned to coral. Moreover, the blood which flowed immediately after the beheading of the Gorgon gave birth to Pegasus, the winged horse which Bellerophon rode to slay the Chimera (a terrifying fire-breathing monster with the head of a lion and the tail of a dragon), and to Chrysaor, father of the monster Geryon, famous on Olympus for the lunar attribute of a golden sickle with which he confounded his enemies.

Medusa exemplifies beauty transformed into horror, but she also embodies the concepts of suffering and regeneration. In order to understand how these aspects accord with the changing appearance of the witch, represented as either a white-haired aged crone clad in black and flying on a broomstick, or as a young, voluptuous and scantily clad love goddess, in both instances capable of bearing Satan's demon offspring, it seems appropriate to go back to a leading literary source, Hesiod's *Theogony*, which says

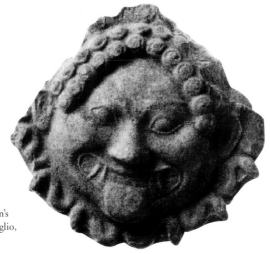

3. Antefix with Gorgon's mask from Serra di Vaglio, Archaeological offices, storerooms, Potenza.

of Medusa: " …Ceto bore old women fair of cheek, white-haired from birth: the immortal gods and men who walk on earth call them the Old Women…And she bore the Gorgons, who live beyond famed Oceanus at the world's edge hard by Night, where the clear-voiced Hesperides are: Stheno, Euryale, and Medusa, who suffered a grim fate. She was mortal, but the other two immortal and ageless." The myth makes reference to Medusa's mortality, leading to eventual frailty and old age, and this was to prove an important factor in establishing her most commonly represented image as an old and ailing woman, as described above.

Medusa represents the woman who freely and cunningly employs and propagates spells and incantations, but she also uses her *eros* and *thánatos*; this is why she suffers the fearful fate of meeting her death through decapitation. Medusa is the creature whose compelling gaze is, quite literally, petrifying. Her image epitomises horror and as such

it strikes, enthrals and enslaves. In Classical times the eyes were considered the principal source of danger because, according to the philosopher Democritus, they marked the entrance and exit ways of a thin fluid which could provoke misfortune.

St. Thomas Aquinas held that it was actually possible for a gaze to influence a person's mind and set them on the road to perdition. In the sixteenth century, though no less prevalent a belief in Medieval times, the 'evil eye' was considered a primary incontrovertible sign of the practice of witchcraft because according to popular tradition to 'cast the evil eye' on someone meant to corrupt and ensnare them, or, even worse, to bring down misfortunes and disasters on the life of the unfortunate victim.

In the Western world the witch was thus the mirror-image of Medusa and, like her, she used all her gifts and powers to create, evoke and enhance her body and her charms, and, as a final goal, to seek the infinite (the Absolute) through her coupling with Lucifer-Satan, the purpose of which was the acquisition of knowledge. Achieving this status constituted the proof of the legitimacy of the witch's earthly punishment, as experienced by Medusa, her direct progenitrix. The witch, like the mortal Gorgon, was destined to receive the severest of punishments, torture, and thus amputation and abasement following the death of the body. The witch, like the Greek Medusa, turns to stone, seduces and kills everyone she meets, bearing them off into the shadowy corners of the night. One method used to establish this particular image was the manner of depicting the eyes which, as the source of enchantment, were clearly defined in great detail in both Classical and post-Classical times. "We die under the gaze of the other whom we are looking at", states Jean Clair in his thoughtful study of the figurative evolution of Medusa (*Méduse. Contribution à une anthropologie des arts du visuel*, 1989) and the social and psychological impact of her presence on the modern world. He says that it is her nature to live among both gods and men: "…she is the guardian between two worlds, that of the living and that of the dead, the world of visible things and that of things which are invisible, the world of ordered reason and that of madness and chaos", a definition that applies to both Medusa and the witch, as one who also has the power to reason, her aims and objectives being realized through madness and chaos.

Medusa is the most vulnerable of the Gorgons besides being the most earthbound. Three is the magic number which unleashes the power of the Kingdom of Hades. Not only the Gorgons number three but also the Greek Moirae (Clotho, Lachesis and Atropus); there are three Parcae, analogous figures in Roman mythology, who are said to hold man's destiny in their hands: the first spins, the second measures the thread (an individual's lifespan), while the third snips it, as the fancy takes her, thus establishing the temporal cycle of all living beings. Had they assumed the diabolical aspect of the Gorgons the Parcae might have been considered the forebears of the witch in the post-Classical age.

Besides the mortal Gorgon there were also the Lamiae, female monsters who sucked the blood of young children and then killed them, further ancestors of our conceptual image of the witch. According to early Olympic legend Lamia was loved by Zeus and his wife

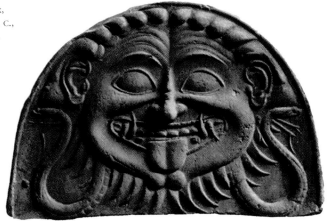

4. Gorgon antefix, mid-VI century B. C., Museo nazionale, Taranto.

Hera, wild with jealousy, avenged herself by causing all her children to die. Lamia took refuge in a cave where her despair made her jealous of other more fortunate mothers, driving her to seize and devour their offspring. Unable to rest after her first hideous crimes Lamia appealed to Zeus who gave her the gift of sleep but only when possessed or suffering, in fact, Lamia could only sleep by temporarily plucking out her eyes.

The story of Medusa is thus very similar to the story of Lamia, another *alter ego* of the witch, given that both images exercised their greatest power on nights of the full moon. The witch of the post-Classical world resembles Lamia because when attending the Witches' Sabbath she appeals to a supernatural power for love and understanding, just as Lamia, in her misery, called for the understanding of Zeus. Lamia and Medusa represent two sides of the same coin and in later times they indeed became known by a single name.

The words *Lamiae, malificae* and *striges* were used in Roman times to describe women who practised witchcraft. There are two explanations of the name adopted in Italian. Some, like Bernardo Rategno da Como (early sixteenth century), maintain that *strega*, witch in Italian, is derived from the name of the river of the underworld, the *Stige* (Styx), referred to by Dante. The English 'witch' is derived from Old English *wicca* but its earlier etymology is uncertain.

Some characteristics of the archetypal witch of the Middle Ages can be traced to the Old Testament. The connection between witches and nocturnal birds of prey has its roots in antiquity. In Isaiah (34:14-15) we read: "The wild beasts of the desert shall also meet with the wild beasts of the island, and the satyr shall cry to his fellow: the screech owl also shall rest there, and find for herself a place of rest. There shall the great owl make her nest and lay, and hatch, and gather under her shadow…" The witch exemplified a creature of the night and by the end of the twelfth century, as we know from the work of Gervase of Tilbury, she was described as a flying nocturnal figure, like the owl, a bird which became a symbol of her power because of its ability to see in the dark (*lucula noctis*).

Classical literature includes no lack of references to women practising sorcery. From *The Sorceresses* of Theocritus to Horace's *Epodes* witches are attributed with the power of awakening the dead; invoking sudden changes in climate, season and time, such as the sudden contraction or expansion of time shown by the unexpected transformation of night into day, or *vice versa*; of turning the living to stone; causing stone to live and preparing potent love potions. In the modern age Lamia was the more elegant form of witch and this explains the allusions to her Classical origins and the nature of her particular physical characterization. Even during the Middle Ages Lamia was already widely held to be the forerunner of the Medieval witch. In his *Polycraticus*, John of Salisbury states: "some say they hold secret nocturnal conclaves and revels presided over by a moon goddess, or Herodias or a lady of the night...and offer children to the witches

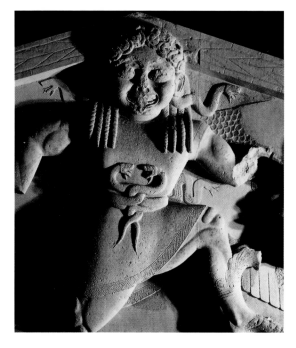

5. *Gorgon*, detail from temple façade, Archaeological Museum, Corfu.

(*lamiis*): sometimes they cut them to pieces and devour them with voracious greed; sometimes the presiding woman takes pity on them and they are returned to their cradles."

Previous studies of witchcraft have failed to draw attention to the link between the Medusa myth and the witch of the post-Classical world. This link is obviously less direct than the connection discussed above between the witch and Lamia, although Medusa and the *striges* exist on a similar cerebral level, one that goes beyond the weaving of spells and evocation of the dark forces unleashed by diabolical possession. Psychic enthralment and energy released by the gaze are characteristic both of Medusa and of the witch of later times and they are attributes which embody the *tópos* of magic, understood not only as an opportunity for drawing on all-powerful outside forces for a

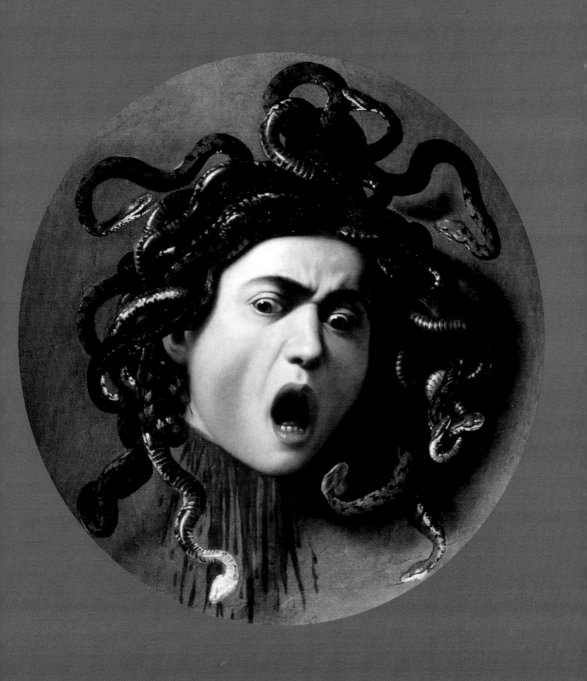

6. Caravaggio, *Head of Medusa*, 1596-1598,
Uffizi Gallery, Florence.

wide variety of purposes, but also as undefined forces which exist in the conscious mind and the soul, capable of coercing, inspiring love or seducing, overthrowing all spirit of reason. As a synthesis of beauty and thought, the spirit is concerned with seduction which involves the exercise of both body and mind.

Lamia and Medusa are thus two faces of the same image. Why do we use these two mythological figures to discuss the witch's image as represented in Medieval, Renaissance and later art? If the witch is one and indivisible in Western social and religious history, this is not true of her role in the history of art and of its original iconographic principles. From the point of view of characterization, we see the alternation of the two images used to exemplify these figures: the purely spiritual and the purely carnal. These are the two categories which prevailed in the artistic sphere, either in symbiosis or according to some well-ordered pattern of alternation.

The works discussed here clarify the method and direction of this present study which has sought to understand and explain why the iconographic representation of witches has always followed this twofold pattern, this paradoxical insistence on beauty and horror, thought and action, the imposition of will and reflection. Depictions of the witch seem to have swung with amazing regularity between these two mental and physical poles: hideous frenzy and beguiling grace. Throughout the ages man has fitted the sorceress into these two descriptive categories and imbued them with mysterious ancestral significance.

Jean Clair adopted a method of explaining the evolution of the myth and of the female icon itself (particularly the mystery inherent in the sublime instance of the severed head), referring to the philosophical dichotomy presented by the German philosopher Nietzsche in *The Birth of Tragedy* (*Die Geburt der Tragödie*, 1872), that is, that of Apollo and Dionysus. Nietzsche tells us that in Classical Greece, dramatic tragedy apart, these two concepts of Medusa alternatively came together or clashed unceasingly.

Medusa's head, carved on a fragment of a I-II century glass paste medallion, Benvenuto Cellini's head of Medusa held in the hand of *Perseus* (1545-54), and the example produced in 1801 by Canova all interpret the subject according to the Apollonian concept, the serenely lofty iconography which was expressed in lovely serene figures with flowing locks and gentle reassuring looks. However, the Gorgon's mask at the Belvedere temple in Orvieto (fourth century B. C.) the *Medusa* (590 B. C.) in the centre of the west face of the temple of Artemis in Corfu, and, above all, those painted by Caravaggio (1596-98, fig. 6), and Rubens, 1618 (fig. 7), show all the hideous features which make them disturbing, forbidding presences, exuding sensual passion and full of violence.

With these two iconographic categories our aim is not only to emphasize the obvious iconographic divergence by using Nietzsche's useful duality of Apollo and Dionysus (lucidly presented by Clair), but also to extend Nietzsche's concept to embrace not only Medusa but also the witch of the Medieval period and of the modern age with, we hope, the same happy results.

As Nietzsche writes: "We will have made a great advance in the science of aesthetics

when we achieve not simply a logical understanding but also an intuitional conviction that the development of art is linked to the duality of the Apollonian and the Dionysian, in the same way that procreation comes about through the twofold nature of the sexes in continual conflict, with rare moments of reconciliation… For a better understanding of these two instincts we should first envisage them as the two artistic worlds as defined in dream and rapture, the physiological phenomena of which show the same divergence that exists between the Apollonian and the Dionysian. According to Lucretius, the splendid figures of the gods first appeared to human souls in their sleep. In the same way, Schopenhauer has described the frightful horror which assails man when he unexpectedly loses confidence in cognitive forms… If we set joyful transport next to this horror…we have an idea of the essence of the Dionysian, rendered still more accessible to us by being compared with rapture."[1] The philosopher contin-

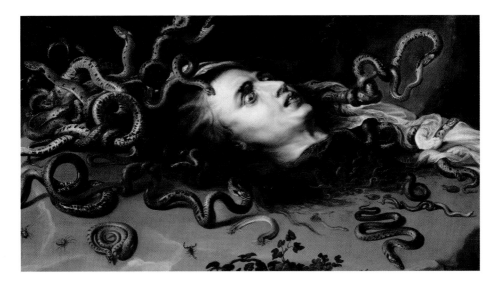

7. Pieter Paul Rubens, *Head of Medusa*, oil on canvas, 1618, Kunsthistorisches Museum, Vienna.

ues by drawing a parallel between the behaviour typical of the sexual agitation which can turn men into beasts (as occurred in Dionysian revels, and invoked in the dithyrambs) and the witch's philtre.

In the light of Nietzsche's words we might consider that these two spirits co-existed in the witch of the modern age: the Apollonian spirit, outwardly pleasing and calm, at one with nature, and the Dionysian spirit, possessed, destructive and morally deplorable. These are the figures of Lamia and of Medusa. Lamia represents carnal love, the witch who regularly celebrates the Sabbath on nights of the full moon, just as the myth recounts how Lamia chose to lie with Zeus, her beloved, in the darkness of the night. Medusa is the woman who seduces with her mind and coerces others with the power of her gaze and with her cunning, the thinking Medusa of the modern age.

Nietzsche explains the two concepts of Apollo and Dionysus by using Raphael's *Transfiguration*, where the lower, Dionysian, half of the painting with the image of the stricken boy and the horrified and stunned bystanders, is in contrast with the upper Apollonian half, radiant with an atmosphere devoid of suffering, full of noble joy and, above all, beauty. Our study follows this same path to retrace the sense of the beautiful and the sublime, and the terrible and introspective example of the witch's image.

Over the centuries representations of the witch continued to swing between the figures of Apollo and Dionysus, and hereinafter we will replace these by simply referring to Lamia and Medusa. During the late Middle Ages, for example, when the burden of guilt and dying in sin were at their most extreme, the image of Lamia, the passionate and lecherous witch, was reintroduced. She became a Bacchante and is frequently illustrated dancing – a famous path to perdition – her naked body adopting lewd and ape-like poses while her parted legs expose her vagina to the viewer as, writhing like a snake, she laughs with pain and pleasure. A good example of the Lamia witch can be seen in the cathedral of Saint Etienne in Auxerre in France (fig. 17) where a female figure riding a goat appears on a fourteenth-century modillion in the interior of the church. There is no difficulty in identifying the female figure as a witch since the goat is the supreme symbol of Satan. The woman of the relief wantonly flaunts her nakedness, while her boldly loose tresses fall freely over her shoulders. Her face is only lightly worked, the eyes are closed and, elegant and suggestive as the features are, she certainly lacks any penetrating or commanding gaze.

On a wooden choirstall in the church of Saint-Sulpice in Dienst is a startling portrait of an evil woman in the guise of a siren. Although witches were quite rarely portrayed during the Middle Ages, being submerged in scenes dominated by devouring monsters, this does not detract from the pattern we have adopted since this female form, half human and half fish, drawn from her precursor in the *Odyssey*, is depicted in the wood carving in Saint-Sulpice as a young woman with clearly defined breasts and long ringlets falling freely over her arms and shoulders. In her left hand she holds a flute, an instrument associated with love, but it is her features which catch our attention for though carefully worked her face is quite devoid of expression. Indeed, her face seems to express no feeling whatsoever: the eyes are half-closed and the mouth is equally uncommunicative. This is an example of the iconography of Lamia who does not bewitch with the gaze, the threshold of the mind, on the contrary, she uses her beautiful voluptuous body as the snare. This magic figure represents woman and her attributes, symbols of the sins of the flesh, capable of leading man from his rightful path and objective, God. Mental powers play no part here, emphasis is laid on the pleasures of the flesh alone. The body is Lamia's only vice. *Vanitas vanitatis* emerged as one of the unforgivable sins of a woman who became a witch because of the eros unleashed by her body.

However, towards the end of the Middle Ages and during the early Renaissance the witch lost this purely physical character and acquired the thinking and reasoning pow-

ers associated with Medusa. The return of neo-Platonism and the concept of ideal beauty not only affected lay painting during the second half of the fifteenth century in Florence, before Savonarola's political and artistic counter-revolution – we have only to think of Botticelli's paintings of a Venus who communicates through the beauty of her gaze, or Leonardo's Virgins who enthral the viewer with their enigmatic faces – but it also influenced, albeit to a lesser degree, the iconography adopted for *striges*, now exclusively represented according to the Medusa prototype. In both Martin le Franc's illuminations and in the engravings ornamenting Molitor's text on witchcraft the witch and Medusa have a strikingly fierce gaze while their apparently wasted bodies are completely covered.

During the sixteenth century beauty came again to the fore as a sensual and youthful naked woman. This is how she is normally presented in Albrecht Dürer's engravings, in those of his pupil Hans Baldung Grien, and in Lucas Cranach's work. Like the image in a looking-glass this figure absorbs the two expressions of her being, that of the mind, of Medusa, and that of Lamia, the instinctual and carnal.

We should mention Dosso Dossi's portrait of the sorceress Circe-Alcina (from Ariosto's *Orlando furioso*, c. 1525) in the National Gallery in Washington, one of the leading examples of the iconographic shift to a double persona. The subject is portrayed in a magical woodland world, perfect and evocative, inhabited by deer, lionesses, pelicans and domestic animals, all displaying an air of perfect serenity, still and attentive as they listen to a sweet music, the tranquil expression of thought. Circe-Alcina is portrayed as a beautiful young woman, a virginal Venus, spirit and conscious self. The subject is depicted naked leaning against a rock, with no sexual overtones, and indeed her flesh is the colour of alabaster, a tone frequently adopted for virgins, and from the expression on her angelic face she seems wrapt in deep concentration, captured as she is about to weave her magic spells.

In the Middle Ages the witch was identified with vice and wickedness and though sensual she was ugly, but during the Renaissance the two opposing images of Medusa and Lamia became merged. During the Enlightenment it was the semblance of Lamia that prevailed, the source of agreeable erotic pleasures, while in the Romantic age the witch reappeared in the guise of Medusa, and thus no longer as the woman who wantonly bewitched with her body and captured the soul with lascivious wiles. She once again emerged as a figure of the soul and the spirit, stripped of all Dionysian urges and desires.

1) Friedrich Nietzsche, *La nascita della tragedia ovvero grecità e pessimismo*, edited by P. Chiarini, Bari 1992, pp. 21-22.

Medusa

8. *Medusa.*

The Origins of the Myth.
The Classical Prototype

"To Phorcys Ceto bore old woman fair of cheek, white-haired from birth: the immortal gods and men who walk on earth call them the Old Women, fair-robed Pemphredo and saffron-robed Enyo. And she bore the Gorgons, who live beyond famed Oceanus at the world's edge, hard by Night, where the clear-voiced Hesperides are: Sthena, Euryale, and Medusa who suffered a grim fate. She was mortal, but the other two immortal and ageless."[1]

This is how Hesiod describes the mysterious triadic myths in the *Theogony* (c. VII century B. C.). The first triad was composed of Pemphredo, Enyo and Perse, knowledge of whom is essential to an understanding of the destiny of the mortal Gorgon (Medusa),[2] who lived in a dark cavern which lay in some unnamed forest region where the sun failed to shed either warmth or light, and the cold rays of the moon produced no happier results. The Graeae were born as white-haired old women (traditionally attributed with a human head and the body of a swan), bearing a close resemblance to the image of the witch as later interpreted in European art. All three had hideous faces and made vile gestures, barely visible in the surrounding gloom. In the night their white hair glowed in the dark, highlighting their deeply-lined and haggard faces. They had but one tooth which they shared between them, and one eye which they passed to and fro to see and predict the future, far beyond the possibilities of ordinary mortals. In contrast to the ugliness of their bodies they offered the brilliance of their *noèsis* (knowledge). They were visited by Perseus on his search for the most wicked of Gorgons[3] of the second triad, but when the Graeae proved reticent he deprived them of their eye and forced them to reveal where Medusa, Stheno and Euryale were to be found.[4]

Anyone with even a minimum of knowledge of witches and their powers cannot fail to recognize the precursor of the fortune-teller in this description of the Graeae. We can be quite sure that the witch represented in art with animalesque attributes and a physically misshapen body, though gifted with extraordinary powers of divination, owes a great deal to this early 'Trimurti'.

The Graeae played an important role in the tragic and dramatic story of Medusa's life. In Classical myth she is represented as having enormous wings, steely scales on her breast, snakes springing from her head and a compelling gaze which is unbearable to human sight.[5] In the figurative art of the ancient world, the animalesque attribute associated with a deity carried particular significance and reflected negatively on the figure concerned, remaining unchanged in figurative art into Medieval and later times. The Gorgons and their animal attributes, symbolise a superhuman primal urge.

The witch's cerebral character, diametrically opposed to her sensual, bewitching per-

sona, proves to be the forerunner in mythology and can be recognised in evil triads such as the Graeae, the Gorgons, the Moirae[6] (fig. 10) and the Keres[7] ("…and the Fates, to whom Zeus the resourceful gave the most privilege, Clotho, Lachesis and Atropos, who give mortal men both good and ill")[8] to which we might add Demeter (whose name means 'she who strikes from afar').[9] The latter, in despair at the loss of her daughter Persephone, stolen by Pluto and borne off to the Underworld, moved among mortal beings in order to gather news of her beloved daughter. Veiled and dressed in mourning, she was given lodging by Metanira who entrusted her with the care of her son Demophoön.

Pain and suffering at the loss of her daughter Persephone drove Demeter mad and at night she began to anoint the infant's body with ambrosia (the food of the gods), exposing him to the fire so that he would become overwhelmingly strong and invincible. The goddess believed that the unguent spread on the child's body had the property, after long exposure to fire, of rendering him immortal. Like the Graeae and Medusa this woman used her magical gifts, in this case as a medication, to raise a human being

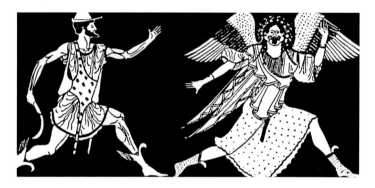

9. Medusa.

to the level of the gods.

Hecate too, the daughter of Asteria and Perses,[10] like the terrible figures mentioned above, is an archetypal witch and the protectress of childbirth and of women suffering in labour. Her image was placed over the entrance to houses since it was believed she could alleviate the pangs of childbirth, or torment those who did not please her. Hecate was a lunar deity (fig. 11) and therefore related to Persephone. Both lived in the underworld, both were gifted with supernatural powers, and both were feared as figures of the shades, devotees of magic and queens of the infernal regions. The heads of Hecate, Artemis and Persephone not infrequently appear in triads, either sharing a single body or equipped with the bodies of three different animals (lion, horse and dog) joined along the spine.

The sorceresses of the new era appealed eagerly to Hecate when they needed someone to intercede on behalf of their charges in childbirth. This mythical figure was often invoked by those seeking a painless and safe delivery. During the Middle Ages, the sor-

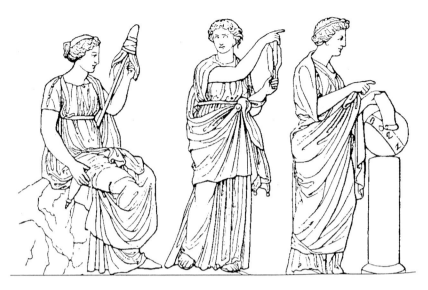

10. *The Moirae.*

ceress intoned chants and prayers while preparing her magic potions, the dispensers of delight and alleviators of suffering in the treatment of illness.[11] To invoke Hecate was an appeal for a reliable support, for assistance in the success of some enterprise.[12]

The history of the sorceress in the Western world accredits her with a special gift, the power of her gaze, capable of coercing and overcoming any living obstacle. The question of this gaze is of fundamental importance to an analysis of the whole phenomenon of witchcraft, for in this lies the witch's strong mental powers which could never be subordinate to that of the senses and the body, even if, as we shall see later, the latter was also useful and could be brought into play to influence its victims. Thus, it was possible to corrupt using either of these human weapons, or a cunning combination of the two.

The gaze is none other than the essence of the power of the mind. On hearing the imperative "Look at me!" the listener is prepared to receive an order, to bow to a superior intellect.[13] Even when delivered in a non-specific general manner the demand "Look at me!", that is, "Look at this precise part of the body", unconsciously implies an exchange of gazes. Eyes can soothe the spirit or they can cause disquiet and disturbance; or they can kill, as in the case of Medusa who was able to express this order through the power of her mind, without using the spoken word.

Egyptian mythology recounts the story of Isis who, on discovering the coffin of her dead brother-husband Osiris in the Phoenician city of Biblos, was consumed with grief and wanted to open the sarcophagus in solitude. While she was looking at the body she became aware that she was not alone. Indeed, the son of the king of Biblos was watching from a hiding-place and Isis, furious at the intrusion, decided to strike him with her gaze, felling him to the ground.[14]

In history and myth alongside every appearance of a witch gifted with remarkable psy-

chic powers[15] there is a lovely sensual woman who is related to the image of Lamia, which we have just discussed. According to Hesiod's account she followed in the footsteps of Aphrodite (and hence Venus), the goddess of beauty who was born of sea-foam, foam springing from the sexual organs of Uranus whom Cronos had jealously castrated, casting his organs into the open sea. The phallus fell among the ocean billows, floating for countless days and spreading, besides his blood, the sperm which produced Aphrodite over a wide area. She was born as the lovely Aphrodite, a goddess of extraordinary beauty,[16] and with her charms and prophecies she drove men to perdition and madness. It was she who made Paris fall in love with Helen, she of the beautiful locks, a love that presaged death and destruction. The Erinyes, or the Furies of Roman mythology, were also born of Uranus (fig. 12). Together with the Graeae, the Erinyes can be considered the true precursors of the typology of the later witch. Alecto (Fury), Tisiphone (Vendetta) and Megaera (Hate) represented death but also the guardians of the natural laws. We are told they left Erebus (the deepest and most hidden region of the Underworld) on the fifth day of each month and rose to the earth enshrouded in mists, surrounded by Fear, Rage and Pallor, to devour the hearts of sinners. They are also described as having snakes springing from their heads, darkish skin and voices like barking dogs;[17] they appeared on nights of the full moon and their presence was felt all over the world by the wolves, who replied to their call with raucous howls.

These are two different images (Medusa and Aphrodite-Lamia) but the similar effect

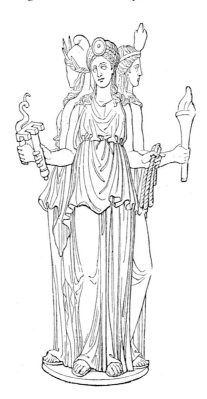

11. Triad composed of Hecate, Artemis and Persephone.

they produce, driving men mad, forms the basis not only of the visual iconography but also of the cultural concept of the witch. They form two poles of attraction that are indispensable to all human action, love and psyche, and both subjugate, corrupt, bewitch and kill. Both Medusa and Aphrodite perform deeds of death and destruction. They are destined to bring chaos on mankind, especially through the medium of love. The former, Medusa, for love of the power and the invincibility of knowledge, the second, for love of the body and soul, which is nothing more than the knowledge of human frailty; everything which revolves around them implodes.

In Classical mythology we also find another precursor of the erotic witch of the Aphrodite type. The witch Medea was the daughter of King Aeetes of the land of the Golden Fleece, the pelt of the mythical ram on whose back Phrixus (Jason's great-uncle) rode to escape a terrible sacrifice. Jason, the son of Aeson and Alcimede, set sail aboard the Argo, eager to find the Golden Fleece. Without the help of the gods he would never have succeeded in his mission; indeed, it was the lord of Olympus who sent the daughter of the king of Colchis to his aid.[18] The maiden had magical powers which had been conferred on her by both Hera and Aphrodite; indeed, they employed these to make the young Medea fall in love with Jason so that she would use her powers on behalf of this noble hero.[19] When Jason appeared before the king to ask him for the trophy, the king demanded that he perform a valorous deed in exchange. Jason was to yoke together two bulls with hooves of bronze and use them to plough a field while,

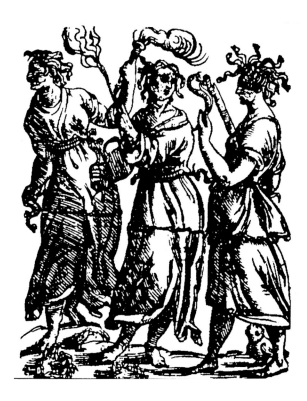

12. *The Erinyes.*

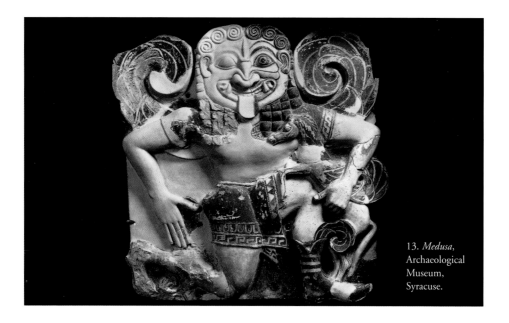

13. *Medusa*, Archaeological Museum, Syracuse.

at the same time, sowing it with dragon's teeth from which fierce warriors would spring, ready to kill anyone in their path. If Jason had not received the help of the king's daughter he might well have fulfilled his task but he would have fallen victim of his own achievement because, as soon as the sowing was over, the warriors would have sprung from the earth and immediately slain him. Medea brought her magic into play and to save her beloved she gave him an ointment to protect him against misfortune.

In Homer, the arts of prophecy and magic are central and they help to untangling the intricate thread of those stories which lack a logical basis. In the *Iliad*, the figure of the soothsayer Calchas makes an appearance in Book I to explain why the gods rage against Agamemnon, king of Argos, causing the resulting victory of the Trojans over the Achaean army, chiefly due to the arrival of the plague which was held to be a punishment inflicted by the wrathful Zeus. "…and Calchas son of Thestor rose to his feet. As augur Calchas had no rival in the camp. Past, present and future held no secrets from him; and it was his second sight, a gift he owed to Apollo, that had guided the Achaean fleet to Ilium."[20] It is Calchas who reveals the affront that a king, in this instance Agamemnon, has given to an augur: " 'There is no question', he said, 'of a broken vow or any shortcoming in our rites. The god is angry because Agamemnon insulted his priest, refusing to take the ransom and free his daughter. That is the reason for our present sufferings and for those to come'."[21] In this passage we see the relationship linking the figure of the priest (or seer), he who presides over man's mysterious and sacred fate, and that of the magician of the later times, the only figure capable of giving the common man an explanation of the fateful events imposed by the deity.

The art of prophecy and magic is created by man and governed by destiny. This not only condemns mankind to suffering but at times may also protect him from his own

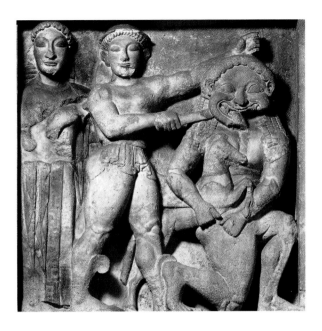

14. *Perseus beheading the Gorgon*, metope from the Temple of Selinunte, Archaeological Museum, Palermo.

mistakes and save him by forewarning him of grievous events. He, or she, who 'knows' is in the position of living both in and outside the earthly sphere: the magician or witch find their counterpart in the liberated slave (the philosopher), he who is close to knowledge, or to the Sun as a Good, with reference to Plato's story of the cave.[22] As the slave in the myth, the seer too will be slain because his gift of knowledge is considered harmful by those who do not 'know', who are unaware of both the present and the future. However great the difference between the context and outcome of Plato's story and a witch's spells, it is important to reflect on the relationship which unites these two examples, that is, death, due to the threat of intellectual diversity and superiority.

A similar fate is suffered by the daughter of the king of Ilium, Cassandra, who had the gift of prophecy. She was condemned to live apart and alone because of her ability to predict the future of her husbands. She was killed by being decapitated, like the mortal Gorgon, by Clytemnestra after the city of Troy was taken by the Greeks. Like Medusa Cassandra is associated with snakes. The myth recounts that immediately after her birth she was taken to the Temple of Apollo, where she passed the night; the following morning she was found wreathed in a nest of snakes which bestowed on her the power of prophecy.

The polychrome high-relief with a full length figure of Medusa (in the Archaeological Museum in Syracuse) is an expression of the psychic powers so strongly associated with this mythical figure (fig. 13). She is kneeling and shown in profile below the waist, wearing a short skirt which is open in front, while her torso, shoulders and head are given a frontal view. Her winged footwear is an interesting feature, similar to that which Perseus was given by the Stygian nymphs, together with his wondrous helmet and shoulder bag, to help him to decapitate Medusa (Hermes[23] had earlier presented this

brave young hero with a sword designed to help him defeat all evil foes; Athena too had bestowed on him a burnished shield so that he could see the reflections of the Gorgons without meeting their deadly gaze).[24]

This solidly built Medusa holds Pegasus under her left arm, the fruit of her relationship with Poseidon, to whom she had, moreover, appealed for the immortality she still lacked. The interest of the figure lies almost exclusively in the face: two powerful, staring eyes, defined by curving brows and a further two deep lines which follow the curve, all completed by heavy pouches below the eye sockets, more fully worked than the other features. The pupils are green and encircled with carmine. The intensity of the gaze is expressive of the most keen and intense thought and the flat, broad nose is a prelude to the fearsome sneering mouth, stretched so wide that it impinges on the jaws and cheekbones. The dentation of the grinning mouth is marked, the canines replaced by horrid fangs and a hideous protruding tongue emerges from between the lips and hangs limply down over the chin. There are no attractive features of any kind and all power is concentrated in the eyes which communicate her special psychic gifts.

The metope from the Selinunte temple (now in the Archaeological Museum in Palermo) illustrates Perseus in the very act of decapitating the great-eyed Medusa (fig. 14). Here too, as in the preceding image, she holds Pegasus under her arm. In physical terms, we see how the masculine body of the warrior Perseus in his winged footwear is not unlike the powerfully built, even muscular, body of Medusa who has the build of a trained athlete. The position of the legs and hips displays obvious physical strength; the shoulders and arms are well-developed, the arms tensed in a final helpless display of emotion, the urge to hold the winged horse so closely against herself that she is in danger of crushing it. As in the previous relief, Medusa inspires horror: her enormous mouth emphasizes her greed and her staring eyes reflect her extraordinary psychic powers.

The red-figured cylix in the Vatican Museums also illustrates the myth of Medusa (fig. 15). The scene depicts the story of Jason in his search for the Golden Fleece, shown hanging above his head in the branches of a tree, while the great snakelike dragon whose task it is to guard the precious fleece holds in his mouth the moribund Jason, slowly re-emerging from the depths of its monstrous jaws. The goddess Athena has come to Jason's aid, attired in her customary military style and holding her attribute, the owl, in one hand. On her breast she bears the image of the fierce-eyed Gorgon. With its deadly compelling gaze the head of Medusa has the power to vanquish all who look at her, and thus also Jason's foe, the dragon. Medusa's head has protruding fangs, glaring eyes and a long tongue, stressing the repellent appearance which instilled terror in her enemies. The long, drooping tongue emphasizes the arrogance and intensity of her gaze, while also indicating her immeasurable courage, scorn and audacity. This episode reveals how Jason used guile to achieve victory over the monstrous beast. Before facing her he covered his body with an ointment that would make him invincible, given him by Medea who had wanted to accompany her beloved into the forest to make the dragon drowsy with her magic song, enabling the hero to carry off the precious fleece.[26]

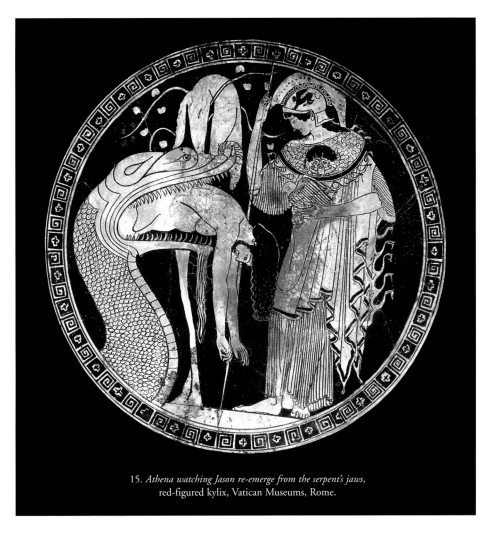

15. *Athena watching Jason re-emerge from the serpent's jaws,*
red-figured kylix, Vatican Museums, Rome.

Medea is the very antithesis of Medusa. She is the beautiful seductive enchantress *ante litteram*, whose love for Jason drives her to carry out monstrous crimes against her own family, her father, brother and uncle, Pelias, the bronze giant Talos of Crete, and, finally, her own children. We are told that in the later part of her life, after she had killed Pelias, whose own children cut him to pieces because Medea had persuaded them that this would restore the old king's youth (the daughters were to boil their father's members in a great cauldron), she and Jason settled in Corinth, where she gave birth to two children. In this city Jason fell madly in love with the king's daughter and Medea, devastated by his betrayal, devised the most hideous punishment imaginable, that of murdering her own children in order to bring suffering on her loved one, first using her magic powers to kill Jason's new bride.

This tragic myth tells us that those gifted with magic powers cannot support the yearnings of love without enduring suffering and moral defeat. The beautiful and seductive

Medea is destroyed by her love for Jason. On this cylix the woman is portrayed as a graceful figure, young and tall with fine features, she is shown watching the slaying of the bronze giant, for only she is capable of finding his vulnerable spot, represented by a pulsing vein in his ankle.

Medusa, on the other hand, who is repulsively ugly and wicked to all and sundry does not die, being a sorceress, a superior being, her psychic powers are immortal and eternal and though she meets a bodily death when decapitated by Perseus, her force survives forever. Indeed, on the cylix mentioned above, Athena bears her living image on her breast.

Which of these two emerges victorious, the woman with a powerful mind or the woman of feminine charms? Medusa, or Media (that is, Aphrodite or Lamia). Perhaps

16. *Odysseus threatening Circe with a knife*, tomb relief, IV century B. C., Town Museum, Orvieto.

both or perhaps neither. Medusa prevails with her mental powers but is the loser in physical terms. Medea's body triumphs because her love endures until the end, but she loses in terms of mental powers because she is swayed by human emotions. Medea personifies emotion and as such her visual image and her deeds are affected by her passions. Medusa represents the intellect and thus, in art, her image is chilling and unappealing. Medea looks to eros and Medusa to *thánatos*.

Like Medea, Circe is undoubtedly another example of a witch of the Lamia type. Her story is recounted in Homer's *Odyssey*,[27] where the sorceress, the progeny of the gods, bewitches and waylays hapless travellers in order to know them carnally. We are told that when Odysseus landed on the island of Aeaea, the home of the goddess Circe, she was so driven by her passion for this noble king of Ithaca, that she turned his companions into swine in order to prevent his departure.[28] Odysseus says: "…By and by it bub-

bled / and when the dazzling brazen vessel seethed / she filled a bathtub to my waist, and bathed me / poured a soothing blend on head and shoulders, / warming the soreness of my joints away. / When she had done, and soothed me with sweet oil, / she put a tunic and cloak around me…"[29]

A relief on a IV-century B. C. tomb in the Town Museum in Orvieto (fig. 16) depicts Odysseus in the act of threatening the sorceress with a great knife watched by two of his companions from the voyage with heads of swine, further victims of her enchantment. Circe is handsome and seductive, and her facial features are expressive of her disturbing femininity. Her form too is openly suggestive and emphasized by her dress which falls lightly over the curves of her body. Circe's physical appearance evokes a very different response from the one produced by the image of Medusa. Her appearance has more the feeling of the bewitching enchantress; shaped like a Greek urn, her body is engaging and voluptuous, indicating her power to enthral and deceive. It is her beauty and her knowledge of the ways of love that lead Odysseus to become ensnared.

Female figures who were forerunners of the iconography of the Medieval witch existed in Roman culture too. The Laws of the Twelve Tables, drawn up by the decemvirs between 451 and 450 B. C. and displayed in the Forum to be studied by all as a symbol of the democratisation of power, condemned those who "malum carmen incantare".[30] Several historians of Imperial times make explicit reference to magicians and witches, guilty of fashioning wax or metal effigies of their victims in order to cause them harm.

In the eighth *Eclogue*[31] Virgil refers expressly to magic and Horace describes two sorceresses in his *Satires*, Canidia with her black robe bound about her waist, and Sagana ("For myself, 'tis not so much the thieves and beasts wont to infest the place that cause me care and trouble, as the witches who with spells and drugs vex human souls: these in no wise can I bring to naught or stop from gathering bones and harmful herbs, as soon as the roving Moon has uplifted her beauteous face.")[32] He goes on to say that these two women have magical gifts, using dolls as vehicles to exercise their powers ("One image there was of wool, and one of wax…One witch calls on Hecate, the other on fell Tisiphone.[33] Hideous to behold!")[34] When the wax model of the chosen victim was cast into the flames venomous snakes and fiendish hounds appeared.[35]

In the *Fasti* Ovid gives a highly detailed description of some sorceresses called 'Striges', hideous old women who could transform themselves into birds of prey, and these must be considered the archetypal model of the later witch: "They have huge heads, goggling eyes, beaks curved for plunder; / Their feathers are cast with grey, their claws hooked. / They fly at night and target children still unweaned, / …Screech-owl is their name; and the cause of the name / is their hideous screeching at night. / Either they are born birds or become so by magic."[36]

Lucan gives us another finely detailed description in his *Pharsalia*[37] when writing of Erichtho, the sorceress of Thessaly. This work is a poem which recounts the various stages of the civil war fought by Caesar and Pompey. Although it focuses on lamenting

the disappearance of the republican institutions, replaced by Caesar's tyranny, the inglorious results of which culminated in the battle of Pharsalo, it also contains some passages on more macabre topics. Erichtho, tall with a pallid face and hollow cheeks, is described as a woman noted for her dishevelled wild locks, wreathed with vipers ("She never appeared abroad in daylight and quitted the tombs only on wet or cloudy nights, when she went out to catch and bottle whatever lightning happened to fall."[38] She could raise those killed in battle and she it was who predicted the outcome of the final clash to Pompey. The account of the particular rites associated with her are also extremely interesting. Lucan states how: "If the corpse was not cremated…" Erichtho "…always attacked it with greedy passion. She used her fingers to scoop out the glaring eyeballs, and gnawed the pale nails off its withered hands. If the corpse had been hanged, she would first bite the nose free, and then tear away the other extremities… She was composing a new and special spell, the like of which had never been heard before, whether by wizards or the gods of wizards."[39] Lucan goes on to give a detailed description of the multi-coloured and outlandish clothes worn by sorceresses, similar to those worn by the Furies. During the I and II centuries A. D. this may well have been the usual dress of prostitutes whose brightly coloured clothes, chiefly yellow and green,[40] frequently led them to be considered mad or possessed and cursed with every possible affliction.

If this interpretation is correct it is clear that in Roman culture, as in Greek, two distinct concepts of the witch existed side by side: one in the guise of the priestess, the other of a woman experienced in the ways of love.

1) Hesiod, *Theogony*, lines 273-281, translated by M. L. West, Oxford University Press 1988; and later: "And when Perseus cut off her head from her neck, out sprang great Chrysaor and the horse Pegasus. He was so named because he was born beside the waters of Oceanus, while the other was born with a golden sword in his hands", cit., lines 282-284.

2) A. Morelli, *Dei e miti. Enciclopedia di mitologia universale*, Verona 1989, p. 330.

3) According to Homer, Medusa's head was in the possession of Persephone and in the *Odyssey* he writes: "and the horror took me that Persephone / had brought from darker hell some saurian death's head." (Homer, *The Odyssey*, Book XI, lines 634-645, translated by Robert Fitzgerald, London 1962).

4) On the Graeae, sisters of the Gorgons and old and white haired since birth, see: A. M. Carassiti, *Dizionario mitologico. Le figure mitologiche della civiltà greco-romano*, Genoa, 1996, pp. 139-140.

5) The myth of Osiris, oldest son of Geb and Nut,

who was both the brother and husband of Isis, tells us that they lived on the fertile banks of the Nile and that he was a wise and magnanimous ruler. His brother Seth was jealous of him and waylaid him in the marshes, killing him and putting his body in a coffin which he cast into the waters of the Nile. However, the great love of Isis and her sister Neftis caused the coffin to re-emerge. When Seth heard of its recovery, he determined to complete his evil deed and returned to the marshes to wreak further destruction on the corpse. He cut the body of his brother into fourteen pieces which he scattered throughout Egypt. With loud lamentations Isis (according to Plutarch in *Isis and Osiris*) succeeded in recomposing his body and restoring him to life with the aid of a magic spell, and the power of her love.

6) A. M. Carassiti, *Dizionario mitologico*, cit., pp. 196-197. The Moirae were the daughters of the Night and of Erebos and they held sway over life; even the gods could not escape them. They were connected with the cult of Zeus and Apollo. On

this aspect see also A. Morelli, *Dei e miti*, cit., p. 343. The word Moira means 'part', and as lunar deities they symbolized the three phases of the moon, waxing, waning and full.

7) A. M. Carassiti, *Dizionario mitologico*, cit., p. 232. Originally there was only one, and she protected those in childbirth. Later, due to the influence of the myth of the Greek Moirae, they became three. On the Keres see: A. Morelli, *Dei e miti*, cit., p. 296. The word 'Ker' signifies 'fate', i.e. destiny, and indeed Aeschylus describes the sphinx as "a Ker which ensnares men".

8) Hesiod, *Theogony*, cit., lines 903-906.

9) Demeter was the daughter of Cronos and Rhea and the goddess of agriculture, vegetation and the fields. She it was who, in her misery, made the earth sterile when her daughter Persephone was carried off to Hades. While she was wandering the earth in search of her beloved daughter she used her gifts to give immortality to Demophon, son of the king of Eleusis. (A. M. Carassiti, *Dizionario mitologico*, cit., p. 72).

10) She was considered the goddess of spirits and magic. Traditional iconography shows her either with three heads and a single body or with three bodies joined down the spine, that is, trimorphic. (A. M. Carassiti, *Dizionario mitologico*, cit., pp. 79-80).

11) On the connection between the witch and the myth of Hecate, see the essay by P. Castelli, *L'immagine della strega nell'Antichità. Le antenate di Malefica*, in 'Art e Dossier', VIII, 1993, pp. 28-29.

12) Hesiod, *Theogony*, cit., lines 412-416: "There she (Asteria) conceived and bore Hecate, whom Zeus son of Cronos honoured above all others, granting her magnificent privileges; a share both of the earth and of the undraining sea."

13) J. Clair, *Medusa. L'orrido e il sublime nell'arte*, Milan 1989, p. 26ff.

14) F. Jiménez Del Oso, *Streghe. Le amanti del diavolo*, Milan 1995, pp. 16-21.

15) In Roman mythology Medusa and Demeter were replaced by Diana, the goddess of hunting, without any conceptual changes.

16) In antiquity Isis was also recognized as a great sorceress and her aid was invoked during the rites performed to heal the sick, see: A. Grignola, *Egitto. Una grande civiltà*, Colognola (VR) 1997, p. 69.

17) According to Euripides there were three of them, old and hideously ugly, and they persecuted the murderers of family members (blood relatives, those without respect for their fathers or brothers), both alive and dead. They made their presence known with their barking cries. For Plutarch there was only one. In Roman mythology they became absorbed

into the Furies. For further details see A. M. Carassiti, *Dizionario mitologico*, cit., pp. 103-104; and also A Morelli, *Dei e miti*, cit., p. 218-219.

18) For the story of Medea and Jason see: A. Morelli, *Dei e miti*, cit., p. 329, and *Medea*, the tragedy by Euripides.

19) On the sufferings of Medea and on her magic powers: F. J. Del Oso, *Streghe*, cit., pp. 28-32.

20) Homer, *The Iliad*, Book I, p. 25, translated by E. V. Rieu, London 1950.

21) *Ibidem*, p. 25.

22) Plato, *Republic*, VII.

23) A. M. Carassiti, *Dizionario mitologico*, cit. pp. 141-144.

24) F. J. Del Oso, *Streghe*, cit., pp. 22-23.

25) *Ibidem*, p. 23.

26) *Ibidem*, p. 29.

27) Homer, the *Odyssey*, cit., Book X, lines 112ff. Circe was the daughter of Perseis and Helios, the Sun, and sister of Aeetes, king of Colchis. She lived on the island of Aeaea and makes numerous appearances in the *Odyssey*, all of which are given references in the edition cited above.

28) The sorceress was banished after murdering her husband, the king of the Sarmatians. She fell madly in love with the fisherman Glaucus; Odysseus alone escaped her magic spell (A. M. Carassiti, *Dizionario mitologico*, cit., pp. 60-61).

29) Homer, the *Odyssey*, Book X, lines 360-366, cit.

30) P. Castelli, *L'immagine della strega nell'Antichità*, cit., p. 29.

31) Virgil, *Eclogue* VIII.

32) Horace, *Satire*, I, 8, prose translation by. H. R. Fairclough, Loeb Classic 1929; and also "...the elder Sagana. Their sallow hue had made the two hideous to behold. Then they began to dig up the earth with their nails, and to tear a black lamb to pieces with their teeth; the blood was all poured into a trench, that therefrom they might draw the sprites, souls that would give them answers." *Satire*, I, 8, cit.

33) A. M. Carassiti, *Dizionario mitologico*, cit., p. 320.

34) Horace, *Satire*, I, 8, cit.

35) P. Castelli, *L'immagine*, cit., pp. 29-30.

36) Ovid, *Fasti*, VI, lines 133-140, translated by A. J. Boyle and R. D. Woodard, London 2000. According to this writer the terrible women came from the Marsian region, today the area of Abruzzo that abuts on Lazio.

37) Marcus Annaeus Lucan, *Pharsalia* VI, prose translation by Robert Graves, London 1956.

38) *Ibidem*.

39) *Ibidem*.

40) P. Castelli, *L'immagine*, cit., p. 32.

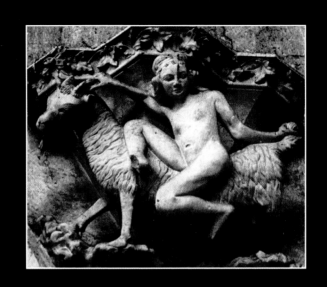

17. *Naked witch riding on the back of a goat,* XIV
century relief, Church of Sant-Etienne, Auxerre.

The Meeting of Opposites During the Middle Ages

The need to eliminate the early rites of initiation and the pagan world's celebrations of nature (particularly those common to peasant cultures related to the chthonic deities and the hypochthonic protectresses of fertility and health)[1] which still lingered in the Christian Europe of the IV and IX centuries led to the introduction of forms of punishment for those practising witchcraft (enforced in the mid-thirteenth century on a strict judicial basis). This was motivated by the problem of ensuring that the Church had full control over its entire flock of worshippers, whatever their social position. This was particularly important on those occasions when the *comunitas* was most involved and gathered into a single *corpus*, occasions which included festivities of various kinds, medicinal stratagems for protection against misfortune and sorrow, the daily superstitious practices to ward off the scourges of famine and sickness and the invocation of heavenly bodies. While describing a witch as a priestess of the occult, the sources both investigate and condemn the pseudo-mystical aspect of supernatural prophetic powers, as well as those aimed at healing the sick with the use of medicinal herbs (suitably blended and brewed).

In 314 the practice of magic was condemned by the Council of Ancira, but it was at Alvira in 340 that stiff penalties were introduced for those who killed through the practice of witchcraft. The Rotari edict of 643 tackles the problem of witchcraft, but makes no explicit reference to the particular powers of magicians or the results of their sorcery. Furthermore, from this document we learn that the witch, referred to here as 'masca' ("stria quod est masca") was not an exceptional figure, isolated from society, but could be found living freely in the community.

These sources describe a figure well inserted into the basic pattern of daily life in small towns (preparing and selling ointments for countless curative purposes) and this gives us evidence of a degree of tolerance among the general populace, despite the fact that in theory the witch continued to be looked upon as someone apart and 'different'. The witch is described as somebody straying from the Church through foolishness, and it should be remembered that this is why there was no moral reason to justify brutal persecution, or indeed the death penalty. There are notes on punishments to be inflicted on those who bring harm on themselves, such women being the unknowing victims of their own mischief, often without any supernatural contribution. These details clearly show how at this time the members of a community were on reasonably friendly terms with the witch and how she existed on the level of a commonplace domestic presence. The question of magicians, witches and warlocks, looked on in a negative light as an

obvious sign of the sinful paganism which stubbornly persisted in rural areas, is close-ly examined in the edict of Liutprand of 727, which condemns magic as being at odds with Christian morality and underlines the dangerous associative nature of the congregations, enemies of the true faith.[2]

In around 775 the important document *Capitolatio de partibus Saxoniae* was drawn up which forbade the killing of witches and firmly condemned those who were bewitched by the evil-doers, besides reproving those who indulged in the eating of witches, since at the time of this manuscript it was the practice to eat the flesh of such women to acquire their remarkable magical powers. Anyone hoping to absorb the psychic powers of a sorceress by consuming her limbs, skin or brain was in error. The *Capitolatio* thus openly implies, especially in the passage concerning sanctions against the devourers of witches, a belief in the reality of the witch's superiority (unlike the Rotari edict) as the mistress of an alternative reality, and in her ability to manipulate nature for her own ends.[3]

18. The relief known locally as 'La Potta di Modena', (The Twat of Modena), XII-century metope, Sculpture Museum, Modena Cathedral.

This whole matter would not seem extraneous to the general instability of the Medieval Church, undermined by religious heresies which gave rise to proselytisers all over Europe. These included the sects of Paulicians, Bogomils, Bulgars, and, especially, the Cathars,[4] against whom the papacy tirelessly employed all its forces. Similarly, in 1100 the Church underwent a further rupture which was determined by the unseemly behaviour of various prelates, a rupture which, though it may not have been responsible for a decline in the followers of the dictates of the official Church, certainly contributed to arousing a strong desire to revive the rigour and spirit embodied in the earlier Christian Church. At the end of the twelfth century this found expression in the merchant Peter Waldo and the communities he founded, the Waldensians, committed to opposing any religious display of pomp and splendour and to fighting all forms of moral corruption (vanitas and lust) on the part of the clergy.[5] At the end of the tenth century this situation was compounded by the high mortality which decimated the population with repeated epidemics, famine and illnesses caused by malnutrition and the absence of even elementary notions of hygiene. This position was worsened by the

inability of normal medical practices and extremely limited diagnostic skills to reduce the high mortality rate. It is understandable that in this climate of gloom and depression magic sects began to flourish and the use of 'alternative' medicines increased, produced by the charlatans and healers who operated in every urban centre.[6]

The first to make a direct connection between witchcraft and heresy was Rabano Mauro. *De Universo* (784), particularly in the chapter entitled *De magicis artibus*, contains some reflections drawn from the edict of Liutprand. Rabano Mauro reiterates the belief that witchcraft is the product of evil (unless it is to be considered as designed and dispensed by God) and, like the early pagan superstitions still alive at the time of Christ, found their outlet in fervent religious sects whose aim it was to destroy the Church institutions by tricking and deceiving the faithful worshippers.[7]

A text of fundamental importance in Medieval literature dealing with demonology, which both preceded and accompanied the persecution of witches, is the *Canon Episcopi*. This should be dated to the ninth century,[8] although historical tradition mistakenly attributes it to the time of the Council of Ancira.[9] In fact, this must come from a Frankish capitular,[10] similar to the fragments of Louis II's capitular (867). This brief text was written for the instruction and use of bishops adhering to the 'Society of Diana'.[11] And indeed she is a leading topic in this treatise, translated into several languages over the course of the tenth and twelfth centuries.

An important contribution was made in the tenth century by Reginon, Bishop of Prüm,[12] entitled *Libri duo de synodalis causis et disciplinis ecclesiaticis*.[13] The author reconsiders and expands on concepts already discussed during the preceding century (drawn from the *Canon Episcopi*) such as flying at night and the fornication of witches with the devil. Burchard of Worms (1025)[14] also alludes to the *Canon* in his *Decreta*. In his *Polycraticus*, John of Salisbury (1120-1180) was certainly the first to officially propose a connection between Diana and Herodias and the witches' covens, going beyond the vague suggestions contained in the aforementioned *Canon*.[15]

In the *Canon Episcopi* stress is laid on the most amazing aspects of the world of witchcraft: riding through the night on the back of a goat. "… And those who abandon their Creator and seek the aid of the devil have strayed from the true path and are prisoners of the devil; and hence the Holy Church must be cleansed of this scourge. It should also be remembered that certain depraved women who have turned to Satan and been led astray by illusions and diabolical temptations, claim and believe that they ride at night on certain beasts to follow Diana, the pagan goddess (or Herodias), with a countless multitude of women; they describe crossing great expanses of land in the silent hours of darkness, of obeying her commands as their mistress and of being summoned to serve on certain nights…"[16]

This passage is of special interest because, apart from pointing out how an actual experience of magic was considerably more meaningful than confused and unguided *speculatio mentis*, it reveals the desire to rationalize the phenomenon as such and hold it to be actually impossible. There are in fact two main positions to be reflected on: the first

holds that it is possible for Satan to act on the minds of credulous women by actually possessing them, causing them to experience extraordinary and highly sensual sensations in their sleep; the second argues that events envisaged and experienced by the imagination and in a dream-like state can actually come to pass in reality.

In the *Canon* mentioned above, apart from Diana with whom the witch often chose to identify herself, there is also a reference to Herodias,[17] the seductive and evil wife of Herod. This twofold image, although still rather unclear, is interesting because it presents a double personality for the sorceress. A dual characterization emerges from this document since two mythical female figures are referred to as embodiments of sin, with the aim of representing a single transgressive being, like the two-faced Janus.

The first figure (identified as Diana the Huntress in cultured circles) represented the witch as a 'woman of nature' connected with a female heavenly body, the moon, in virtue of her cyclical life. Moreover, Diane was also venerated as the protectress of childbirth and fertility. Once worshipped in the Holy Wood at Nemi, she was responsible not only for watching over those in childbirth but also over life in general (both of animals and plants). She was frequently identified with Hecate since she shared the same position in mystic rites and in acts aimed at extolling the imagination.

The second figure, Herodias (as she was commonly known), was the symbol of unbridled sensuality. According to Medieval legend she was the victim of a spell which condemned her to wander in the company of an evil spirit because she had plotted to make Herod give her the head of St. John the Baptist. This kind of witch officiated at magic rites held to propitiate the passions.

Condemned by the Church, these two figures well express the dual character of the witch, one using her mental powers for practices that were both for and against mankind, while the other her cunning bodily wiles, capable of enslaving men and setting them on the road to perdition. Thus, the *Canon Episcopi* presents an image of

Medusa *in nuce* (originally Diana the Huntress, the psychic agent for mental energy), and of Lamia (or Herodias), a disquieting and bewitching creature with an insatiable sexual appetite, responsible for actions resulting from uncontrollable urges of an erotic nature.

Burchard of Worms, besides reporting and discussing the practice of flying through the night sky, deplores the persistence of dreadful (pre-Christian) initiatory rites, conducted exclusively by witches. These included leading a naked virgin to a river in which she had to dip leaves of the henbane to encourage rain.[18]

In the eleventh century the Church began to condemn heretics on the basis of their way of life, when adjudged immoral or diabolical. This involved, for example, the Cathars (from Greek *katharòs* = pure) who led a simple austere life, dressed strictly in black, were extremely abstemious with food and drink, practised abortion and did not frown on homosexual love. Such behaviour did not fail to arouse disapproval, suspicion and persecution by the Church hierarchy which not only held these views to be repugnant but, above all, to cast doubt on the very canons of their faith, in this instance, the cosmos governed solely by two opposing forces, good and evil, and the existence of a devil who laid siege to man.

The defamatory campaign against the dissident Catharist sect began officially in 1022, when some priests in Orleans were accused of heresy for their unwillingness to hold that the blood and body of Christ were actually present at the Eucharist, and their rejection of the baptismal sacrament as an effective means of liberation and renunciation of Satan. This episode led to the prejudiced judgement that the congregations of this sect were devil worshippers, as we read in the testimony of Aldemar de Chabannes, and later, the telling and decisive evidence of Paul de Chartres.

The Councils of Montpellier in 1062 and Toulouse in 1119 were instrumental in establishing the most efficient methods for eliminating the Cathars. These were followed by the III Lateran Council (1179) which went so far as to list and acknowledge as legally correct those actions, even if violent, which were directed against the satanic sect in the cause of the defence of Christianity. Canon 27 states that Cathars were to be excommunicated for life. Corporal punishment was introduced in 1184 with the drawing up of the *Costitutiones*, at the wish of Lucius III and in accordance with the directive of Frederick Barbarossa. These regulations empowered the episcopal authorities, on identifying the scurrilous heretics, to excommunicate the sinners and confiscate all their goods, and, moreover, to subject their bodies to exemplary tortures to cleanse them forever of their mortal sickness. In around 1110 the sect was described as an assembly composed of worshippers of the devil, and according to the evidence of some Christian clerics, he did indeed appear among them and was honoured and worshipped with meditation and prayer. In lonely places, on nights of the full moon, the evil women invoked the devil and he appeared, grave and shadowy, ready to alleviate all forms of suffering in exchange for fornicating with all the women present. These unions led to abortions and cases of infanticide.

In 1223 Gregory IX's Papal Bull (*Vox in rama*) condemned the Cathar sect, reporting that in one of its rites it worshipped a black cat. This ceremony involved suspending the animal from the ceiling and kissing its hindquarters, after which every form of depravity was permissible. There are references to homosexual unions, orgies of every possible kind, infanticide and endless banquets, the absolute apex of the pleasures of sex and the table. This was the official stance, and the message was spread that the sect was full of foul adulterous women who were devotees of every form of depravity, gifted with supernatural powers and practising dark magic rites.

In the twelfth century the Church elaborated a system for trying the crimes of heresy and witchcraft, both punishable by the extreme penalty of burning at the stake. Frederick II of Swabia later drew a parallel between heresy and its accompanying practices, and the crime of *lese majesté*. Punishment for sorcerers and heretics was only communicated officially in 1231, despite having been in force since 1224, and it was included in the papal constitution *Excommunicamus* as proper and just. In 1235 Pope Innocent IV, the author of the Bull *Ad extirpanda*, gave the order for a widespread and systematic persecution of heresy and the practice of magic, entrusting the inquisitors with broad powers.[19]

During the Middle Ages images of the witch were relatively rare since the designers of iconographic programmes gave preference not to the figure of the 'diabolical woman' but to the more menacing immediacy of the image of Lucifer, the personification of temptation and evil. There were several reasons for this choice. One was to wage effective battle against the heretical sects by identifying them directly with the devil, the deceiver; while the second concerned the fact that during the centuries surrounding the first millennium, in virtue of the mysterious passage in the *Apocalypse* or *Revelation*, of St. John the Divine ("And when the thousand years are expired, Satan shall be loosed out of his prison, And shall go out to deceive the nations which are in the four corners of the earth, Gog and Magog, to gather them together to battle: the number of whom is as the sand of the sea.")[20] the Church hierarchy elected to use painting to convey this fatal and apocalyptic vision in order to make a deeper impression on the minds of the faithful concerning the basis of sin. The evil figure of Satan, God's adversary, was depicted more than any other: in choirstalls, on the decoration of lanterns, on the interior pediments of doorways and in the centre of the frescoes on a church's interior façade, where the most popular subject was the *Last Judgement*. The devil is shown enthroned amongst the ranks of the Damned, men and women in the place of eternal death, completely naked and horribly mutilated. The witch was relegated to a more minor position in these scenes of hell, only occasionally taking the lead in ambivalent roles such as Eve the temptress, or startling zoomorphic creatures, sirens and monsters with feminine attributes, figures derived from the monstrous forms of Classical tragedy. In the late Middle Ages only scenes showing the devil as the tempter and those depict-

20. Taddeo di Bartolo, *The Gluttons in Hell*, Collegiate Church, San Gimignano (Siena).

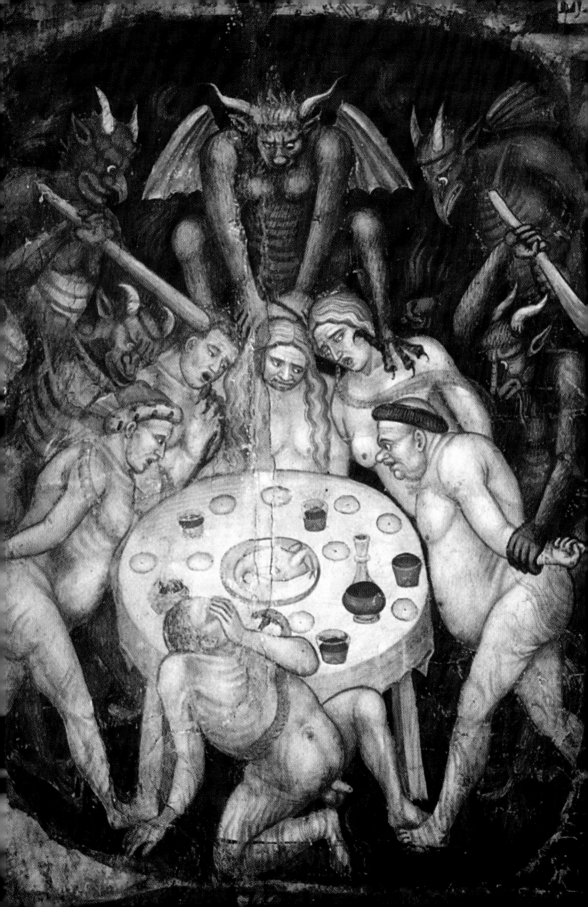

ing the Last Judgment, including scenes of a hierarchically structured hell teeming with figures of the Damned being tortured by lesser devils (in accordance with the strictures concerning the punishment of the Seven Deadly Sins),[21] competed with iconographic programmes illustrating the fundamental principles of the Church, programmes which vied for first place with New Testament subjects such as the *Coronation of the Virgin*, the *Annunciation*, the *Crucifixion*, the *Road to Calvary*, the *Lamentation* and the *Resurrection*.

However, this does not mean that the figure of the witch disappeared entirely. The chief moral dilemma in the late Middle Ages revolved around real fears of the end of the world, which seemed to be presaged by strange phenomena, including the countless deaths caused by famines and plagues. The epistle of St. John the Divine was taken as a model for the penitential school of Medieval literature and this fanned alarm and anxiety concerning the end of the world, leading the concept of the Biblical origin of Sin to be studied with an intensity which caused all other worldly sins to take second place. There are some remarkable depictions of bald, nude women, opening their legs to brazenly expose their genitals to the viewer. In Ireland, where this particular image appears, these figures were once known as *Shela na-Gig*, which some scholars hold to mean 'women of pleasure'. The iconography, which appeared from the tenth to the thirteenth centuries, started in northern Europe and then spread over the rest of the continent. The earliest news of these works comes from Richard Payne Knight in 1786, followed in 1866[22] by the discoveries of Thomas Wright who listed several female figures which he discovered in a church in Rochestown in Tipperary;[23] others were also found later in the counties of Cavan and Fermanagh.

Although much effort has been expended attempting to insert these figures into the fertility cult (Murray),[24] some scholars consider this connection to be reductive since in some churches they play no small role as ornamental motifs.[25] It seems probable that they are figurative expressions of the punishment of the sins of the flesh. Although *Shela na-Gig* may have been intended as protection against the evil eye and the practices of witchcraft in general, it is also true that this kind of female figure is related to the Classical Greek Baubo, the Athenian peasant woman who took in Ceres (when searching for her daughter Persephone) and entertained her, after giving her a drink made from barley (*kykeon*), with lascivious jokes and, in particular, a view of her vulva which she shamelessly exposed by raising her skirts. This story exists in literary form in an Orphic fragment and in Homer's *Hymns*, and it remained alive throughout the Mediterranean basin until the end of the eleventh century. According to Patrizia Castelli, during the Middle Ages the representation of Baubo may have lost its original significance as being related to fertility and at the close of the Medieval era her presence (like *Shela na-Gig*) would have been intended to draw attention to the sins of vice and lust,[26] with which women were particularly identified.[27] In his *Enarrationes in Psalmos*, Philo of Alexandria perceives the Biblical Eve as a lascivious temptress, a symbol of the sins of the flesh and the corruption of the soul.

In the light of these observations, the figure of an androgynous female displaying her genitalia on a twelfth-century carved metope now in the sculpture museum of the Cathedral of Modena, and known locally as the *Potta di Modena*, ('the Twat of Modena'), reveals how strong the obsession concerning female sensuality was at this time (fig. 18). This is a frontal view of a woman with long flowing hair and attractively defined features, who is parting her legs to expose her genitalia, and given what we have just noted this may represent a moral warning, an explicit rejection of anything connected to, or suggestive of, the sexual sphere. In our opinion this image must exemplify the concept of a figure devoted to vile and unnatural sexual practices considered to be at odds with honest Christian values.

A study of the face, which is that of a young girl, would confirm this hypothesis: her eyes are small and narrowed, her mouth tiny with full lips and, her youthful breasts are slight but well formed. These qualities would seem to suggest physical powers of an

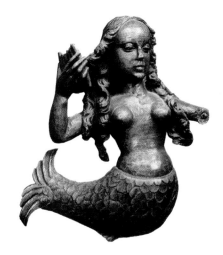

21. *Siren*, carved wood, church choirstall, Saint Suplice, Dienst.

erotic nature, rather than psychic ones, making this an unusual image of the sinner and adulteress.

Another representation of a woman with a gaping vulva forms part of the decoration of the apse in the church of 'Notre-Dame de la Visitation' in Bruyères-et-Montbérault, in France, a thirteenth-century work (fig. 19). Although this relief is extremely sketchy in definition, a certain attention has been paid to the face of this androgynous figure, the almond-shaped eyes are large and prominent, almost swollen, staring and defined by a double line, emotionally quite disturbing, as are the broad nose and the flat lipless mouth, which could belong to a man. The figure flaunts her vagina, her most precious possession, in no uncertain manner, and framed by her generous thighs, she opens herself to all with large hands which form a *pendant* to her bared breasts which are depicted as heavy and swollen, the symbols of some perverse pleasure. The image would seem to exemplify a popularly held and negative male view of women, and the fact that much

less attention is paid to her physiognomy than to her bodily parts perpetuates the notion that a woman's wickedness lies more in her sex than in her head.

A striking example of the Lamia type of witch can be seen on a fourteenth-century corbel in the interior of the cathedral of Saint Etienne in Auxerre depicting a naked female figure riding on the back of a goat (fig. 17). This interpretation is undoubtedly correct since the animal in question is a goat, the supreme symbol of Satan. The woman brazenly flaunts her nudity and her boldly loosened hair falls freely over her shoulders. Her facial features are little characterised: her eyes are lowered, and although she is finely featured her gaze is certainly neither penetrating nor meaningful. This witch is in full possession of her faculties and for the first time we come across an attribute which was to be popularly adopted during the late Middle Ages: the goat. This animal has its roots in Semitic culture and to Christians was therefore quite alien to the Redeemer and Saviour from sin. In this context it was a means to take flight in the night, though in the fifteenth century it was frequently replaced by a broomstick, which the witch grasped between her legs for her sexual satisfaction as well as a means of locomotion.

On a wooden choirstall in the church of Saint Suplice in Dienst there is an amazing carving of a diabolical woman in the guise of a siren (fig. 21). As already said, we have little record of witches and their attributes from the Medieval period because they were usually submerged in scenes of hellish tortures, but when she does put in an appearance she is derived from either the Lamia or the Medusa model. This particular image, half human and half fish, is inspired by the *Odyssey* and portrays a young woman with well-developed breasts and wavy hair falling in ringlets over her shoulders and arms. Unusually, in her right hand she holds an instrument used for inviting amorous encounters, and her facial features are unusual too, finely carved but with little expression. The face is curiously blank and reveals no inner psychic powers; the eyes are half-closed, as is the mouth. This is iconographically modelled on Lamia, who does not bewitch with the gaze, the window of the mind, but instead captures attention with the beauty of her voluptuous and sensual body, together with the musical instrument which, in her hands, becomes an instrument of power. This magic figure illustrates a woman whose power lies in her physical appearance. Her attributes symbolize the sins of the flesh, weapons which can cause man to swerve from what the Bible stipulates as the true object of his attention, God and the *logos*. Thus, the woman is she who turns man from reason.

A stone relief (1130) from the architrave of the north door of the cathedral of Saint Lazare (now in the Musée Rolin, Autun) depicts the Gislebertus *Temptation of Eve* and illustrates the Medieval view of woman as a demon or witch of the Lamia type. We see her standing surrounded by the fruits of the tree of good and evil, calmly selecting a well-ripened fruit from a curling branch which issues from the mouth of the fateful serpent.[28] The figure is gracefully delineated, with long smooth tresses falling from a cen-

22. Giotto and his workshop, *Hell*, fresco, 1300-1305, Scrovegni Chapel, Padua.

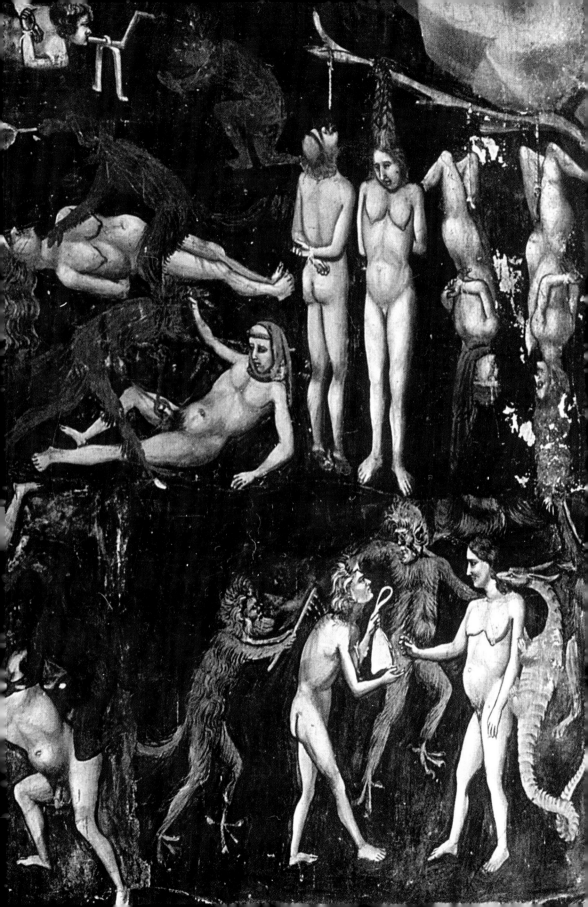

tre parting to spread over her shoulders and down her back; she has an oval face and large almond-shaped eyes with a languorous gaze and a small mouth with barely parted lips. She holds her left hand to her ear, the better to hear Satan's call.

Her pose expresses complete passivity, showing that the artist wanted to illustrate her total dependence on the devil, the demon tempter and enemy of God, as the New Testament tells us. The mind is unable to rebel against the body, characterised by a display of sensual breasts and thighs, and reveals itself as incapable of action. This is a direct reference to the sins of the flesh which assail those who err. This image of the wicked temptress certainly springs from the Lamia type, the wretched woman is in the throes of Satan's embrace, a victim of sinful perversities and therefore unable to exercise her free will.

As an example of divergent concepts during the Middle Ages and how attention was not always focused on the witch's beauty, we shall now consider another female type, a Satanic figure but this time modelled on the Medusa type, the bewitcher of minds. We refer here to a beautiful mermaid with a bird's body and the tail of a serpent (1190), a detail on a capital in the cloister of the monastery of San Cugat des Vallés (Barcelona). The figure clearly shows how the message to be conveyed to the monks was of woman's brutish instincts, not so much conveyed by the flaunting of her body, but as arising from the volition of her soul, which has its seat in the mind itself, that is, from an act of will and arising from a disturbed and powerful mind. She has no features of a sensual nature; indeed, the siren's body is completely hidden by thick and carefully arranged plumage. Nevertheless, the head is large and out of scale; the hair is drawn back onto the nape of the neck and frames an angelic countenance; the gaze is fixed and intent, the nose long and narrow and the mouth full and smiling. This is the fateful mask of Medusa, the power of whose gaze can blind and kill.

The Middle Ages gave birth to a new Medusa in the form of a strange siren, or mermaid, with the body of an eagle. It was certainly by design, following the instructions of the monastery's leading clerics, that this artist chose to present the woman's body in the semblance of an eagle, the bird that flies so vaingloriously to the heavens and dares the heights reserved for God, fortified by her devilish wickedness (the serpent's tail is not only a fanciful and symbolic expedient but evidence of her relationship

23. Workshop of Coppo di Marcovaldo (attrib.), *Hell*, detail of mosaic, second half of the XIII century, Florence Baptistery.

with Satan).[29] Such combinations of monstrous forms and figures undoubtedly draw on a work much studied for the fantasy of its illustrations, the *Liber Monstruorum de diversis generibus*, in which the misshapen and monstrous, besides taking on symbolic and allegorical meanings which were references to the absence of divine perfection in our mutable, imperfect earthly existence, were thought capable of exercising a powerful influence on the lives of the men.[30] Forming a *pendant* to the latter work is *Imago Mundi* by Onorio di Autun (1125-1152), illustrating the most hideous monsters composed of the various bodily parts of familiar animals. The text suggests that the repellent form of some of these monsters lies in the violent and confused jumble of animal parts: the body of an ass, talons of a crow, breast and paws of a lion and horse's hooves.

In discussing the exact characteristics of the siren, we should recall that in the *City of God* St. Augustine transfers the monstrous fantasy of the bestiaries to human beings. He asserts in no uncertain terms the existence of creatures with but a single eye set in the middle of the forehead and feet which point backwards, in the opposite direction to the face. Moreover, he does not exclude the possibility of the existence of individuals of double sex (able to both father and give birth), of others without a mouth, and more still supported by a single leg and distinguished by other distressing deformities.[31] However, St. Augustine considers magic a form of possession to be associated with the vain idolatry of the pagans. Furthermore, he states that demons are not capable of radically changing natural phenomena, and hence the metamorphosis of man into beast typical of magic rites is a mere delusion of the senses.[32]

During the thirteenth century the image of the evil woman who used her body to entice became used as an exterior ornamentation of churches and cathedrals. The image of hell on the octagonal dome of the Florentine baptistery, rendered in mosaic from a design by Coppo di Marcovaldo during the second half of the thirteenth century, depicts a man and woman being grasped in the hands of a terrible Lucifer, not unlike a gigantic multi-coloured basilisk.[33] The woman is screaming in torment, her white limbs draped in her long flowing hair (fig. 23).[34] The Damned seated at the feet of the Prince of Darkness are similarly represented as young, naked and handsome in appearance. It is possible that illustrations of women being damned were used

24. Giotto, *Wrath*, fresco, 1300-1305, Scrovegni Chapel, Padua.

by those responsible for choosing iconographic programmes to draw attention to instances of heresy and witchcraft, held responsible for serious unnatural acts.

Similar iconographic clues are to be found in images of the Damned frescoed by Giotto and his school in a scene of hell that is a side-scene to the *Last Judgement*, on the interior of the façade of the Arena Chapel in Padua (1304-1313). Following the same general layout as the Florentine mosaic,[35] Giotto and his pupils reintroduce the iconography of Coppo's vision of hell.[36] There is a particularly striking view of a sinful, naked young woman with large slack breasts, her sex clearly displayed (fig. 22). The hair is reminiscent of the Lamia pattern, the long dishevelled tresses falling below her waist, reminding the viewer of this adulterous woman's rebellious nature. The women in this painting can be identified with assurance because of the illustration of two forms of torture, the ordeal by water and the wheel, trials frequently adopted for witches during the early Middle Ages.[37]

As far as the general structure of the vision of hell in Giotto's fresco, painted later (c. 1305) than the other Biblical scenes on the walls of the chapel, and in the area of the altar, we see a strong similarity between this Lucifer in Padua and the one in the Florence Baptistery. Both are evocative of the image of Lucifer in a twelfth-century *Last Judgement*, another work in mosaic, on the interior of the façade of the church of Santa Maria Assunta on the island of Torcello,[38] where he is shown engaged in torturing those guilty of pride.

To continue with the fresco cycle in Padua, we should mention the female figure symbolizing the sin of *Wrath* (fig. 24), probably painted by Giotto himself. The woman wears a long robe, parted in front as she struggles to tear off the garment covering her breast. Her strained expression is redolent of powerful forces. Her look of concentration is remarkable: her eyes are anxiously narrowed and express the full intensity of her concentration, as she adopts the only means at her disposal. In this instance it is difficult to draw a close parallel between this figure and the Medieval witch, but in order for Wrath to be presented as a disturbed and unkempt middle-aged woman in this way cannot fail to remind us of the Medusa myth and the woman who uses her mind to draw on power, rage and violence, to cast spells and turn those who look upon her to stone.

Towards the close of the thirteenth century she became presented in even more explicit and terrible terms in treatises on demonology and in painting. In the twentieth canto of the *Inferno* Dante Alighieri draws attention to the intolerable pride contained in the infamous claim that they could surpass the bounds of human knowledge and he condemns them to a fearful fate. Since in life such women over-reached all limits with their fatal gaze, when dead and in the place of eternal death they would be obliged, their necks being twisted, to look forever backwards and walk slowly and with great difficulty.[39] In the *Inferno* the image of a witch emerges as a woman who uses herbs to cast spells and fashions wax dolls which she pierces with pins to inflict harm on the person that the doll represents, albeit in a sketchy fashion. At the end of the twentieth canto

46

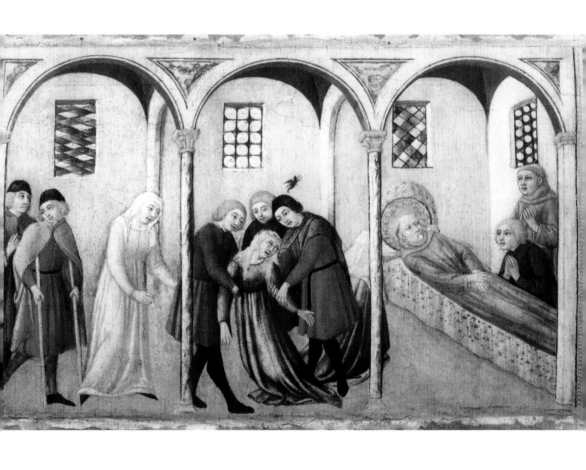

25. Sano di Pietro, *St. Bernardino exorcising a woman possessed of the devil*, tempera and gold on wood, private collection.

Dante writes: "And see those wretched hags who traded in / needle, spindle, shuttle, for fortune-telling, / and cast their spells with image-dolls and potions."[40] These lines contain a description which was to be become the common image of the witch in her Medusa guise during the fifteenth and sixteenth centuries, an old crone busily working with her spindle, another phallic symbol (capable of endowing her with power)[41] and once the magic attribute of the Roman Parcae and the Greek Moirae (Atropus, Clotho and Lachesis), all responsible for man's fate.[42] The spindle was also held to have apotropaic properties, serving to ward off the attacks of other witches who, disguised as animals, stole children at night and carried them off into the darkness.[43] The woman with a spindle represents she who weaves plots against the enemy, confusing the minds of the unfortunate.

Until the twelfth century a woman's image was linked to that of Eve and of Original Sin, understood not only as intellectual arrogance and pride but as sexual deviation. Indeed, both literary and visual Medieval religious imagery frequently portray women as possessed by the devil, preparing to be exorcised, or redeemed sinners, mystics or suffering penitent saints (fig. 25).

With the dawning of the new century, in virtue of the advent of chivalry, the witch was looked upon in a new light. In courtly literature a lady was no longer the passive object of her suitor's flattery, or indeed of his brutish instincts, and became a thinking subject endowed with mental powers, capable of arousing the love (of the right kind) of her suitor, usually a solitary knight keeping watch over a castle. "Free" love became the refrain of the troubadours' songs in which sensuality, though carefully controlled, and albeit disguised in metaphorical terms, became an important aspect of daily life.

This is the setting for the previously mentioned figure of the siren witch (of the Medusa type) with the body of a bird in Barcelona (1190), represented as an interpretative meditation on the III century (?) Greek text, the *Physiologus* in which the woman moves from a purely mystical plane to become the object of amorous desire. In the poetry from the school of the Sicilian bards and singers we find this concept interpreted as a butterfly, and in painting, as the figure of a unicorn, an animal similar to a horse but with a tall, stately, snow-white horn in the centre of its forehead, a symbol of Christ's resurrection which here acquires an erotic significance. There are suggestive representations of young women fingering the horns of unicorns, which allow themselves to be tamed out of appreciation of the maidens' odour of virginity. The combination of the youth and purity of a woman and the precious horn of a unicorn cannot, given its non-religious form, escape having sexual implications.

While a natural horn was a sexual symbol in courtly and aristocratic circles, in the lowly degraded world of the witch its place was filled by a spindle, also pointed, white and frequently shown grasped in the hand like a deadly weapon with magic powers.

Iconographic evidence of the early appearance of the spindle can be found in Codex c. 31v in the Musée Jacquemart-André in Paris, datable to around 1320, where some illuminated manuscripts illustrate naked woman armed with spindles to ward off danger-

26. *Witch riding on a feline creature*,
illumination from Martin le Franc's codex,
Le Champion des Dames, 1450,
Bibliothèque Nationale, Paris.

ous beasts. Likewise. in the Cambridge manuscript, in the Fitzwilliam Museum (press-mark 298, c. 91r), datable to between 1312 and 1316, we find a man roughly driving off a fox (symbolising the wily cunning of the witch), and beside this appears an image of a witch brandishing a large spindle.

Another new form of iconography to emerge during the course of the fourteen century were tournaments with magicians and witches riding astride goats and sheep and attacking each other by striking with their spindles. Witches armed with spindles are often presented as dishevelled and naked,[44] with the disordered locks which symbolise their deep-rooted disregard of social conventions. This pattern of complete rebellion gave concrete form, artistically speaking, to the awe-inspiring woman who led the celebration of the Witches' Sabbath,[45] or other frenzied initiatory or Bacchic rites, all culminating in wild orgies in which the spindle became an instrument of pleasure. This iconography was to become very popular in northern Europe during the fifteenth century.

1) F. Troncarelli, *Le streghe. Tra superstizione e realtà. Storie segrete e documenti inediti di un fenomeno tra i più inquietanti della società europea*, Rome 1983, p. 21.

2) For a concise treatment of witchcraft in Medieval edicts see: M. Centini, *La stregoneria*, Milan 1995, p. 9.

3) *Ibidem*, p. 10.

4) On Medieval heresy see: R. Manselli, *L'eresia del male*, Naples 1980.

5) On the history of Waldo and the Waldensians: G. Tourn, *I Valdesi, la singolare vicenda di un popolo-chiesa*, Turin 1983.

6) F. Cardini, *Magia, stregoneria, superstizioni nell'Occidente medievale*, Florence 1979, p. 65. On this question, by the same author, see: *La strega nel medioevo. Resistenza pagana al cristianesimo, condizione femminile, emancipazione sociale. Le basi del problema*, Florence 1977.

7) Rabano Mauro, *De Universo*, IX-XIV centuries.

8) M. Lombardi, *Immagini dell'altro mondo, in Gostanza, la strega di San Miniato. Processo a una guaratrice nella Toscana medicea*, in 'Quadrante 28', edited by F. Cardini, Rome-Bari 1989, p. 90.

9) Burchard of Worms, *Decretum*, in Migne, *Patrologia Latina*, CXL, 831-854. This is the author (965-1025) who, drawing on the work of Reginon of Prüm, erroneously attributed the *Canon Episcopi* to the council mentioned above.

10) E. Baluze, *Capitularia regum francorum*, Paris 1677, II, coll. 365-366.

11) M. R. Lazzati (editor), in S. Abbiati, A. Agnoletti, M. R. Lazzati, *La stregoneria. Diavoli, streghe, inquisitori dal Trecento al Settecento*, Milan 1984, p. 21.

12) Reginon of Prüm, who died in 915, participated in the drawing up of the treatise until the year 900 (cf. *Canon Episcopi*, edited by M. R. Lazzati, in S. Abbiato, A. Agnoletti, M. R. Lazzati, *Stregoneria*, cit., pp. 21-26).

13) *Libri duo de synodalis causis et disciplinis ecclesiasticis*, Leipzig 1840, II, p. 354.

14) J. B. Russel, *Witchcraft in the Middle Ages*, Ithaca-London 1972, pp. 75-82; 291-293.

15) John of Salisbury, *Policratycus, Sive de nugis curialum et vestigium philosophorum*, Oxford 1909, vol. II, p. 24. On this question see also the essay by E. Verga, *Introno a due inediti documenti di stregheria milanese del secolo XIV*, in *Rendiconto del Regio Istituto storico lombardo di scienze e lettere*, s. II, 32, 1890, pp. 170-171.

16) *Canon Episcopi*, translation taken from S. Abbiati, A. Agnoletto, M. R. Lazzati, *La stregoneria*, cit., pp. 23-24.

17) The earliest author to mention Herodias is Raterio di Liegi who lived between 890 and 974. He became bishop of Verona and references to Herodias appear in his *Praeloquiorum libri*, in Migne, *Patrologia Latina*, CXXXVI, 157.

18) Burchard of Worms, *Corrector et medicus*, *Patrologia Latina*, CXL, coll. 973-6.

19) M. Centini, *La stregoneria*, cit., p. 13.

20) *Apocalypse (Revelation)*, 20: 7, 8.

21) I. Delort, *La vita quotidiana nel medioevo*, Rome-Bari 1989.

22) R. P. Knight, *An Account of the Remains of the*

Worship of Priapus, London 1786.

23) T. Wright, *The Worship of the Generative Powers during the Middle Ages of Western Europe* (1866), in R. P. Knight and T. Wright, *Sexual Symbolism. A History of Phallic Worship*, New York 1957.

24) M. A. Murray, *Female Fertility Figures*, in 'The Journal of the Royal Anthropological Society', 64, 1933, pp. 93-100.

25) P. Castelli, *Quelle immagini ambigue. L'ostensione dei genitali nella scultura romanica*, in 'Art e Dossier', 125, 1997, pp. 39-42.

26) *Ibidem*, p. 40. Patrizia Castelli is also the author of *Il doppio significato. L'ostensione della vulva nel medioevo*, in *Il Gesto*, 'Quaderno di Gargonza', edited by S. Bertelli, M. Centanni, Florence 1995.

27) J. Andersen, *The Witch on the Wall*, Copenhagen-London 1957, pp. 64-71.

28) The definition of Satan as 'old serpent' appears in the *Apocalypse* (Revelation) 20 : 1-2.

29) On Satanic symbols in the Middle Ages see also L. Lorenzi, *Devils in Art. Florence from the Middle Ages to the Renaissance*, Florence 1997, pp. 23-27.

30) *Storia universale dell'arte. Il basso medioevo. Il Romanico. Il Gotico*, Novara 1990, pp. 23-27.

31) St. Augustine, *De Civitate Dei*, book XXII, *Patrologia Latina* XLI (Tournhout, s. a.), 12-803.

32) F. Troncarelli, *Le streghe*, cit., p. 18.

33) On the relevance of Coppo di Marcovaldo's mosaic as a source for Satanic iconography in fourteenth and fifteenth-century Florence, see: L. Lorenzi, *La presenza del maligno nell'oreficeria fiorentina del Quattrocento*, in 'Antichità Viva', XXXII, 3-4, Florence 1993, pp. 65-71; Idem, *La pittura di morte a Firenze al tempo dei terribili fatti del 1348*, in 'Città di Vita', LI, 2, 1996, pp. 147-150.

34) On Coppo di Marcovaldo's scene of hell see: L. Lorenzi, *Devils in Art*, cit., pp. 30-31ff., as well as the relevant entry on p. 65.

35) L. Lorenzi, *Inferni e diavoli nell'arte gotica a Firenze*, 'Città di Vita', LVI, 1, 2001, pp. 45-62.

36) For the iconography of the devil in Florence during the fourteenth century: L. Lorenzi, *In compagnia di Lucifero*, 'Medioevo', 1, 2001, p. 64ff.

37) L. Link, *Il diavolo nell'arte*, Milan 2001, pp. 155-157.

38) The three images of Lucifer in the scene of hell are ornamented on either side by two dragons with open jaws and sharp claws busy tearing to pieces male and female figures of the Damned. This singular iconography recalls the famous capital with a bull from the palace of Artaxerxes at Susa in Persia, V century B.C. (L. Link, *Il diavolo*, cit., p. 129).

39) Dante Alighieri, *The Divine Comedy. The Inferno*, canto XX, lines 10-15, translated by Mark Musa, London 1984.

40) Dante Alighieri, *The Divine Comedy. The Inferno*, canto XX, lines 121-123, translated by Mark Musa, London 1984.

41) F. Troncarelli, *Le streghe*, cit., pp. 27-28.

42) L. Randall, *Images in the Margins of Gothic Manuscripts*, Berkeley, Los Angeles 1996, plates 305-306, 316, 706, 708-710; see this work also for similar iconography.

43) F. Troncarelli, *Le streghe*, cit., p. 29.

44) On these wild women see the essay by R. Bernheim, *Wild Man in the Middle Ages*, Cambridge 1952.

45) See codex 3384 in the K. Library of Copenhagen of the XIV century, cc. 117r; the Yates Thompson 8 codex in the British Library in London, cc. 7r, 53r; the Cambrai codex, c. 118v; and other manuscripts referred to in Troncarelli, *Le streghe*, cit., pp. 34-35.

27a, b. *Witches wearing the typical headwear of the Waldensians,* illumination from *Le Champion des Dames,* 1450, Bibliothèque Nationale, Paris.

Daughter of Venus.
The Image of the Witch in the Fifteenth Century

The 1400s was followed by the century when the Counter Reformation demanded the persecution of witches, which was enacted by the Inquisition. Before the Lutheran schism and the subsequent events which overturned political and social life in Western Europe, the popular image of the witch was still coloured by an earlier Medieval tradition which envisaged her as a general embodiment of evil. Prior to the advent of Humanism, in Christian culture the witch had achieved neither dignity nor autonomy in her contact with the devil,[1] and this is why she was unhappily envisaged (while continuing to be named, driven out and depicted) as an extreme metamorphosis of the New Testament *daemon*, as explicitly referred to in the story of Simon Magus.[2]

At the close of the Middle Ages trials for heresy were in part based on the fear of a resurgence of magic practices. However, witches were usually found to play no part in the non-conformist forms of religious worship, their spells and incantations being derived from a pagan *humus* typical of rural life and reshaped by late Roman culture.[3] At the height of the Humanist era, almost every investigation of witches by Church or lay authorities showed that the woman in question usually had a special propensity for irregular behaviour. Hence, this excluded the direct presence of Original Sin, the extreme negative element opposing Goodness and God.

The figure of the witch was defined between the twelfth and thirteenth centuries when, thanks to John of Salisbury (died 1182), it was established on the testimony of many witnesses that acts of cannibalism and other fearful rites were practised by the follow-

ers of Diana (Hecate). It was therefore hardly surprising that these individuals were identified as Satanic monsters, or vampire birds whose task it was to suck the blood of newborn infants. The late Middle Ages slowly drew away from these alarming images and by the end of the fourteenth century, the arts were responsible for giving these much-feared women some degree of recognizable autonomy.

During the century under discussion, the subject's representation differed little from the iconography typical of the dark Medieval model, characterized by flying through the night air on the back of a goat.[4] Despite the fact that it was during the Middle Ages that the subject was raised concerning a written account of flying, it was to be during the early Renaissance that an interpretation of this image was presented, a creature hovering in the sky, increasingly less frequently accompanied by the devil himself, which gave rise to the popular idea of a solitary woman who came and went flying on her broom-

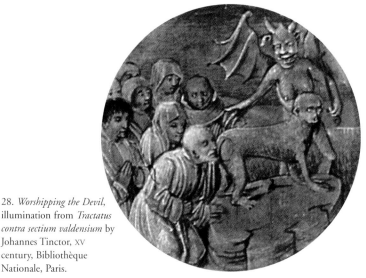

28. *Worshipping the Devil*, illumination from *Tractatus contra sectium valdensium* by Johannes Tinctor, XV century, Bibliothèque Nationale, Paris.

stick. This notion was to prove highly successful and was much adopted in painting, illuminations and engravings.

The question of flight, which has its roots in the New Testament, with specific reference to the Gospel according to St. Matthew (4: 5-7), describing how the devil bore Christ to the pinnacle of the temple,[5] and the episode described by Luke (4: 5-7) when Satan took Christ to a high mountain to show him all the kingdoms of the world, were questions which were discussed over a period stretching from the last quarter of the fourteenth to the early fifteenth century, expanded on and confuted with arguments of a pragmatic nature, all of which must have made an impact in terms of iconography.[6]

The theme discussed by many treatise writers reintroduced some of the central issues of the *Canon Episcopi* (ninth century), now re-examined from a more explicitly metaphysical viewpoint. During the fifteenth century an intense debate began which involved dis-

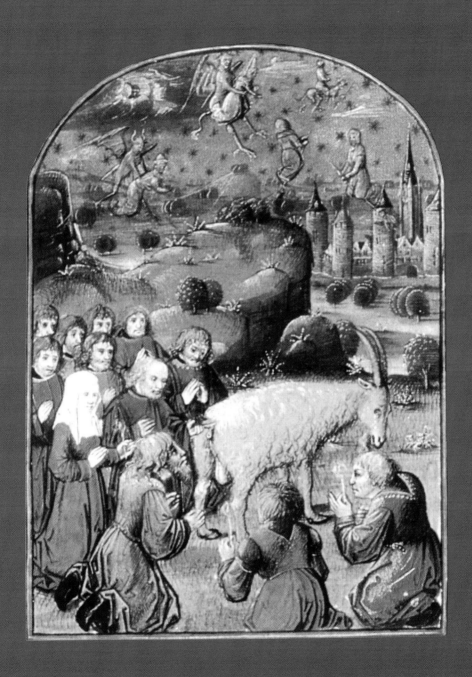

29. *A gathering of witches*, illumination from
Tractatus contra sectium valdensium by Johannes
Tinctor, XV century, Bibliothèque Nationale, Paris.

cussion of some passages of fundamental importance in the text *Canon Episcopi.* Indeed, in 1398, the Paris parliament examined this work for the first time and revised some of its affirmations, in many instances shifting the attention from form to subject matter. What interests us most here for our study of the witch in art is the question of flying, no longer presented as fanciful and dreamlike but as a perfectly real and feasible event.

A reintroduction of some of the themes and images from earlier centuries was undoubtedly due to another treatise entitled *Commentaria,* drawn up and written by the Spanish Biblical scholar Alfonso Tostato (c. 1400-1455).[7] The work is doctrinal in character, at least in some passages in the *Quaestio XLVII,* and it clarifies some Medieval *tópoi* of the flying witch possessed by the devil; these are not drawn from the Scriptural tradition but from the more popular oral tradition, designed for a reasonably broad if not select audience.[8] Our interest in the *Quaestio XLVII* lies in the suggested dichotomy between reality and dream, which the *Canon* had excluded by making the second responsible for any appearance of the former. In this work Tostato asserts that flying is not only possible in sleep, that is, in the world of the unconscious, but also in the physical world. At the same time he recalls the devil's ability to make topographical changes, without which flight would be impossible. The scholarly commentary to this early text concludes by denigrating the power of the witch since she is unable to fly under her own volition and is entirely dependent on a superior force, the devil himself, as an active spirit, an abstract element to grapple with, slightly less haunting as a realized phenomenon.[9]

In traditional iconography the aspect tackled in *Commentaria* played an indispensable part in the diffusion of the flying myth which was so common in Central and Northern Europe. Some images from early in the century show the witch accompanied by one of Satan's emissaries, as he bears her off into the skies. The means of transport for this event was usually still illustrated as a black goat at the end of the fourteenth century but in the late fifteenth this finally gave way to the broomstick.

The notion of the witch as a woman engaged in magic practices is reintroduced by the Spanish treatise writer, who adopts a twofold image: Herodias and Diana the Huntress.[10] Despite the fact that the author hastens to assure us that these two figures are no more than personifications of the devil, the fact that he considers a double character for the witch, patterned on both the Lamia and Medusa models, does not seem a mere philosophical abstraction or a useful distinction for simplifying his analysis. These two goddesses reveal the two paradigms which are interpreted by the two forms of presentation: in the guise of a sensual woman or in the role of strong and active woman. The author discusses the latter example more fully, citing specific cases and events, while the former is idealized and little explored.[11]

From the sum of Tostato's arguments it emerges that the Humanist world was by no means ignorant of the old Medieval position concerning the flying witch but, with millennium fever at an end and the impossibility of associating the phenomenon of the

wicked witch with the chief embodiment of evil and source of misery and pain, Satan himself, Humanist thinking sought every conceivable means to change her image, transforming her from a diabolical transcendental subject to an *ens* that was entirely of the earth. Medieval devils accompanying the witch were now shadowy presences, silent and watchful custodian angels.[12]

We find pictures of flying witches in the illuminations of a manuscript entitled *Le Champion des Dames*, 1450, in the Bibliothèque Nationale In Paris (fig. 27). The female figures are dressed in peasant clothes and recognizably members of the Waldensian sect. Before examining the topographical details, and the possible relationship with other depictions of witches from the same period, we should just summarise the events which led the Waldensians to be connected with witchcraft.

The persecution of witches took place in concomitance (as we have already stated) with

30. *Witchcraft with a bow and arrow*, woodcut from *De lamiis et pythonicis mulleribus* by Ulrich Molitor, Constance 1489.

the actions and preaching of the monk Peter Waldo, a former merchant of Lyons. He opposed the Church authorities over the luxury and pomp which he held to be a widespread evil, and, having diverged from his path in favour of poverty and chastity, he decided to adopt a way of life devoted to preaching the Gospel and, with special attention to the immediate needs of the poor he established an independent order directed at the salvation of souls.[13] His followers, concentrated chiefly in France, Switzerland, Austria and Northern Italy, were excommunicated by the Council of Verona in 1184 and obliged to take refuge in the countryside in the hope of escaping ostracism, but they did not escape being persecuted as practitioners of witchcraft and magic.

Arras was the epicentre of this persecution which culminated in the trial and subsequent torture of the entire community, accused of forming a maleficent sect. The inquisitorial authorities extracted supposed confessions from some representatives of the community who were accused of practises which did not conform with Christian ethics, such as Sabbath gatherings in the dark woods on moonlit nights after first covering their bodies with a special herbal ointment which could provoke hallucinations and, as far as women were concerned, at times employing a special rod which they placed between their legs as an instrument of pleasure.[14]

The persecution and punishment of the Cathars was particularly merciless because they, like the Waldensians, confessed that in the woods, not far from the town, they had

31. *Witches brewing their evil potions in a cauldron*, woodcut from *De lamiis et pythonicis mulleribus* by Ulrich Molitor, Constance, 1489.

seen the devil appear in the guise of an enormous goat with a long black coat, his purpose being to participate in an unmentionable orgiastic revel. The ceremony was said to include the celebration of Mass; the consecration to be realized by swallowing toads, earlier laid ready on the altar, while others were burnt to produce magic powders to render the fields barren and provoke mysterious maladies, besides for brewing love potions.[15]

In the mid-fifteenth century in France the image of what we will call the Waldensian witch became widespread. As we see on studying the witches depicted in the codex of Martin le Franc, she is presented as a familiar everyday figure;[16] indeed, she has a downright homespun air, not in the least threatening. Thus, after the Medieval period there

was a gradual disappearance of the wicked, perverse temptresses who were presented as fearful examples for the faithful flock. A new image of the witch appeared, no longer a daughter of Eve but a more 'contemporary' ordinary woman. Martin le Franc's witches are portrayed as humbly dressed, in the everyday clothes typical of respectable women, often wearing a cloak and bonnet. The broomstick also played a particular role which went beyond its ability to fly, becoming emblematic of the new image's slovenly habits. We believe that the pre-eminence of the Medusa type of witch is explained by a lessening of interest in Lamia and her troubling beauty because she was no longer well-suited to the new age.

The repression of witchcraft was very much an early-Renaissance phenomenon and though the starting-point was the original Waldensian community, set up at the end of 1100, the real persecution of Waldo's followers, held to be witches and magicians, came

32. *Witch and her demon lover*, woodcut from *De lamiis et pythonicis mulleribus* by Ulrich Molitor, Constance 1489.

later, over a period stretching from 1420 to 1430. Before this time, during the years between 1320 and 1420, we have news of twelve trials conducted by the Inquisition and a further twenty-four by the civil authorities over a broad stretch of Europe, including France, the French and Swiss Alps and the Jura. But from 1421 onwards there was a mounting frenzy of repressive activity (particularly concentrated around the 1480s) which led to numerous large trials by the Inquisition, and the institution of 120 lay tribunals.[17]

The first large-scale trial for witchcraft was held in 1460 and was conducted by a Church tribunal, according to the procedure of secret examination and the use of torture. There were plentiful denunciations and generalised confessions which involved an increasing number of people in an unstoppable chain reaction. The protagonist of the

episode which fired this systematic repression was the monk Robinet de Vaulx, tried and executed in 1459 for the crime of witchcraft. Before dying he denounced two of his companions, a prostitute called Demiselle and a painter, Jean Lavite, who were both arrested, interrogated, tortured and found guilty before being burnt at the stake.[18] The Duke of Burgundy, who presided over the case, asked for the opinion of Church authorities and university masters (specially summoned for the occasion to his chambers in Louvain) and was assured that *vauderie* was a reality and no mere fantasy. This assertion proved, like Alfonso Tostato's earlier treatise, to be completely at odds with the *Canon Episcopi*.

The style of the iconography in Martin le Franc's codex in Paris was continued by other codices in which the practice of magic is given as the reason for the condemnation of the Waldensian community. Among these is a mid-fifteenth century codex entitled *Tractatus contra sectium veldensium* (Paris, Bibliothèque Nationale), written by Johannes Tinctor and most skilfully illuminated by Flemish masters in the International Gothic style. One of these illustrations (fig. 29) depicts a night scene of the devil being worshipped by a group of Waldensians. In the foreground, against a steep rocky background framing a distant castle surrounded by a moat, stands a goat, its genitalia being worshipped by a group of kneeling followers holding candles as symbols of their devotion. Only one woman is included, dressed in simple everyday clothes, while overhead in the starry sky fly bands of witches and hairy demons with bat's wings and long sharp claws, riding astride birds, goats and broomsticks.

In the lower part of the picture a kneeling woman, no longer in her first youth, is engaged in paying homage to the goat's genitalia and she is reminiscent of the witches in Martin le Franc's codex. The Waldensian woman in the *Tractatus* is presented as a respectable housewife who does not bare her body, let alone assume erotic poses. In her foreground position she has all the appearance of a devout Christian quietly taking part in a ceremony which, given the solemn air of the other participants, must be of a gravely important nature. The desire to represent the witch as an ordinary everyday figure was strictly limited to the pre-Renaissance period, and this also applied to the figurative representations of her flying on a broomstick.

In this instance also, with reference to Tostato's essay, we now see a timid attempt to accord the witch some degree of autonomy, a creature with a mind of her own. She is not without a devil who comes to assist her, either disguised as some hideous monster sprouting bat's wings, or in the semblance of a goat, the form of which is reminiscent of late thirteenth-century painting.[19]

There is another interesting illumination in the same codex (fig. 28) depicting a similar scene and women with covered heads. The object of worship is even more central, while the witch has been successfully transformed into a priestess of evil. It could be said that in this case Medusa prevails over the Lamia model. Hence, the idea that shameless carnality was the sole means of corrupting the soul was on the wane in northern Europe.

Since this was the time of numerous trials of members of the Waldensian community, the iconography of the witch was required to match the appearance of a modest ordinary woman, part of the everyday social fabric. As we have said, earlier signs and symbols of an erotic nature which referred exclusively to the sin of lust began to disappear. 1484 was an important year for canon law and for the story of witchcraft in western Europe. Pope Innocent VIII promulgated the Bull *Summis desiderantes affectibus* which denounced and condemned the practice of magic in northern Germany, where numerous witnesses testified that large numbers of people consorted with devils, described as succubae and incubi, the wicked creatures of the woods.[20] The text of the Bull inspired

33. *Witch and demon flaunting themselves and flirting together,* woodcut in *De Ritter von Turm,* 1499.

the famous *Malleus maleficarum* written by two Dominican inquisitors, Heinrich Institoris and Jakob Sprenger, and published in Speyer in 1487 after being approved by the theological college in Cologne. The most interesting passages in this weighty treatise are those concerning the possibility of flight. The philosophy of Aristotle is frequently cited as having admitted this possibility, particularly as regards travels effected by the imagination. A turning-point in the practice of magic is shown by the fact that the witch is now accorded greater autonomy, in respect of the devil. This was to have a noticeable influence on iconography which, at the end of the fifteenth century, usually showed the witch as a solitary creature with no particular connection with Satanic symbols or allegories.

In the volume *De lamiis et pythonicis mulieribus* written by Ulrich Molitor in 1489, now

in the Bibliothèque Nationale in Paris, we see witches engaged in weaving their spells. If we were unaware of the nature of the treatise nothing would suggest that these were perverse and wicked creatures. Some of the illustrations to this work are especially instructive, such as the one showing a modestly dressed young woman occupied in practising a spell with a bow and arrow (fig. 30).[22] Although she has loose flowing hair and is obviously pleasing in appearance, she does not seem to be using any seductive tricks, indeed, given her peremptory air, the success of the curse would seem totally dependent on her wits. This witch is not to be identified with the classical Lamia or the Biblical Herodias referred to in Alfonso Tostato's work, but rather with Diana the Huntress, a goddess attributed with both courage and intellect. This scene unofficially cleared the field of the persistent Medieval stereotype of a sinful enchantress, a seeker of the carnal pleasures from which she absorbed her evil forces.

In another scene we see two witches on either side of a great cauldron. These women are neither young nor beautiful, they are full of grimaces and wicked leers, with circles under their eyes and heavy brows. These features would seem to emphasize the Medusa-like character of their penetrating and frightening gaze, accentuated by their deeply lined complexions.

Another engraving in the same work illustrates two witches preparing a devilish brew as they lower a snake and a cockerel into a steaming cauldron (fig. 31). These creatures embody the devilish attributes: the snake represents temptation, while the cockerel indicates contempt for Christian values, with direct reference to St. Mark (14: 30). In this passage Christ says to Peter: "…before the cock crow twice, thou shalt deny me thrice." The view of the old crone supplies convincing evidence of the inclusion, along-side the obvious Lamia elements, of some characteristics of the Medusa model. Old age was associated with wisdom and experience in the area of magic, besides which, those condemned for sorcery during the fifteenth century were indeed largely elderly.

Molitor's text also includes images which give a general all-round picture of the sorcer-ess. One scene portrays the devil in an intimate and private, albeit impure, aspect of amorous dalliance. *The Witch's Demon Lover* (fig. 32) is perhaps one of the most instruc-tive illustrations in the volume and captures a very particular moment in the life of a sorceress, the triumph of passionate love. The encounter is treated with great delicacy and depicts reciprocal, and quite normal emotions. The pair embrace tenderly and their faces draw together with apparent affection. If it were not for the rapacious talons form-ing the devil's hands and feet this could be simply a meeting of two lovers of advancing years; both figures are modestly dressed and turn to each other with perfect ease.

On close examination we find that the two have almost identical features: the same eyes, same shape of mouth, similar jaw-line, and the same wrinkles. It would not be out of place to suggest that the two images are formed by the reflection of one in a look-ing-glass: the witch's mirror is the devil, and vice versa, and representing a witch alone would be equivalent to representing the devil as the scene's protagonist. Although it may be true, as we have suggested above, that during the late Middle Ages the witch

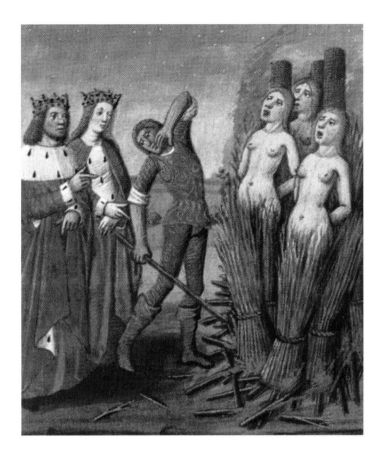

34. Hans Baldung Grien, *Witches being burnt at the stake on the orders of King Childeric*, illumination from *Chronique de France*, 1492, Bibliothèque Nationale, Paris.

ceased to be illustrated accompanied by the baleful attribute of the devil, it should not be forgotten that the Satan was always just around the corner, assisting the witch without materializing now that she had acquired full autonomy. In the *Inferno* Dante groups magicians, soothsayers and witches together (according them almost equal position) with minor devils and ordinary sinners.[23]

From around 1420 the rise in the number of trials for witchcraft and magic practices had the result, in terms of iconography, of encouraging the portrayal of perfectly ordinary women, closely resembling those who were indeed being condemned and tortured. Because most of the women so brutally treated by the courts were white-haired, gaunt and extremely poor, this is how the witch came to be represented in illustrations. It is hardly surprising that in Molitor's text (containing contributions by the author himself, Duke Sigismund of Austria and Konrad Schatz) witches are referred to as a natural everyday phenomenon. In fact, it includes an account of a particular instance of witchcraft which took place in Innsbruck in 1485, although, strictly speaking, it has little connection with devilish powers.[24]

Johan Nider was a man who believed in the power of witches and between 1435 and 1437 he produced *Formicarius*, a treatise written in the form of a dialogue between a

theologian and an illiterate man called Piger.[25] This text, like Tostato's, excludes the idea that a witch's evil practices are the work of the devil, ascribing every apparently supernatural event to an over-imaginative mind afflicted with melancholy. However, in the second volume of the work he expressly denies the possibility of flight, limiting a witch's gifts to mere expertise in medicinal matters, while still maintaining the existence of a close link between heresy and experiments with nature, a further reason why illustrations continued to reproduce the image of an old crone busily engaged in brewing magic potions.

Despite the fact that the witch of the Medusa type became established during the age of invention and reason, the traditional image of Lamia still lingered on. We find one example of this in an illuminated manuscript, dated 1492, by Hans Baldung, known as Grien (1484-1545), in the *Chronique de France* which illustrates a group of condemned witches being burnt alive, on the orders of King Childeric (fig. 34). We are presented with three totally naked women, each tied to a post, almost adolescent in appearance, the beauty of their graceful bodies, tapering like Homer's sirens, is in strong contrast to their unhappy expressions as they scream for mercy. Their facial features are in keeping with the youth of their bodies and would suggest the concept of the witch as temptress, which, at the end of the Humanist era, seems to have re-emerged with renewed force to compete once again with the image of the wicked old crone.

The reason for this switch lies in a multiplicity of factors. At the end of the fifteenth century, while there were still troublesome groups of heretics and infectious diseases continued to be a problem, a gradual change was under way in the living and cultural conditions of people in Europe. With the end of the plagues and repeated famines there was a resumption of intellectual activity, including the discovery of Classical writers, new theoretical studies, a revival of neo-Platonic philosophy, commercial success and recognition of man's autonomy and free will as the master of his fate, all of which led to a fresh view of man's natural surroundings, now understood as being a valuable source for the acquisition of new forms of knowledge. Man as the centre of the universe and the observation of nature became the bases for a philosophy of life which influenced the various branches of knowledge, especially the sciences, literature and the fine arts. The woman was returned to the role of providing inspiration for artists and poets. As a lay figure she could again become, as in Classical times, an object of contemplation, inspiration and even love, understood as a pure sentiment, and thus no longer envisaged as a *spiritu patiens*, but as a creature of joy and restored dignity.

We can see how woman was entirely recreated, in both body and soul, by studying fifteenth-century paintings of the *Madonna and Child*. In Florence, the heartland of the Renaissance, Mary's proud beauty and sensual grace help us to understand how explo-

35. Master of the Middle Rhine, *The Love Spell*, tempera and oil on wood, mid-IV century, Museum der Bildenden Kunste, Leipzig.

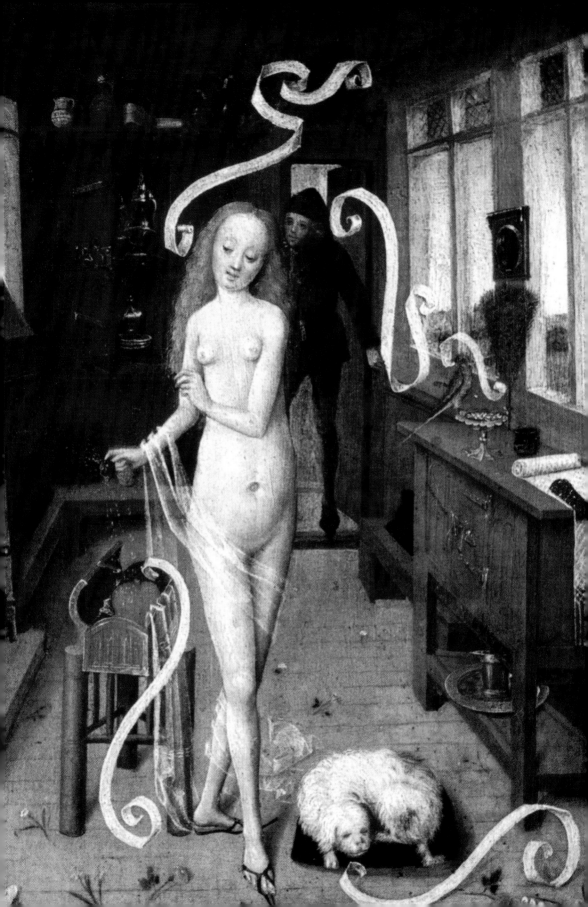

rations of human feeling and the natural world, considered a life-giving force, were blended together into the image of an aesthetical harmonious woman, the perfection of her soul reflected by her body. Paintings of the Virgin by Masaccio, Filippo Lippi, Piero della Francesca and others restore her with a dignity which the previous period had ignored by insisting on a uniform devotional image. There are numerous Renaissance paintings of a lay character in which the nudes reclining on couches or Venus rising from the waters (such as Sandro Botticelli's *Venus* or Giorgione and Titian's beautiful women) formed a starting-point for an entirely fresh female image, now related to new forms of freedom.

These changes could not fail to benefit portrayals of the witch and, by the end of the fifteenth century, these appear to have broken away from the *tópos* of the hideous wicked witch. Lamia's replacement of Medusa (apart from the illumination in *Cronique* mentioned by Baldung) is officially confirmed by a small panel in the Museum der Bildenden Künste in Leipzig, attributed to the anonymous Master of the Middle Rhine (fig. 35) and dated towards the end of the century.[26]

The Love Spell, as the painting is called, portrays a quite startling scene in this iconographic shift from Medusa to Lamia. It shows a small room, with two windows set side by side and a fireplace on the left wall, and contains various objects, including a fan of peacock feathers and a small raised crystal dish with a gilt border set on a double-doored cupboard. On a shelf in a wall-niche in the background are two single-handled jars, and, on the right, we see the black-clad figure of a man, peering through the half-open door in a sinister manner. In the centre of the room, a beautiful, naked girl (a witch), wearing nothing but a wisp of silk, is busy casting a love spell. Roses and lilies of the valley lie scattered on the floor, and on a cushion a white dog lies asleep. Beside the young woman is a stool on which stands a wooden casket, probably containing magic charms and philtres. The young witch's delicate features are highlighted by the light piece of cloth and the elegance of the slippers on her feet; she is surrounded by a swirl of white scrolls.

We are struck at once by her beauty: her long flowing tresses, her delicate and expectant expression and lowered gaze, small breasts and tapering legs, her sex just hinted at. These are all features which reveal a clear shift in iconography, one which was to be further explored by Dürer in the engravings of witches that he produced between the late fifteenth and early sixteenth centuries.

At the height of the Renaissance the terrible Medusa with the power to influence and corrupt gave way to a new Venus, the Temptress. The Medusa model represented in the engravings to Molitor's treatise and Martin le Franc's illuminations, was superseded by the Lamia image of the *Cronique* illuminations and of the panel under discussion here. This witch is no less than a reborn Eve whose appealing and graceful air is blended with a dose of erotic and seductive charms. It would be no exaggeration to call this witch the prototype of a perfect integration between the Lamia and Medusa models. With reference to the former, this witch is obviously to be identified with the image of Venus the

Temptress, neglected during the second half of the fifteenth century, since on closer examination we notice exact similarities of form with the Eve on the outer panel of Jan van Eyck's polyptych of the *Lamb of God*, completed in 1432 (carefully defined erogenous zone, small but shapely breasts, broad belly and tapering thighs). As regards the second aspect, the timidity of spirit and modesty which the flushed and artless face would suggest seem quite at odds with her charming naked body. This figure thus presents a balanced duality between sexual instincts and psychic mysteries.

Between the witches illustrated in *De lamiis* and the graceful girl painted on the Leipzig panel we discover the missing link which supplies convincing evidence of the shift from the ugly old Medusa back to the distracting young Lamia. This link is vital to an understanding how this change, although it was swift, was not unexpected, given that in a

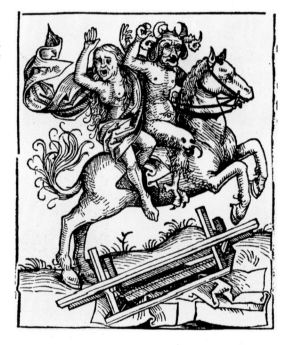

36. *Witch on horseback in the company of the devil*, woodcut from *Liber chronicarum* by Hartmann Schedel, 1493, Marucelliana Library, Florence.

Following pages
37. Albrecht Dürer, *The Four Witches*, engraving, 1497, Department of Drawings and Prints, Uffizi Gallery, Florence.

38. Pontormo, *The Visitation*, oil on wood, 1528-1529, Church of San Michele, Carmignano (Prato).

print dated 1493, produced a year after the illumination in the *Cronique*, there appears the figure of a flying witch with Medusa-like features in a late-Gothic style, combined new stylistic features of the sixteenth century. We are referring here to *Witch on horseback accompanied by the devil* (fig. 36) in *Liber chronicarum* by Hartmann Schedel (1493), in the Biblioteca Marucelliana in Florence, formerly Magliabechiana. This picture probably marks the meeting between the two *formae mentis* which, in the history of art of the modern age continued to exchange pride of place.

As has emerged from Castelli's studies, the subject is taken from a Medieval romance entitled *Speculum Historiale*, by Vincent de Beauvais, and the picture in question illustrates the moment when a witch is being happily carried off by a devil. Despite the fact that the general layout recalls Dürer's famous engraving *The Rape of Persephone*,[27] the

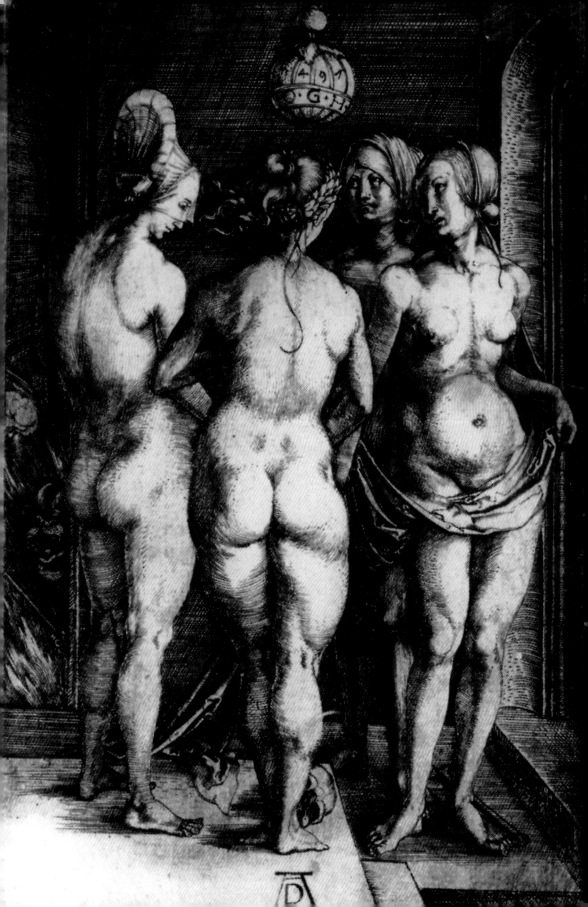

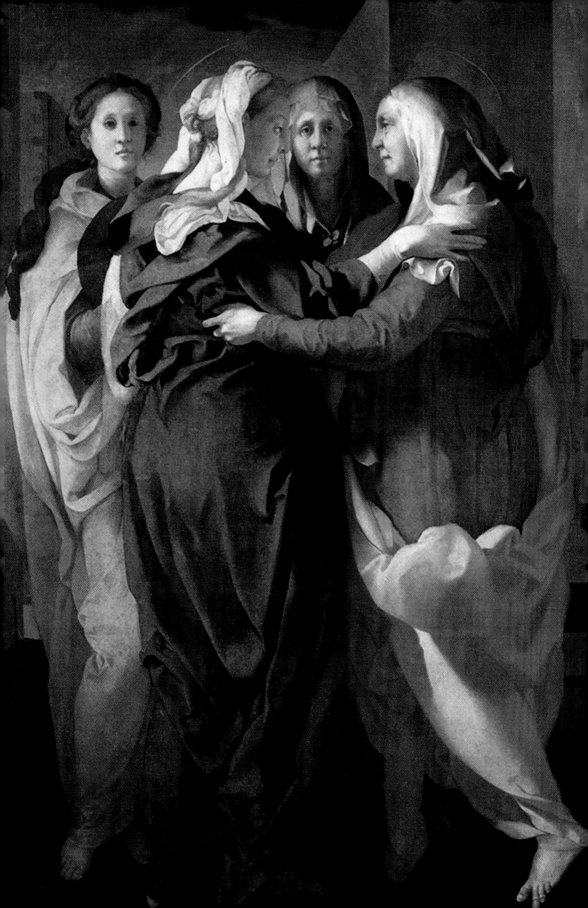

scene is worthy of study for a number of other reasons. Firstly, the presence of the devil displays the success of a prevailing theme of the Medieval treatise, in which the witch was depicted as embodying the daughter of the infernal regions. Furthermore, the demon's attributes are those typically shaped by the Medieval imagination (goat's horns on the head and bird's talons for feet), even though the animal they are both riding is no longer either the Medieval goat or broomstick but a spirited horse of Classical inspiration. The female figure has a wrinkled face and is almost naked, her breast is bare and her long hair is blowing in the wind. She is a perfect integration of the two iconographic models: on the one hand, a youthful half-clad figure, and on the other, a cunning old witch. The face has little to do with the body, the deep lines distort the area around her jaw; the rounded open mouth conveys her delight at being borne off by the devil, a pleasure that is also expressed by her raised arm. This pose is reminiscent of ancient Greek masks of Medusa, the staring eyes and gaping mouths of which terrified all who saw them.

The artist who offers the best example of the shift from the Medusa to the Lamia prototype is undoubtedly Albrecht Dürer. The engraving entitled *The Four Witches* (1497, Florence, Department of Drawings and Prints, Uffizi Gallery; the date appears in the centre of the globe overhead, beneath the letters "O. G. H.") portrays four completely naked women, the only veil being draped in a strategic frontal position (fig. 37). We know they are witches because of the leg-bone and skull lying on the ground at their feet, and also because of the devil peering through the doorway on the left, in the guise of a monster with a curved horn on his forehead and a gaping mouth. The artist's imagination was stirred by a letter in *Malleus maleficarum*, reprinted in Nuremberg in 1494 and 1496.[28] The composition echoes the Classical group *The Three Graces*, with which the artist would have been perfectly familiar. It has been suggested that the two women portrayed full face are drawn from a print of *Victory and Fame* by Jacopo de' Barbari, produced a few years earlier. Luciano Berti instead, has convincingly related the exchange of glances in this scene to Jacopo Pontormo's painting *The Visitation*, in Carmignano (fig. 38).

In this engraving the heavy bodies, while perhaps imperfect, are nevertheless sensual, warm and sexually attractive. The formal composition lies in the sharp divergence between the bodies and the faces because, while the former are rotund and less than perfect, the latter, in the case of all the figures, show an outstandingly complex characterization. The facial expressions of the witches on the right-hand side, shown frontally, seem to convey some deeply significant message; the first, turning towards the figure in profile, has an unpleasant expression with pinched lips, long thin nose and narrowed upturned gaze, almost like one possessed. The witch behind her is silently listening to the conversation of the other three but her angry gaze, with glaring eyes underlined by heavy pouches, betrays her suppressed wickedness. Though naked, these two figures are still based on the Medusa model, but the figure shown from the back and the one in profile belong strictly to the Lamia image since in both we can recog-

nise a passive *dispositio mentis*. In fact, the former figure appears to be engaged in caressing her own body, while the second has a remarkable, if cumbersome, headpiece which partially veils her face. This latter figure, in particular, is the epitome of passivity with her small fine nose and lowered gaze. She looks less like a witch than a bathing nymph and the viewer is struck by her physical and spiritual beauty, both qualities being expressed by the air of relaxed calm which succeeds in isolating this figure from the rest of the group. Two of these figures are of the Lamia type, the back-view and the profile, and the other two, the strange, intense figures in a frontal position, the Medusa model. The fifteenth century came to a close with the gradual elimination of one of these figures, Medusa of the powerful gaze, although she lingered on in new guises or in combination with the more alluring charms of the naked Lamia. The iconography of the witch in housewifely garb was now in decline. However, the image of the witch flying astride various animals persisted. Indeed Dürer reintroduced Medieval iconography, portraying a raging wicked witch, half-naked and riding a goat. Luca Signorelli (1441-1523) followed the same path in his frescoes of the *Inferno* in the San Brizio Chapel in Orvieto Cathedral, completed in 1502 (figs. 39, 40).

On 5 April 1499 Luca Signorelli signed a contract with the cathedral authorities for painting the two Gothic vaults in the chapel, built in 1408. The artist, famous for having executed "multas pulcherrimas picturas in diversis civitatibus et presertim Senis" which include his major cycle at Monte Oliveto, fulfilled this undertaking by painting the seven walls of the chapel with scenes of *The Preaching of Anti-Christ*, *The End of the World*, *The Resurrection of the Body*, the *Damned* and the *Blessed*, the *Inferno* and *Paradise*. The literary sources which provided him with inspiration were the *Apocalypse* and the Gospels, some passages from *Legenda aurea* by Jacopo da Varagine and the book of the *Revelations* of St. Bridget, printed in Lubeck in 1492. We must presume that he was also influenced by the iconography of German prints, especially Dürer's *Apocalypse*, published in 1493, and Schedel's *Liber chronicarum*, published in the city of Nuremberg, again in 1493. Mario Salmi and André Chastel maintain that this cycle is to be considered against the background of political and religious events at the end of the century: Savonarola's republic and its inglorious demise and the preaching and the rigorous piety of his followers, the 'piagnoni' (weepers).

Two years before Dürer produced *The Four Witches* and six years after his illustration of the *Apocalypse*, a similar image of Lamia appeared in Italy, under the influence of the northern European school in the case of the frescoes in Orvieto. In the scene of the *Damned*, the image of the witch being borne through the air on the back of a winged devil (fig. 39) is of fundamental importance for assessing the success of this new Renaissance model of the witch which was soon to supplant that of the haggard Medusa.

In this scene we see how the relationship between the witch and the devil which prevailed throughout the Middle Ages is reaffirmed. This would suggest that Italian iconography of the period was more traditionalist than its German and Flemish counterparts. Moreover, the overall design for the apocalyptic cycle in the monastery would

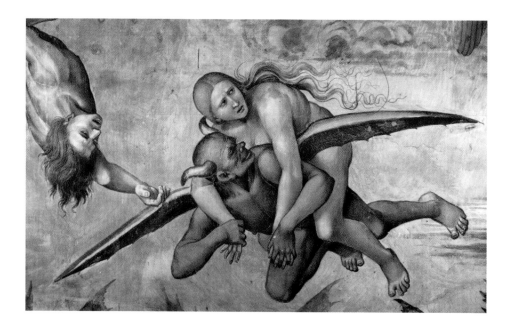

certainly not have been afforded full freedom of interpretation. The most interesting aspect lies in the way the two protagonists are conceived: both young and handsome; the naked devil is smooth skinned and muscular and gazes with unusual gentleness at the witch above him. We notice the charming touch of the wretched pair's interlaced fingers, suggestive of the carnal pleasures they are about to enjoy in the house of sin.[30] The naked witch with her long fair hair has a suffering and regretful gaze which is, however, directed at the Archangel Michael standing on the right. It would appear that this woman has no wish to be carried off by the devil and is imploring St. Michael to intervene, a vain hope, alas. While the devil is the dominant presence here, we are also aware of the parting of the two souls, no longer closely united by evil. This original scene has been interpreted by scholars as making a precise reference to the private life of the painter who, it is understood, was in love with a beautiful girl who was not always faithful to him. Thus, the reason why this witch is looking not at the devil but elsewhere may be explained by the unhappy relationship of the two lovers.

We can see how the witch in question will suffer at the hands of the devil when we look at one of the Doomed, very probably a witch, drooping and weak, being forcibly embraced in the arms of a grey-skinned devil with a horn in the centre of his forehead (fig. 40). Here too there would seem to be a precise reference to events in the artist's own life since the witch is represented as a young and seductive maiden, her delicate features and perfect breasts pointing to the fact that she is reborn in beauty.

In 1939 Arthur M. Hind, the curator of the Department of Prints and Drawings at the British Museum, published some Florentine prints. Datable to around 1470, these include examples which show that artists in Florence were more up-to-date in their portrayals of witches than either German and Flemish artists or those in the rest of Tus-

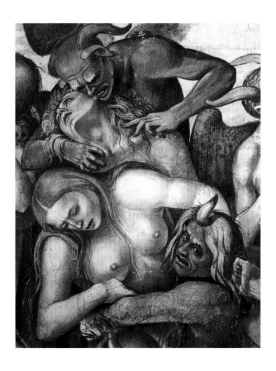

39, 40. Luca Signorelli, *Witch being borne through the air by a devil*, and *Witches and devils embracing in the infernal regions*, detail, frescoes, 1499-1503, Chapel of San Brizio, Orvieto Cathedral.

cany, including, in particular, Signorelli.[31] In Florence the image of the enchanting witch was already in place. A detail in an engraving by an anonymous Florentine artist illustrating *Six episodes in the journey of three pilgrims on the road to St. James of Galicia*, depicts, in the lower part of the central scene, a lovely naked witch being burnt at the stake, her elegant coiffure being typical of ladies of the nobility. Apart from the charms and attractions of her body, more frankly explicit and disquieting than Dürer's matronly forms, what is surprising about this figure is the complete frankness with which her sex is described: the woman's pudenda is clearly displayed and quite freely defined.

Another anonymous engraving, from the same collection of prints, illustrates the legend of the *Necromancer Virgilio*[32] and presents a female figure (portrayed in a Classical setting dominated by views of the Coliseum and the Arch of Constantine) standing on a tall pedestal while the bystanders below stab at her well-delineated sex with pikes. Her sensual form, which recalls and anticipates famous late-Renaissance depictions of Venus, belongs to a young woman of captivating beauty, enhanced by her elegant graceful bearing. Moreover, her appearance confirms that in the age of the reflowering of arts and sciences a woman's body was no longer taboo and thus, in the iconography of witchcraft too, it was no longer ascribed with the lascivious features which were believed to indicate moral turpitude.

1) There are numerous accounts of convictions for witchcraft in Medieval Church documents; among these we should mention St. Augustine's diatribes in *De civitate dei* and *De Trinitate*. The theologian condemns the practice of magic as a devilish device, a legacy of pagan worship, and states that the frequently mentioned metamorphoses are mere illusions.

2) *Acts of the Apostles* (8 : 9-20). In *Exodus* too (22 : 18), we read "Thou shalt not suffer a witch to live". And again, in *Leviticus* (20 : 27) "A man also or woman that hath a familiar spirit, or that is a wizard, shall surely be put to death." However, there are also divergences of opinion in the Bible. Indeed, when Saul (I *Samuel*, 28) sees the Philistine camp, and after the Lord has failed to respond to his pleas, he decides to consult "a woman that hath a familiar spirit" and asks her to invoke Samuel. It is revealed that Jehovah would no longer favour him if he were to allow the Hebrew camp to fall into the hands of the Philistines.

3) These were the myths and rites from the peasant and pastoral world for ensuring fertility and good harvests. This was the home of the cult of Diana, a lunar cult presiding over gatherings of the "mulierculae". Diana, the lady of the dead, of the night and of hunting, but also the strong and untamed mistress of nature. This nocturnal cult existed in complete opposition to daytime worship which revolved around the Lord's Prayer (cf. F. Troncarelli, *Le streghe*, Rome 1983, pp. 21ff.). For example, we have records of Bacchic orgies in honour of Diana in the VI century A. D. conducted by a priest in the guise of a satyr (F. Troncarelli, *Le streghe*, cit., p. 23).

4) F. Troncarelli, *Le streghe*, cit., p. 32. There are numerous depictions of naked witches astride monstrous beasts and such images were a *topos* for portrayals in northern European circles during the sixteenth century.

5) This passage in *St. Matthew* states: "Then the devil taketh him up into the holy city, and setteth him on a pinnacle of the temple, And saith unto him, if thou be the Son of God, cast thyself down…"

6) Some images of flying witches can be found in the Medieval codex, Douce 118, in the Bodleian Library in Oxford (c. 1302), c. 116r: a naked woman with a golden bough astride a monstrous beast; and in the Jacquemart I codex in the Musée Jacquemart-André in Paris, (c. 1320) where, on c. 70r, a woman is shown dancing on a winged monster.

7) For biographical details on Alfonso Tostato (or Tostado) see: S. Abbiati, A. Agnoletto, M. R. Lazzati, *La stregoneria. Diavoli, streghe, inquisitori dal Trecento al Settecento*, Milan 1984, pp. 353-354.

8) "It should be said that here (in the *Canon*) it is not denied that women may be transported by the devil at night to distant places, but all their claims are not to be believed, that is, that they are the followers of Herodias and Diana, a pagan goddess, and to believe that Diana is a goddess, the pagans believing as they did in more than one deity." (*Quaestio XLVII. Possono gli uomini talvolta essere trasportati dal diavolo attraverso luoghi differente?*, in *Commentaria in Primam Partem Matthaei*, chap. IV, Venice 1615, p. 410; M. R. Lazzati, *Alfonso Tostato*, in S. Abbiati et al., *La stregoneria*, cit. p. 49).

9) "Thus, it was not true that these women were nightly summoned by Diana and forced to obey her as their mistress…Diana is the devil…" (*Quaestio XLVII. Possono gli uomini…*, cit., p. 410; M. R. Lazzati, *Alfonso Tostato*, in S. Abbiati et al., *La stregoneria*, cit., pp. 49-50). In this passage Tostato states that the deities are masks of the devil and to believe in them does not imply diverging from the true faith.

10) M. R. Lazzati, *Alfonso Tostato*, in S. Abbiati et al., *La stregoneria*, cit., p. 47.

11) Aside from Tostato, Raterio di Liegi (*Praeloquiorum libri*, I, *Patrologia Latina*, col. 157) mentions the existence of the cult of the lustful Herodias (the vengeful wife of Herod responsible for the beheading of John the Baptist). The cult of Herodias was associated, and eventually combined, with the worship of Diana.

12) Another example of a close study of magic and of its condemnation appears in the work of Bernard Gui (*Manuel de l'inquisiteur*, edited by G. Mollat, I, Paris 1964, pp. 20-25), written in around 1320. This examines the nature and number of forms of sorcery and avoids branding all magic practices as heretical. Similarly, see also N. Eymerich (*Le manuel des inquisiteurs*, edited by F. Feria and L. Sala-Molins, Paris 1973, pp. 66-71) who distinguishes between demons and the spells cast by witches to invoke them.

13) G. Tourn, *I valdesi. La singolare vicenda di un popolo-chiesa (1170-1976)*, Turin 1983, pp. 9-14ff.

14) G. Tourn, *I valdesi*, cit., p. 51. 'Vauderie' was used as the equivalent of witchcraft; going to the 'vauderie' (from the French Vaudois = Waldensian) meant attending the Witches' Sabbath. The story of the Waldensian witch hunts is recounted in *Traité de la Vauderie*. Following the persecution Théodore de Bèze, in Geneva, accused the Inquisition of having committed acts of grave injustice against the

reformist sect in the Piedmont valley.

15) On the Cathar heresy see: R. Manselli, *L'eresia del male*, Naples 1980. On the action taken to eradicate the Cathar heresy, there is an interesting contribution in the work of A. Nageroni, *Il diavolo*, Milan 1996, pp. 22-23.

16) Parts of the codex related to this theme are cited and discussed in J. Sallmann, *Le streghe amanti di Satana*, Milan 1995.

17) *Ibidem*, pp. 20-21.

18) *Ibidem*, pp. 10ff.

19) For more details on bat wings and their significance in art see: L. Lorenzi, *Devils in Art. Florence, From the Middle Ages to the Renaissance*, Florence 1997; *I mostri del lavabo di Andrea del Verrocchio*, 'Antichità Viva', XXXII, 4, 1994, pp. 43-52; *Inferni e diavoli nell'arte gotica a Firenze*, 'Città di Vita', 56, 1, 2001, pp. 45-62; *L'iconografia del diavolo: In compagnia di Lucifero*, 'Medioevo', 1, 60, 20, 1993-1996, pp. 67-72; *La pittura di morte a Firenze al tempo dei terribili fatti del 1348*, 'Città di Vita', 50, 2, 1996, pp. 141-150; *La presenza del Maligno nell'oreficeria fiorentina del Quattrocento*, 'Antichità Viva', XXXII, 3-4, 1993, pp. 65-72; *L'immagine del diavolo nella miniatura di Attavante degli Attavanti*, 'Miniatura', 5-6, 1993-96, pp. 67-72.

20) G. Bosco, *Innocenzo VIII papa*, in *Bibliotheca lamiarum. Documenti e immagini della stregoneria dal medioevo all'età Moderna*, Pisa 1994, pp. 107-108.

21) On the female dress typical of the late-Gothic period: A. Cittadini, *Il costume nella storia dei popoli*, Bagnacavallo (Ravenna) 1938, pp. 88-89.

22) G. Bosco, *Ulrich Molitor (+ 1501)*, in *Bibliotheca lamiarum*, cit., pp. 110-111. Molitor's position is ambiguous; he does not believe in witchcraft although he seems hesitant about asserting the full responsibility of the evil women. This appears in a treatise written in Constance and dated 10 January 1489.

23) Dante Alighieri, *Inferno*, cit., canto IX, lines 34-36, and also XIX, lines 1- 9, which recount the story of Simon Magus; while in *Purgatory*, canto XIX, lines 58-60. we read " 'Saw'st thou that ancient witch, for whose sole snare / The mount above us weeps? And how one deals / With her', he answered, 'and is rid of her?' ".

24) G. Bosco, in *Bibliotheca lamiarum*, cit., p. 111.

25) G. Bosco, *Johan Nider (1380-1438)*, in *ibidem*, pp. 100-101. The example comes from the monastery of Santo Spirito in Feltre.

26) F. Troncarelli, *Le streghe*, cit., pp. 38-39; E. Battisti, *L'Antirinascimento*, Milan 1962, pp. 141-142, 419, nos. 13-14, plate 26); Id., *La civiltà delle streghe*, Milan 1964, plate 2.

27) J. Poesch, *Source for two Dürer enigmas*, in 'The Art Bulletin', 46, 1964, pp. 82-86; G. Bosco, *Hartram Schedel (1440-1514)*, in *Bibliotheca lamiarum*, cit., pp. 112-114.

28) L. Monaci Moran, *Albrecht Dürer (Norimberga 1471-1528)*, in *Bibliotheca lamiarum*, cit., pp. 205-206; this is the earliest of the artist's prints.

29) L. Berti, *Pontormo e il suo tempo*, Florence 1993, pp. 256-257.

30) F. J. Del Oso, *Streghe*, cit., p. 55.

31) A. M. Hind, *Early Italian Engraving. A Critical Catalogue with Complete Reproduction of the Prints Described*, London 1938.

32) These illustrations are reproduced in *Gostanza. La strega di San Miniato. Processo a una guaritrice nella Toscana medicea*, edited by F. Cardini, Rome-Bari 1989, pp. 90-95.

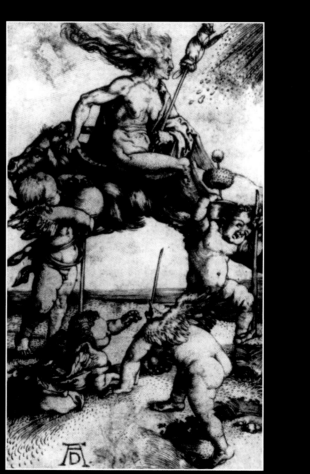

The Witch in the Renaissance:
One Image with Two Persona

From the very earliest years of the Cinquecento there was a quickening of interest in all matters surrounding our subject. The previously cited Bull of Innocent VIII, promulgated on 5 December 1484, constituted the conceptual basis of the weighty deliberations on the issue of witchcraft contained in *Malleus maleficarum*.[1] The authors of this 'Summa degradata' were two Dominican theologians, inquisitors operating in northern Germany, particularly in the Rhine valley (an area comprising the cities of Cologne and Mainz). Heinrich Institoris (c. 1430-c. 1505) and Jakob Sprenger (c. 1436-c. 1496),[2] diligently penned the most weighty account of acts involving witchcraft ever previously drawn up, producing a long list of deeds perpetrated by evil sects and giving a detailed description of methods to be used to unearth secrets, extract the truth and ascertain the guilt of the accused. In an age of cultural renewal this was a prime exemplar of the legacy of the Medieval world. The prescriptive text amounted to a frenzied obsessional codicil to the past, assuming the appearance of some monstrous cathedral in florid Gothic style "flowering at the height of the Humanist era, which was not without the stereotypes of earlier centuries" (Troncarelli).[3]

Published by Jean Prüs of Strasbourg in 1486, *Malleus maleficarum* made an impact throughout western Europe and the work can be held responsible for the two longest periods of witch hunts ever recorded in this region. The first began in 1480 and drew to an end in 1520; the second ran from 1580 until 1670. Circulation of the tract favoured the operation of the powerful inquisitorial machinery set up during the Middle Ages, and this was compounded not only by the action of Emperor Maximilian of Austria who actually placed the two inquisitors under his protection in order to follow their investigations and condemnations at first hand, but also by the creation of an entirely new body, a college of theologians whose duty it was to give a concrete assessment of the gravity of the phenomenon of witchcraft and of its diffusion.[4]

The most interesting parts of the treatise for studying the evolution of the witch's iconography are the first and second parts. The first describes the widespread diffusion of witches' covens, while the second focuses on the reality of the power of evil, by comparison with illusions and dream experiences. The third part concentrates exclusively on penal questions and concerns the condemning of heresy and the forms of punishment to be enforced.

An interesting link emerges between this text, which printing now allowed to be widely distributed, and the move to the Lamia model as the chosen image for the witch. For the first time the text included accounts, presented as factual and non-illusory unlike those in earlier treatises, describing the sexual act, techniques of seduction and obscene

acts carried out by witches in the woods, the home and the church.

In the first chapter of the second part, which discusses the various ways that devils use witches to ensnare the innocent, it states that in the diocese of Augsburg, due to the sudden high mortality rate among the cattle, many women were said to have consulted fortune-tellers and received very strange counsel indeed. This included, for example, blaspheming against Christ and performing lewd acts during religious functions, especially spitting on the ground during the elevation of the host, and muttering obscenities throughout the Mass. We read that one of these women, condemned to be burnt at the stake as an evil witch, in response to the priest as he took leave of the faithful at the end of the Mass after pronouncing the traditional *dominus vobiscum*, was heard to utter the following obscene words: *Kehr mir die Zunge im Ars umb* (roughly equivalent to "lick my arse").[5]

The use of such a coarse phrase in a holy place illustrates how the woman's evil nature is expressed in terms of scurrilously insulting language. The order directed at the priest is a symbolic expression of the (negative) role of the witch in a new Christian society. The witch represents the world turned upside down,[6] the undermining of all rules and all forms of stability. Even the part of the body where her pleasure lies (according to her bold demand in the church), is the exact opposite of the vagina which encapsulates life, an organ with an obviously sacred function in all cultures and epochs. While the reverse could be said of the anus, associated with foulness and perverse pleasures, an exemplar of anti-life, of aesthetic and moral paucity. The excrement it produces is the result of what is without value, what is of no use, and this explains why this particular part of the body was representative of the dark and shadowy regions of witchcraft, the entrance to hell, a place of sterility and death.

The image of the witch as the world turned upside down is illustrated in an engraving that Dürer produced between 1500 and 1501 (fig. 41), now in the Department of Drawings and Prints in the Uffizi Gallery. The body is not presented as an object of temptation since the woman is elderly and naked; she sits astride a large male goat with a spindle in one hand and the whole image is quite startling and effective. She is off to attend the Witches Sabbath, at which the adepts appeared entirely naked. She is shown as one who subverts the natural laws, and indeed we see her riding backwards on the great goat, something we can observe by looking at her hair which is blowing towards the animal's head. On the ground four cherubs are occupied with magic tricks. These figures form what was called the *ludus puerorum*, a fairly common iconographic *tópos* in illustrations of witches, though derived from an earlier alchemic tradition.

One of the novelties of the *Malleus maleficarum* lies in the insistence on the violence and brutality of a witch's sexual activity and her lewd behaviour in, for example, offering her body in order to bewitch young men and women. However, this treatise casts no doubts on her intelligence, quite the opposite, it is only the unicity of her mental processes, as the sole means of corruption, that is under discussion. Thus, the *Malleus maleficarum* is a text which firmly and unconditionally insists on the idea, no longer

new, of the innate wickedness of women, wicked by nature and desire, and this is manifested by the sin of lechery. This view found confirmation in some famous myths which were well known in the fifteenth century and recounted tales of dangerous wicked women (the wicked Pandora in Hesiod's *Works and Days*,[7] or the sinful Eve of the Book of Genesis).

The confessions of witches tried and condemned in the parishes of Constance, Ratisbon and Burbia provided evidence of what had previously been only supposition: carnal union with the devil and, with the aim of corrupting them, with the innocent too. The two inquisitors maintain that the devil consorted with witches for their pleasure and that their gatherings were in fact occasions for wild orgies in which the daughters of evil engaged in all kinds of obscene and erotic practices, in the sway of their uncontrollable amorous desires.

After this period the witch ceases to be simply an elderly caster of spells, and becomes a woman with a sexual appetite and a desire to copulate. Her actions and predictions are no longer directly drawn from the higher sphere of the devil, he who meets her on nights of the full moon to lend her force and energy.

In the second part of Chapter VII, we read how a witch can make a man lose his virility by causing his member to die, but at the same time by means of an imperceptible touch she can suddenly give him an erection, followed by an energetic and unusual climax.[8] Thanks to their seductive charms, it continues, witches corrupt and seduce young men, and even pluck off their members (twenty or thirty at a time, according to the inquisitors' account), later depositing them in bird's nest, like trophies, or in a magic casket where they writhe like living members.[9]

Clearly, this kind of account could not fail to encourage an iconography in which sex and lascivious nudity played a major role. In the early Cinquecento, the Medusa type gave way to the seductive and lecherous Lamia model, the sexually erotic, while still retaining elements of the psychic powers the witch had been associated with in earlier times. This transformation into a lady of pleasure was still accompanied, as in the previous century, by the figure of the old crone who, however, appears increasingly rarely, occasionally depicted as one of the wicked in a painting or engraving as, for example, in the work of Breu the Elder, or one of the horribly deformed creatures of Jacob Bink (1528). Thus, although we discover that this physical type still persisted at the height of the Renaissance, it remains clear that she was increasingly accompanied by the beautiful 'passionaria' Lamia, the new, sensual icon of evil.

Die Emeis. Dis ist das Buch von der Omeissen… by Johannes Geiler von Kaysersberg (1445-1510),[10] a German theologian and preacher of the pre-Reformation, contains two engravings which still present the witch as a wretched old woman living on the fringes of society in her old cottage in the woods, while still an expert at drawing milk from the handle of an axe (fig. 42). These images became subordinate to the image of beauty possessed by the devil, a prey to carnal passions and a victim of nymphomania. Towards the end of the fifteenth century, in 1480, the confession before the Church

inquisitor of one Maria la Medica, a witch of Brescia, offers us an early description of a pleasurable sexual union with the devil in a hermaphrodite orgy which was repeated three times a week,[11] followed by a religious ceremony in honour of the Trinity of Evil, that is, Satan, Lucifer and Beelzebub.

In art, as in literature, we have clear evidence of this shift. From the early Cinquecento we have two particularly handsome images of Lamia as a young, and largely naked, woman. The first is Dürer's engraving of *The Dream of the Learned Man* (fig. 43), in the Department of Drawings and Prints in the Uffizi Gallery. The scene portrays an elderly sleeping man being tormented by a devil who is prodding him with a pair of bellows held next to his ear, below, a cherub plays with a sphere and a pair of stilts, symbols, respectively, of Fortune and the inconstancy of Eros. The subject of the dream is the naked young woman who gazes expectantly at the sleeping man. This is an illustration of the devil tempting a sage with the image of a statuesque Venus of evil. This enticing creature (whose form and proportions are drawn from the Medici Venus)[12] might appear to be simply any ordinary voluptuous woman but for the presence of the cherub and the sphere which betray the fact that she is indeed a witch, the sphere being one of the objects frequently found at the Witches' Sabbath.

The second picture is a *Study of two figures for the death of Meleager* (fig. 44), a copy of a work painted by Filippino Lippi in 1493 for the loggia of Villa di Poggio a Caiano. The drawing is realised in pen and silver-point and tinted with brown water-colour and ceruse on white paper (Florence, Department of Drawings and Prints, Uffizi Gallery) and portrays the new ebullient figures, an expression of the changing era. This sheet was catalogued in 1881 among Sandro Botticelli's graphic works as 'Circe',[13] then attributed to Filippino dal Morelli before, finally, being ascribed to a copyist, and it illustrates an unusual aspect of the myth of Meleager, an iconographic subject reintroduced by Ovid in his *Metamorphosis*. The mother, Althaea, is attending to a fire burning on a tripod, while in the background a slave stands beside a curtain, watching. Both women are presented in profile and have handsome bodies, lightly veiled by swirling drapery at the waist. The whole composition is imbued with particular urgency, conveyed in part by the abruptness of the movements and the eagerness of the bodies, the breasts, in particular, being defined in an obviously seductive fashion, firm and youthful in shape. The charming faces have appealing gazes, slim noses and full lips. A note of sensuality is conveyed by the disordered coiffures, from which long tresses have escaped. The artist has successfully contrived to combine the two images of the witch: Lamia, illustrated by the eroticism of these elegant naked bodies, and the Medusa component which enables them to communicate perfectly with their glances. The pleased and half-smiling face of the slave, partly concealed by the curtain, is turned sharply towards Althaea, who raises her eyes from the burning fire-stand to seek for both strength and support from the other woman, all conveyed by a powerful concentration of psychic forces.

The most emblematic images of Lamia are those appearing in a series of engravings by

42. *A wizened old witch*, engraving from *Die Emeis. Dis ist das Buch von der Omeissen…*by Johannes Geiler Von Kaysersberg (1445-1510), Department of Drawings and Prints, Uffizi Gallery, Florence.

Hans Baldung Grien (1484-1545), produced in 1514.[14] Apart from illustrating the Witches' Sabbath in great detail this *corpus* also presents the new Lamia version of the abandoned and enchanting witch.

Baldung's fascinating works illustrate a previously unexplored aspect. In fact, the central theme of the series revolves around the sexual and seductive practices of witches, practices which are an expression of irrational vital forces, the sole means for concocting effective magic potions. In these engravings the women, whether young and old, are always completely naked. Whether the woman's body is old and sagging or firm and desirable she is shown as a creature engaged in violent libidinous acts. These engravings come from the early years of Baldung's career and are concerned with the themes of the Witches' Sabbath and of dreams, subjects which closely engaged the artist's attention.

It seems highly probably that Hans Baldung, the son of the Bishop of Strasbourg's counsellor, besides becoming a gifted student in Dürer's workshop in 1503, was , like his master, extremely well versed in the *Malleus maleficarum* since in terms of subject matter and remarkable narrative skill his engravings, printed in Freiburg on green and brown paper, faithfully illustrate the written text of the second part of the treatise, with only very slight variations in the stories.[15] These variations were almost exclusively due, his different cultural background apart, to the influence brought to bear by the awesome sermons of Johannes Geiler von Kaysersberg, a preacher of Strasbourg (on whom more later), printed posthumously between 1516 and 1517 under the title *Die Emeis*

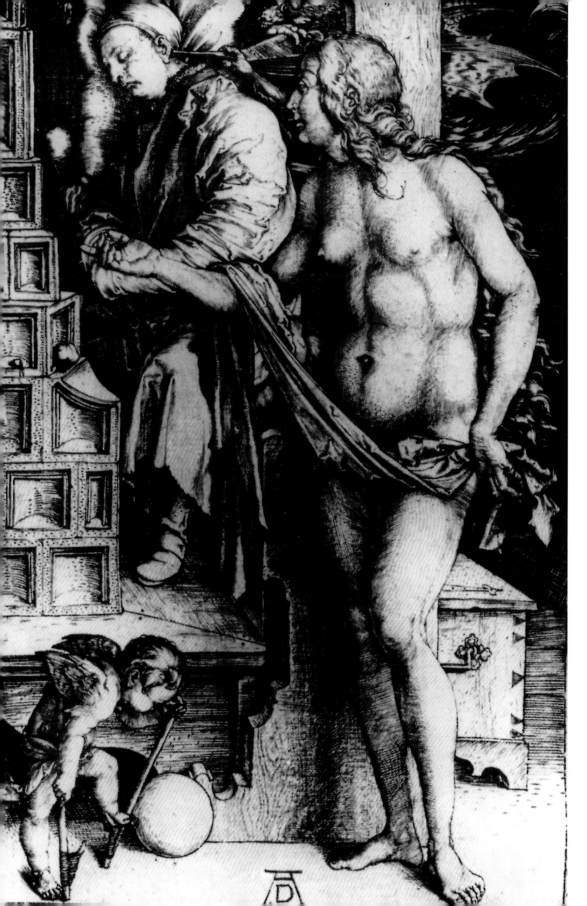

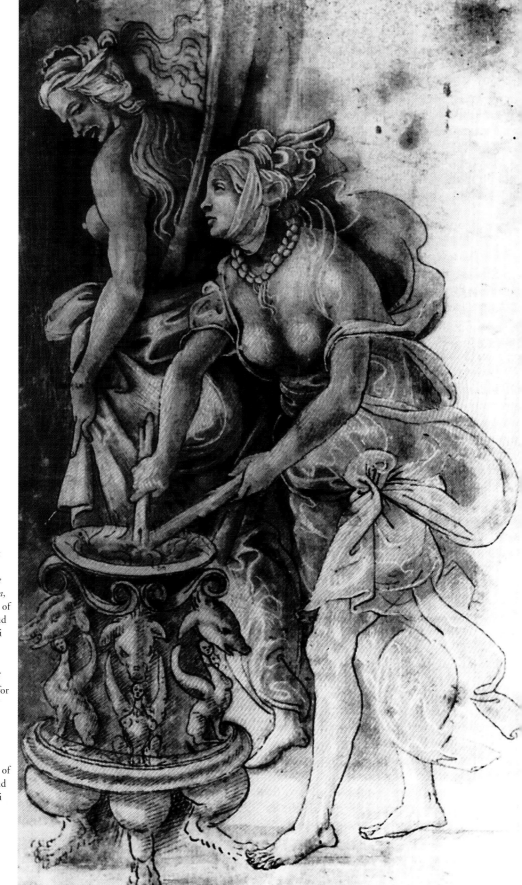

43. Albrecht
Dürer, *The
Dream of the
Learned Man*,
Department of
Drawings and
Prints, Uffizi
Gallery,
Florence.

44. Study of
two figures for
the death of
Meleager,
1493, from
Filippino
Lippi,
Department of
Drawings and
Prints, Uffizi
Gallery,
Florence.

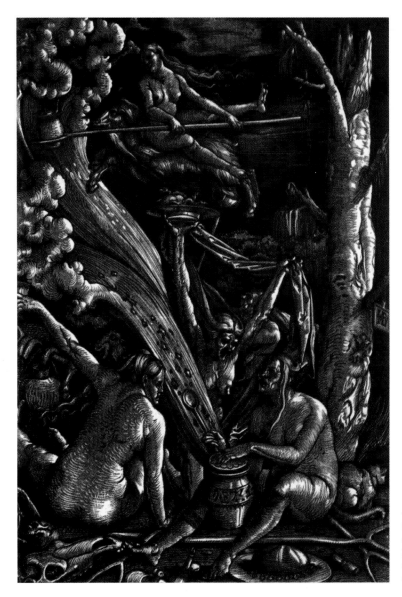

45. Hans Baldung Grien, *The Witches*, chiaroscuro, Bertarelli Collection, Sforza Castle, Milan.

('The Ants'), derived from Nider's famous *Formicarius*.[16]

The drawing entitled *The Witches* (fig. 45), a chiaroscuro in three colours, illustrates typical preparations for the Witches' Sabbath. The most striking feature on the iconographic plane is the artist's bold decision to give the viewer a full display of the nudity of all the evildoers without exceptions for age and without any form of idealization. An old woman is seated on the ground holding between her legs a pot from which issues a dense column of smoke. Her body is old and withered but the artist has not neglected to provide her with a suggestion of curves and even her face, though lined and gaunt, gives us a glimpse of her once radiant beauty (note her full lips and the handsome brow

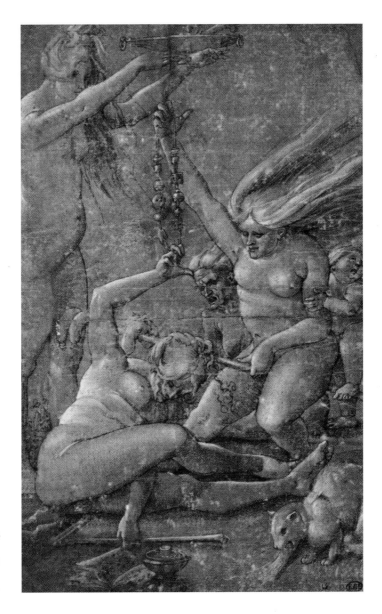

46. Hans Baldung Grien, *Witches in ecstasy*, drawing, pen and tempera on green paper, Cabinet des Dessins, Musée du Louvre, Paris.

framed by her long hair). In front of her, viewed from the back, a relatively young witch is seated on the ground; she too is naked and holds a goblet in her left hand. In the centre, a witch who may be a priestess is performing a ceremony, raising a dish containing the body of a lifeless bird in her right hand as a sign of her power.

This woman's ugliness is as distressing as her forsaken body. The apparent paradox of displaying a ruined body is explained by the concept of nudity experienced, not as a pleasure, but as a duty towards the devil. Above, in the same picture, another witch sits astride a goat while balancing a cooking-pot on a long pitchfork. She is young and beautiful and clearly endowed with graceful curves. Her entranced expression is full of

sensuality, enhanced by her long wind-blown tresses.

The strongly voluptuous effect serves here to give an orgiastic flavour, while the stressing of the swirling column in the earth and sky which rises on the left of the scene, together with the lush and wild vegetation, seems to glorify and complement this wild pagan gathering. The women scream, pant and couple uttering magic words, thus liberating their minds in order to make their actions more effective. Here, as in other images we will examine, the fusion between Lamia and Medusa is achieved with great naturalness.

In the artistic field, unlike the previous century, the naked body seems now to have become indispensable for illustrating magic practices. Thus, the meeting between the

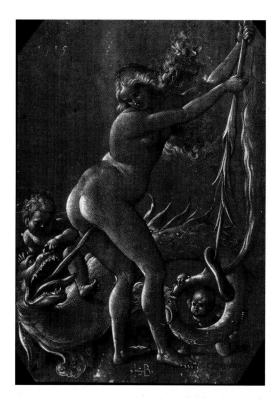

47. Hans Baldung Grien, *Young witch and dragon*, drawing in pen and Chinese ink, highlighted in white on coloured paper, 1515, Staatliche Kunsthalle, Karlsruhe.

spirit, understood as the innermost part, and the body, the instinctive and active part, appears to have become fully sanctioned.

In the work of an anonymous artist, produced with white highlights on coloured paper (1515),[17] we find *The Witches' Sabbath* (Musée de l'Oeuvre de Notre Dame, Strasbourg). The artist gives a strong sense of the primitive and orgiastic nature of the Lamia figure. The witches engaged in preparing the magic ointment (also known as witches' fat) brazenly flaunt their opulent bodies, ample bosoms and dishevelled locks. Even their positions indicate the triumphant emergence of the lewd and lascivious Lamia. The women below are seem from an angle, their legs parted so that from their vaginas they can release a burning ray which scorches and burns the surrounding vegetation; that

same fire that will cause them both suffering and ecstasy. Thus, mental satisfaction finds expression in the body.

The gestures of the possessed women are perfectly matched to this consuming orgy in which the female sex, more than any form of action, emerges as triumphant. Apart from the preparation of the ointment, which is the dominant theme, we are also shown the precise purpose of the Sabbath meeting as conceived in the popular imagination of the time, that is, a gathering for promoting sexual satisfaction, for unending delirious transports of love. This fact is made so explicit that even the flying witch is participating in the amorous sport, happily rubbing her long pitchfork against her pubis. The

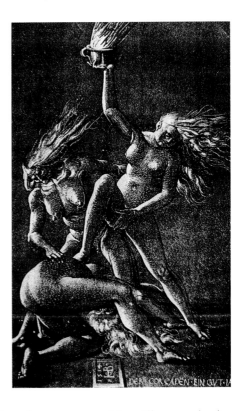

48. Anonymous, *Happy New Year to the Clerics*, 1514, drawing.

Malleus maleficarum puts in writing what these images were quick to illustrate clearly, that is, that witches "…to satisfy their obscene lust, burn with ardour and become adulteresses, prostitutes and concubines to powerful men."[18]

In this series of pictures the emergence of the witch as a pleasure-seeking woman, aware of the power of her body is hardly surprising since this image had already found visual expression some years earlier. Sandro Botticelli, gave substance to his feminine ideal in the *Birth of Venus* (Uffizi Gallery, Florence) and her curving and extremely graceful form, not without sensuality, is dressed in nothing but her long, long hair which, nonetheless, barely covers her pudenda and her breasts. The artistic delight of a portrait presenting such wondrous beauty undoubtedly influenced the iconography of

witches too, if in another key, for however beautiful and seductive a witch might be she was on a different moral plane and there was thus little hesitation in depicting nudes gasping with pleasure, or scenes showing women in lewd poses.

There is a drawing on green paper of a witch modelled on Lamia by Hans Baldung Grien (fig. 46) in the Cabinet des Dessins in the Musée du Louvre in Paris. The artist has drawn a scene of masturbation, one witch making use of a long pole, while in front of her another daughter of Satan, drawn from images of the Virgin, shamelessly imitates her. Moreover, both are holding a maleficent rosary which is not made up of beads but of strange bells, two dice and a tiny skull, the result of a deliberate abortion.[19] On the left of the picture another young witch is bearing a dish laden with bones.

The most remarkable feature is the frenzied activity of the naked bodies. They writhe as if electrified, full of irrational and violent energy (dice were the most common symbol of total chaos). The peak of pleasure is represented by the arrival of the devil, and in particular, the male organ "dedicated to Priapus"[20] which the squirming women seem to await so eagerly.

There is an even more explicit image of sexual satisfaction in the scene *Young witch with a dragon*, again by Hans Baldung Grien, in the Staatliche Kunsthalle in Karlsruhe (fig. 47). The young woman is grasping the branch of a tree while obligingly offering her most intimate parts to the devil, represented here in the form of a fearful beast (a scaly reptile with great open jaws), reminiscent of the snake referred to in the *Apocalypse*, which tickles her vulva with its slimy tongue. The woman's languorous sensual gaze as she almost swoons with physical delight, is expressive of more than mere physical pleasure, and this why she gives herself to the devil so freely and gracefully.

Offering the body to the devil in this manner is referred to in *Malleus maleficarum*, which describes how women make sexual genuflexions to the devil, the only being who, unlike men, is capable of satisfying them. However, this was a Humanist and Renaissance concept and would appear to be new and in contradiction with the secular doctrine of the Church which held that copulation with Satan was quite other than pleasurable, his penis being "frigidum e molle sicut et saepius totum corpus primo immittit…sperma corruptum et crocem, susceptum in pollucione nocturna."[21]

The engraving *Witches at the Sabbath* (Bibliothèque Nationale et Universitaire, Strasbourg) is undoubtedly to be attributed to Baldung Grien and appears in *The Ants* (*Die Eimes*) by Johannes Geiler von Kaysersberg, mentioned earlier. His sermons, written in German in 1508 and collected in this volume, explain that witches do indeed gather for the Sabbath and that the states of possession and hallucinations that affect them on these occasions are, in his view, entirely the work of the devil. This text, illustrated with various engravings, deals more cautiously with the orgiastic character of Sabbath gatherings. In this scene we see how the Lamia type of witch has taken over from the Medusa model, although only one of the three witches is in fact of the Lamia type she is the protagonist of the scene and is engaged in instructing the other two in the making of potions. She is holding the hand of a witch seated on a stool on her left and is

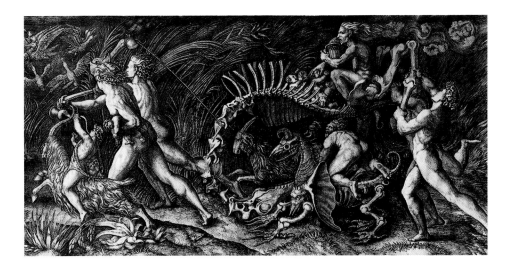

49. Agostino Veneziano, *Witchery*, engraving, 1518, Department of Drawings and Prints, Uffizi Gallery, Florence.

an impressive presence in her nudity. Unlike the other two she is young, beautiful and shapely; her hair is shown escaping from her headdress and hanging in disarray down her back. Her potion is capable of unleashing incredibly violent forces and it is obvious that this figure, a perfect synthesis of mind and body, would capture a viewer's attention.

The dominant themes of these engravings are possession, frenzy and obscene poses. The one entitled *Happy New Year to the Clerics*,[22] dated 1514 (fig. 48) is obviously connected with Western society's obsession with female sexuality and Sapphic love. These three wicked sisters waywardly flaunt their sexual parts. On observing them we are almost conscious of the yells and shudders that accompany their antics. The witch on the floor boldly displays her anus while her face, which we just glimpse below her thigh, has no real features. In fact, the eyes are simply cavities and the open mouth recalls the sketchy outline of the theatrical masks worn in the tragedies of Greek playwrights such as Aeschylus and Sophocles. The old witch also has a blank featureless face, her eye-sockets are empty and she emerges as the terrifying mask of Medusa grafted onto the body of Lamia, or indeed a death mask.

De Striges, by Bernardo Rategno of Como (written between 1505 and 1510), gives close attention to some of the opinions expressed in the *Canon*.[23] The author reiterates, along traditional lines, the impossibility of witches being able to transform themselves (even with the devil's approval) into other non-human creatures. Bernardo Rategno states that those attending the gatherings are fully awake and in complete possession of their faculties. He supplies concrete examples in support of this thesis, including an event which took place in Mendrisio, where the inquisitor Bartolomeo da Omate, the podestà Lorenzo da Concorezzo, and the notary Giovanni da Fossato decided to per-

secute a coven of witches in order to teach them the dangerous evil of their ways.[24] One day, the three men set out to follow the depraved group without being seen, as previously secretly arranged. When the group reached a particular place, not specified in the text, the devil suddenly appeared before them, like a lord waiting to be pleasured by his handmaidens. Before satisfying his terrible sexual appetite, the whole company seized stout sticks and began to lay about the three interlopers, who soon died of the blows. The jurist Rategno concludes this passage as follows: "Who now will maintain that this is the fruit of fantasy?"

Gian Francesco Pico della Mirandola (1469/70-1533), nephew of the more famous Giovanni (1463-1494), is the author of a tract entitled *La strega ovvero degli inganni dei demoni* (The witch, or the deceptions of demons). Although the book was motivated by the wave of arrests which took place in Bologna in 1523, the work describes the witch, as Sergio Abbiati's study has shown, as someone whose character is by nature ambiguous, ready and willing for any form of possession and diabolical depravity. The *Disputa seconda* revolves around four characters: Dicaste, the inquisitor; Apistio, the incredulous; and Fronino, the Wise, a spokesman for the author himself. When the accused is asked to describe a Witches' Sabbath, she quite openly recounts how her body was rubbed with ointment before she sat astride a stool which served to launch her on the road to sin: "sometimes I trampled on the consecrated Host in the circle and immediately met with Lodovico (the devil) and took my pleasure with him." Later, when questioned about exactly where she applied the ointment, she replies "on the parts I use to sit on."[25]

In the *Disputa terza*, when Dicaste asks her what means of transport she used to reach *ludum*, the same accused candidly replies: "with the body and with the mind",[26] thus suggesting that during this period body and soul (Lamia and Medusa) were seen as one and combined into a single image.

Andrea Alciato (1492-1550) defines witches as "pauperes, et foemellae omnes sunt", apostates of the true faith, sick with fantasies, and he adds that they should be treated with herbal remedies.[27] In *De Strigibus* (1523, in 32 chapters) Bartolomeo Spina (1474/76-1546) reintroduces Bernardo Rategno's views and recognizes the objective reality of witchcraft and the orgies on which it relies, denying that the devil might be responsible for producing cunning illusory effects.[28]

Thus, with Spina attacks on the moderate position of the *Canon* were further intensified. Chapter XVII offers a telling example of the desire to assign all untenable stories of flying to the realm of dreams. What follows is the story of the peasant Tommasino Pollastri, as told to a famous doctor of Ferrara, Sozzino Benti, who recounted the episode to Spina. A peasant had told him that on a night of the full moon his neighbour, with his own eyes, saw a gathering of witches and warlocks feasting and dancing before flying off into the sky on long poles. The tale impressed the doctor and made him so curious that he too wanted to hear the dreadful story (roughly relayed by Tommasino) at first hand, perhaps with some more specific details, and he asked the peasant to help

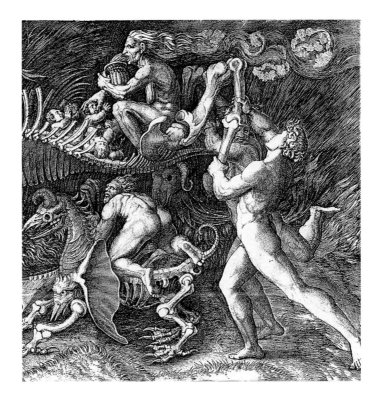

50. Agostino Veneziano, *Witchery*, detail of engraving, 1518, Department of Drawings and Prints, Uffizi Gallery, Florence.

him meet the actual eye-witness. The latter told him that on that ill-famed night he had seen more than six thousand people and heavily laden banqueting tables; some people were eating and drinking, some dancing and some shamelessly coupling; when all were satiated with drink and pleasure they suddenly melted into the mist. Spina finishes his account by saying that this story caused the doctor concerned to believe in the possibility of flying and in the reality of sexual couplings.

Such widely held beliefs concerning a witch's mythical power do not properly belong to the age of science and technical advancement, the age which explored the positive potential of human reason. But, in fact, it was the very intellectual and forward-looking character of the Renaissance, the outcome of a reborn classicism and a 'pagan' love of life now freed of established religious and cultural restrictions, which provided the stimulus for some extremist fringes of the earlier conservative order, the condemnation of the free will embodied by the witch, in particular, and womankind, in general, responsible for unleashing chaos and, if not checked, of overturning the natural order (the cosmos).

One of the most interesting illustrations of this world of chaos is undoubtedly an engraving attributed to Agostino Veneziano, produced in 1518, subsequently entitled *Lo stregozzo* (*Witchery*, fig. 49). The scene is a gloomy procession moving through a dense wood surrounded by marshland, suggested by a flight of ducks (a symbol of evil) and the tall slimy shrubs that are typical of swamps. The skeleton of a large reptile is

being drawn along by two naked youths, shown in profile, the one in the foreground bearing a dead child in his arms. They are followed by a young boy riding a goat and blowing a horn on which the initials of the author are engraved ("A. V."),[29] repeated in pen and brown ink on a small panel below, almost in the centre. Behind the boy's buttocks we see the terrified faces of two small children.

An old witch (Hecate) carrying a basket is seated on the back of this skeleton of a monstrous reptile, also shown in profile. Her face expresses her frightful wickedness; her wind-blown hair streams in spirals behind her and becomes confused with the swirling currents which fill the composition, while she sticks her tongue from her gaping mouth in a gesture of mockery and lewdness. Her body is very like a man's, rigid and heavily muscled. The old witch is supporting a smoking fire-basket with her right hand, while with the left she grasps the head of one of the infants in front of her. Below, we see the skeleton of a two-headed animal bearing a crouching naked figure on its back, the buttocks turned to the viewer. The rear of the procession is taken up by two naked youths brandishing the shin-bones of horses.

This procession follows the description of the pagan orgies reported in many of the previously mentioned contemporary treatises which allegedly report the confessions of witches extracted under torture. As in the other engravings, here too the naked body is presented quite freely, just as the back-view of the man displaying his nether regions appears perfectly natural. The hideous old Medusa witch is the protagonist of this scene, she who takes her pleasure in the sensual flesh of the well-built muscular men engaged in bearing her forward. Their imposing forms may be derived from some particular source: Michelangelo, according to Lomazzo; Raphael, for Bartsch;[30] Giulio Romano, for Delaborde; Rosso Fiorentino, for Chastel. Whatever the chief general prototype, the artist also drew inspiration from a major witch trial held in Val Camonica in the year 1518, and this may have provided him with some further suggestions. In the symbolism and intensity of the whole composition there are two features which should be brought to the reader's attention: the first is the Medusa witch, engaged in the terrible crime of infanticide (two infants are already dead while the others await their fate); the second element, which is too obvious to ignore, concerns the unusual suggestion of erotic homosexual acts. The vigorous young male figures and the man's boldly exposed anus are an eloquent forecast of the sexual activity which is shortly to take place. This would seem further indicated by the inclusion of numerous phallic symbols, including goats' horns and horses' shin-bones.

During the Cinquecento the *tópos* of the old crone was replaced by an entirely new figure, the young naked witch who sought to give and take pleasure in a completely uninhibited manner. The various forms of iconographic expression of this image (departure for the Sabbath, encounter with the devil, preparation of ointments, invoking Satan, coupling with the Evil One, etc.) share a particular characteristic, particularly widespread in German art, consisting in wind-blown hair resembling coils of flame.

In art, a woman with unruly locks, in contrast to the image of the modestly devout

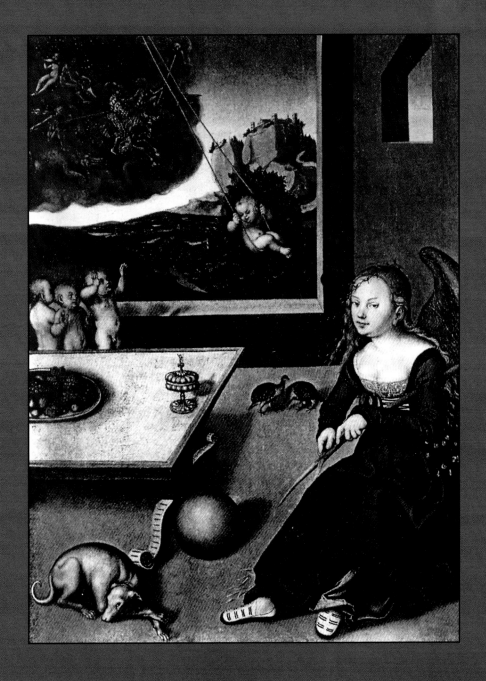

51. Lucas Cranach, *Melancholy*, tempera on wood,
c. 1532, Musée d'Unterlinden, Colmar.

52. Lucas Cranach, *Melancholy*, 1528,
Formerly in the collection of the
Dukes of Crawford and Balcarres.

housewife, refers to an emotional and sexually passionate woman. The model for the
mother of a family, the angel of the fireside, is never presented showing her hair which
is either decently covered with a bonnet or, if she is portrayed in a grand setting,
combed into an elaborate stiff coiffure. The introduction of this new image of the
naked witch was accompanied by the addition of curling rebellious tresses. Moreover,
these dishevelled locks were sometimes illustrated as standing on end, as though acting
as metaphysical lightning conductors. To observe this we have only to look at the manes
of hair depicted by Dürer, Franz Brun and Baldung in the engravings we have described
above.

In a sixteenth-century engraving by an unknown hand entitled *Witches leaving for the
Sabbath* (Castello Sforzesco, Bertarelli Collection, Milan; added art markings) three
half-naked young witches are shown circling around a smoking cauldron, their scanty
cloaks just reaching their thighs. The woman in the centre is straddling a goat and holds
some metal implement in her hand. She has a lost, distracted expression, emphasized
by the disorder of her hair. The charming young witch on the lower left, reminiscent
of Michelangelo's work, is shown in an abandoned and erotic pose as she is caressed by
a wild-haired sorcerer. Above her we see the back-view of another equally young woman
who is about to take flight with the aid of the stick which she grasps between her legs.

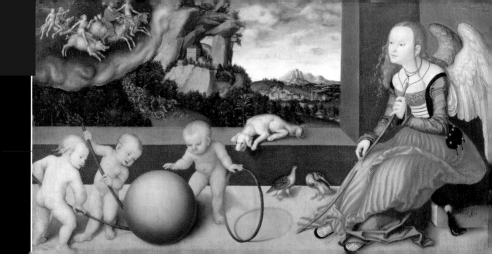

This group of witches of the Lamia type is in contrast to the other two, presumably old, witches entirely enveloped in what might be described as heavy nun-like garments. The one standing in profile appears to be immersed in peaceful isolation. In fact, she is absorbed in prayer and holds a large-beaded evil rosary, while the seated figure encourages the blaze with a pair of bellows. The ratio of Lamia to Medusa is three to two, a sign of the changing times.

Another aspect of the story of the witch concerns some specific characteristics which were held to be pathological (taciturn character and haggard sorrowful face), signs of the ominous sickness which in the Cinquecento was known as melancholy. The arts were responsible for introducing significant changes of positions on this question.

From Medieval times up to the modern age the figure of the melancholy witch centred around the image of an ugly old woman, this being the conjecture drawn from *De rerum veritate* by Cardano, a text published in Basel in 1557.[31] The author gives a detailed description of these women and states that they usually live in the countryside or in isolated places; poor cripples suffering from every form of disease; dark-skinned and full of bile or, indeed, melancholy. A similar description appears in Cesare Ripa's *Iconologia*, first printed without illustrations in 1593, which describes how the witch may appear in the guise of a downcast, sorrowing woman ("…dressed in old rags, without ornament, sitting on a stone with her elbows resting on her knees and both hands beneath her chin, and among the stones a leafless tree."[32] Ripa continues by saying that melancholy damages man in the same way that winter damages the trees.

What was the reason for this melancholy? Why did a lifetime of poverty among the woods or in the bleaker reaches of the countryside encourage a character that alternated between the irascible and the melancholy? Cardano believed that melancholy witches were indeed poor simple-minded women but that they were also physically sick, and, according to his conjectures, this sickness was pathological amenorrhea.[33]

In similar social and literary contexts in which the witch is modelled on Medusa who, for the reasons stated above, can only exercise her evil spells through her gaze, it is surprising to see representations of melancholy witches modelled in the likeness of very young women, mere adolescents dressed like noblewomen. However, this is true of the splendid sorceresses in Lucas Cranach's work, ascribed to between 1528 and 1532, which we shall shortly examine. These works are of similar date to Cardano's text.

Throughout the Cinquecento numerous treatises on witchcraft appeared. Indeed, so many were written that a whole volume would be needed simply to list and describe them. Fabio Troncarelli[34] has identified three different categories of text in this large collection of writing: the "Mannerist", inspired by the position and argumentation contained in *Malleus maleficarum*, the more important points of which we have already mentioned; the specifically demonologic, defined as 'Baroque', where the witch is defined as a daughter of Satan; and, finally, the sceptical and polemical, full of the rationalism and sanity of the Renaissance, defined as 'Gallilean'. Those which supplied material of artistic interest were clearly the first two.

54. Andrea Delitio, *Witch*, detail from *The Birth of
the Virgin*, c. 1480, Santa Maria Maggiore, Asti.

There are several treatises which continued to dwell on the sinister and dark aspects of witchcraft until a later date. In 1580 Jean Bodin wrote *Démonomanie des sorciers*, a text which is totally intolerant and recommends the essential measure of instituting special hearings to try these terrible women, capable of murdering their own children to pay homage to Satan; the only recourse against the evildoers being torture and terror. Three other works on the relationship between Satan and the witch are: *De natura daemonum*, 1581, by Lorenzo Anania, *De fascino*, 1583, by Leonardo Vairo, Bishop of Pozzuoli; and *De maleficis et mathematicis*, 1596, by Peter Binsfeld, Vicar Archbishop of Trier, not to mention contributions by Valerio Polidoro (1536), Girolamo Menghi da Viadana (1577-78, 1580, 1586), and Alessio Porri (1601), among others.

A more rational viewpoint, encouraged by the new interest in scientific matters, is offered by the fascinating *De incantationibus* by Pietro Pomponazzi, written in 1520 and published in Basel in 1556. The philosopher maintains that even supposedly supernatural matters, by definition irrational, have a rational explanation. Everything that occurs in nature has a logical explanation and, as Aristotle states, every manifestation of nature must be subject to a rational explanation. Since witches operate within the natural world, their spells and portents, while unrelated to rational procedures, do not lead to phenomena arising from the purely supernatural world. Pomponazzi maintains that the witch's power is strictly worldly and is exemplified by uncommon mental gifts; thus, the Medusa model would seem to reoccur here.

Taking up on Aristotle's words, Johann Weyer or Wier (1515-1588), personal physician to the Duke of Clèves, Wilhelm V von Jülich-Kleve-Berg, goes even further when he describes witches as poor, mentally deranged women (as Cardano had proposed in 1557) who suffered from fits of catalepsy which produced startling hallucinations, including travelling to distant places. Moreover, in his *De praestigiis daemonum ac incantationibus ac veneficiis* (1563) he maintains that it is only when the unconscious is freed of all rational ties that it can it create mysterious imaginary powers.

Lucas Cranach produced three variations on the theme of *Melancholy*, adopting the pattern of the Medusa model that was in harmony with the work of the philosopher Pomponazzi and the later Weyer. These paintings are in Colmar (Musée d'Unterlinden, fig. 51), formerly in the collection of the Dukes of Crawford and Balcarres family (fig. 52) and in the Statens Museum for Kunst in Copenhagen (fig. 53). The subject matter is an illustration of the witch hunts fomented by Luther's teaching (when he withdraw to the castle in the Wartburg and the devil appeared before him). Indeed, in 1522 he stated that witches were to be considered whores. The three paintings introduce some recurring elements which the painter wanted to bring to the viewer's attention. Cranach was particularly caught up by this subject matter because of his friendship with Luther and, indeed, during the latter part of his life, he became a stern and determined opponent of witches and magical practices.

We can come to an understanding of these different treatments of the same subject if we study the small scene that the painter has introduced in the upper left-hand corner

of the painting, framed by the landscape which appears outside the window. We see a distant turreted castle and the sinister image, on the extreme left, of the raging armies, earlier described in the *Canon Episcopi*. Castelli maintains that this particular episode refers to melancholy, the typical sickness of the solitary and taciturn witch. Medical and scientific theories of the time held that this was a distinctive characteristic of these evil woman, these daughters of gloom.[35]

In all three versions the room holds objects of particular symbolic significance: a circle, a sphere and a pointed stick. These are the witch's implements, especially the sphere, a sacred symbol of prophecy and premonition. On the table stands a handsome dish of fruit, apples and pomegranates, while the cup or glasses in the Colmar paintings, and the one whose whereabouts are not known (formerly in the collection of the Crawford and Balcarres family), are clearly suggestive of wine, the juice that induces delirium, but also torment, a principal cause of melancholy. The partridges beside the young woman are a sign of the new, sexual-erotic character of the portrait of this witch. The clue to the subject matter undoubtedly lies in the inclusion of the two birds, since the treatise *De strigimagarum daemonumque mirandis* by Silvestro Prierias (1456 c.-1523) mentions two partridges in flight, ready to transform themselves in a twinkling of an eye into fifteen beautiful musicians to grace the *ludum*. This bird thus perfectly epitomises the Dionysian nature of this lady's magical gifts.

Aside from the symbolism mentioned above, the most important aspect of these three paintings, and one as yet not fully considered, concerns the representation of the witch herself. Contrary to the description of Ripa and a whole body of more common-or-garden, old-fashioned popular prints (fig. 54) which portray her as bent and white-haired, she had never before been depicted as we see her in these three paintings by Cranach, a beautiful winged creature, a figure hovering between a handsomely dressed young damsel and a female angel. She is busy sharpening the stick she will use in her flight through the skies; her figure is slight breasted and her milk-white skin provides a startling contrast with her untidily dressed red hair (indicating wickedness and rebellion). The contrast between her voluptuous body and the ethereal delicacy of her face is an example of the dual nature of the witch of this period.

This image undoubtedly suggests an angel-woman. Never before had a melancholy witch been illustrated with feathered wings, never before had a witch been depicted as so young as this virginal lady of the court. Given that she is not naked, her beauty is conveyed by her face and her elegant figure. In this case, due to her intense air of melancholy, she must be considered a reborn Medusa (in this example alone). While the delicacy of her form and the beauty of her childish face is derived exclusively from the Lamia model, we recognize the strength and energy of a triumphant Medusa in the power of mind and imagination which she conveys. The events taking place behind her (the raging armies besieging the heavens) are the fruits of her unconscious oneiric vision.

1) The first edition of this work appeared in Strasbourg in 1486-87, the second in Speyer in April 1487. By 1669 it had appeared in thirty-four editions (ten in Lyons, three in Venice, four in Nuremberg, four in Frankfurt, three in Speyer, two in Cologne, etc.). The two Dominicans were given the task of "punishing, imprisoning and chastising" those affected by this scourge.

2) On the two Dominicans see Armando Verdiglione's introduction to H. Institor, J. Sprenger, *Il martello delle streghe. La sessualità feminile nel transfert degli inquisitori*, Venice 1977, p. 11).

3) F. Troncarelli, *Le streghe*, Rome 1983, p. 55. Following the publication of *Malleus maleficarum* its influence provoked a sharp increase in treatise writing. For more detailed information see the work of J. Delumeau, *La Peur en Occident (XIV-XVIII siècles)*, Paris 1978, pp. 348-349.

4) As M. R. Lazzati (S. Abbiati, A. Agnoletto, M. R. Lazzati, *La stregoneria. Diavoli, streghe, inquisitori dal Trecento al Settecento*, Milan 1984, p. 131) writes although the work reflected the particular state of affairs in the Germanic world, the overall pattern of its general structure, and especially the inclusion of precise details concerning the procedures to be adopted, made it of interest and relevance to every inquisitor in Europe.

5) H. Institor, J. Sprenger, *Il martello delle streghe*, cit., p. 179. However, a little further on the work continues"…the devil's aim and appetite lie more in tempting the good than the wicked since from the point of those tempted, the wicked are more easily tempted than the good, and this is because the wicked are more open to the Devil's temptation than the good. Thus, as experience and reason shows us, the Devil seeks to seduce the largest possible number of virgins and maidens."

6) This world had great popular appeal during the Middle Ages, although it was all too frequently repressed by the diatribes of the Church. The world turned upside was perceived as another world, another life. M. Bachtin (*L'opera di Rabelais e la cultura popolare del riso, carnevale e festa della tradizione medievale e rinascimentale*, Turin 1979) writes that turning life into a 'carnival' in this way may have been dictated by the desire to rid society of all forms of inequality by striking at its roots. In fact, as King of the Carnival, the witch was part of this disruption and in many popular stories she is described as riding on a donkey and wearing a mitre on her head, adopting the traditional carnival mask.

7) A. M. Carassiti, *Dizionario mitologico. Le figure mitologiche della civiltà greco-romano*, Genoa, 1996, p. 231.

8) H. Institor, J. Sprenger, *Il martello delle streghe*, cit., pp. 214-215. However, they state that all forms of witchcraft are "the work of the devil's powers of illusion, realised, as described, by causing a disturbance to the organ of sight through the transformation of species that are influenced by the power of the imagination."

9) H. Institor, J. Sprenger, *Il martello delle streghe*, cit., pp. 218-219.

10) According to this theologian, witches did indeed attend the Sabbath, just as they were the victims of Satan's powers of hallucination, which turned them into his instruments. Thus, as emissaries of Satan they were to be condemned to death without excuse or mitigation (see G. Bosco, *Johannes Geiler von Kaysersberg (1445-1510)*, in *Bibliotheca lamiarum. Documenti e immagini della stregoneria dal medioevo all'età moderna*, Pisa 1994, pp. 115-116.

11) F. Troncarelli, *Le streghe*, cit., p. 50. The story of the witch Matteuccia di Francesco da Foligno, tried on 20 March 1428, is recounted in M. Pericoli, *The Record of a Trial and Condemnation of a Witch*, in *Medicina nei secoli*, IX, 1972, pp. 54-84, and also in C. Peruzzi, *Un processo di stregoneria a Todi nel Quattrocento*, in *Lares*, XXI, 1955, pp. 1-17.

12) L. Monaci Moran, *Albrecht Dürer (Norimberga 1471-1528)*, in *Bibliotheca lamiarum*, cit., pp. 207-208.

13) *Ibidem*, pp. 204-205.

14) P. Castelli, *'Donnaiole, amiche de li sogni' ovvero i sogni delle streghe*, in *Bibliotheca lamiarum*, cit., pp. 52-56; *Hans Baldung Grien*, exhibition catalogue, Karlsruhe 1959.

15) The artist's pictures of witches have been catalogued and published by O. Fischer, *Hans Baldung Grien*, Munich 1939, in particular the little published illustration no. 50.

16) G. Bosco, *Johann Nider (1380 c.-1438)*, in *Bibliotheca lamiarum*, cit., pp. 100-101. The Dominican wrote the work during the Council of Basel. It remains uncertain whether he also served the Inquisition as a judge for cases of witchcraft.

17) P. Castelli, *'Donnaiole, amiche de li sogni'*, cit., pp. 54-55.

18) H. Institor, J. Sprenger, *Malleus maleficarum*, Venice 1574, p. 67.

19) There is a description of the preparations for the Witches' Sabbath in M. Sallmann, *Le streghe*, cit., p. 49. The artist here would seem anxious to illustrate the monstrous offspring that witches produce as a result of coupling with Satan.

20) On Priapus see A. M. Carassiti, *Dizionario mitologico*, cit., p. 260. Priapus, the son of

Aphrodite and Dionysus, was a deity who brought fertility to the flock and to the fields. A phallic symbol was displayed to protect vineyards and gardens.

21) F. Troncarelli, *Le streghe*, cit., p. 75. The author tells how the inquisitors' "*invidia penis demoniaci*" probably showed a fear of castration.

22) P. Castelli, '*Donnaiole, amiche de li sogni*', cit., pp. 53ff.

23) A summary of *De strigiis* can be found in the introduction to an analysis of some parts of the work: S. Abbiati, *Bernardo Rategno da Como (1510 ca)*, in A. Abbiati et al., *La stregoneria*, cit., pp. 199-200.

24) The author does not specify whether witches actually attend the Sabbath physically or in their imaginations. He maintains that given that they are heretics they must be punished accordingly, just as every sin of heresy is punished, whosoever commits it. Their chief sin lies in adoring and offering sacrifice to devils, thus replacing the Devil and Almighty God.

25) G. Pico della Mirandola, *La strega ovvero degli inganni de' demoni*, in A. Abbiati et al., *La stregoneria*, cit., p. 237.

26) *Ibidem*, p. 242.

27) Andrea Alciato's biographical details are in A. Abbiati et al., *La stregoneria*, cit., pp. 365-366.

28) On Spina: A. Abbiati et al., *La stregoneria*, cit., pp. 366-367. The work *De strigibus* was published for the first time in 1523, probably in Venice together with other works by the same author (*Tractatus super alias omnes scientias et praecipue humanarum legum* and *In Ponzinibium de Lamiis Apologiae*) which, however, bear the date 1525. The work was reprinted several times: Rome 1576, Cologne 1581, Frankfurt 1582 and 1588, Venice 1584, Lyons 1620 and 1669.

29) Some historical and artistic details on Agostino Veneziano's engraving *Lo Stregozzo* (Witchery) can be found in L. Monaci Moran's entry, *Agostino Veneziano (Venice 1490 c.-1540)*, in *Bibliotheca lamiarum*, cit., pp. 209-210.

30) Bartsch XIV, *Le Peintre-Graveur*, Vienna 1811, pp. 321-323.

31) P. Castelli, '*Donnaiole, amiche de li sogni*', cit., p. 36.

32) *Ibidem*, p. 43.

33) G. Cardano, *De rerum veritate, Libri XVII*, Basel 1557, XV, pp. 365-575; A. Mondini, *Girolamo Cardano, matematico, medico e filosofo naturale*, Rome 1962.

34) F. Troncarelli, *Le streghe*, cit., p. 79.

35) P. Castelli, '*Donnaiole, amiche de li sogni*', cit., pp. 57-61.

55. Girolamo Frilli Croci, *Rinaldo in Armida's Garden*, c. 1520-1524, oil on canvas, Uffizi Gallery, Florence, depository.

The Modern Age:
The Image of the *Venus terribilis*

The seventeenth century marked the end of the age-old belief in the supernatural power of witches, those daughters of Satan who flew off into the moonlit night on broomsticks to meet him in a consummation of love and death

The weakening of similar superstitions also brought an end to the need for tortures proportionate to such degrees of evident wickedness. In 1610 the use of the barbarous trial by water[1] during an inquisitorial session was banned almost everywhere and, again in the early years of the century, during the Zugarramundi trial in Holland, one of the judges of the inquisitorial tribunal of Logroño actually refused to condemn some witches who had been found guilty of heinous crimes. In 1611 Alonso de Salazar y Frías was put in charge of introducing more lenient measures throughout the province. At the same time, there appeared the work of an eminent German Jesuit, Friedrich von Spee, whose tract, entitled *Cautio criminalis, seu de processibus contra sagas* (published 1631) severely criticised blind belief in the supernatural and diabolical power of witches.[2] While the idea that Satan the Tempter used female instruments for his evil ends remained a pillar of Catholic doctrine (an opinion firmly upheld by the Council of Trent),[3] it would appear certain that the whole issue of witchcraft became more problematic when groundless hypotheses were excluded by medical science and by the laws of physics. As a social question, witchcraft would seem to have become a thorny issue and one which was increasingly difficult to define,[4] judges being repeatedly warned to show great caution and ensure that the sentences they pronounced were just and respectful of the truth since a serious error of judgement could undermine the validity of the entire inquisitorial machine, until now so smoothly operated.

Alongside these entirely new stances, others of a Medieval character continued to appear, albeit sporadically. In 1608, *Compendium maleficarum*, by Francesco Maria Guazzo,[5] was published, but it contains no doctrinal novelties. The work bases itself on the historical tradition and the author does not hesitate to repeat some of the more commonly held views on the wicked influence of witches on men and children and on the efficacy of their magic practices.[6] Chapter XIII, in particular, insists on the fact that witches fly at night astride either a broomstick or a goat to attend the Witches' Sabbath,[7] a gathering which the author holds to be the summit of wickedness *contra omnes*. Guazzo has no hesitation in insisting on the matter of flying through the air, the call of the devil, and the deceptive trickery of the witch who takes advantage of the devil's power to fly to him, while deceiving her husband who believes that she lies dreaming beside him. The *Compendium* describes how "… when a witch goes to the Sabbath, in order to prevent her husband from discovering her absence it is her custom to put him

to sleep and leave something in her place, so that should he wake he will think it is his wife."[8] He continues without hesitation to state that celebration of the Witches' Sabbath involves the prior slaughter of large numbers of infants in order to extract their fat, used by the witches to smear their bodies.

The anti-feminist aside which the author uses to explain why there is such a predominance of female witches in such gatherings is interesting: women "…are by nature chatterers and gossips and therefore cannot keep a secret. They immediately tell everything they know to some other woman. Added to this, they are quick-tempered and their physical frailty means they are unable to avenge themselves, they turn to witchcraft so that they can call secretly on the devil to obtain what would otherwise require the use of force."[9] We should mention a passage which refers to purely carnal relations, according to the axiomatic association of the witch and lust, in a description that presents her as a creature of unbridled sexual appetite.

The relevant episode on this question cited in the *Compendium* explores the passionate nature of the *modus vivendi* of a presumed practitioner of the occult, a young woman who was seduced and abandoned by her lover whom she had hoped to marry, driven by despair into becoming a witch. Thus, Guazzo would seem to suggest that this may be a feminine phenomenon that is conceived and nurtured before erupting violently in a desire for revenge against the male sex. Not surprisingly, during the seventeenth century many paintings, as we will shortly see, portray the sorceress of the Lamia type, the beautiful young woman who leads the honest upright man astray with her charms and spells, driving him to seek her for her bodily charms alone.

In 1609, in Aix-en-Provence in France, two Dominican friars publicly exorcized an Ursuline nun, Madeleine Demandois de la Palud, believing that were faced with a witch. The nun, after frightful torture and suffering, accused Father Louis Gaufridy, a curate of Marseilles, who was immediately subjected to unimaginably cruel treatment and forced to confess publicly that he had made a pact with the devil and, as a result, had on more than one occasion corrupted Madeleine and known her carnally. On 30 April 1611, after a trial lasting two months, the priest was burnt at the stake.

During these same early years of the seventeenth century, a shocking case was exposed in Loundun, in France. The abbess of an Ursuline convent, Jeanne des Anges, accused the priest Urban Grandier of having corrupted and bewitched the convent's sisters, and indeed many accused him and cited startling episodes of an erotic nature. His end was inevitable, and on 8 August 1634 he was sent to the stake like a common witch.

It was not until 1671 that the first convincing treatise demolishing the fundamental concept of witchcraft appeared in France. The Capuchin friar Jacques d'Autun wrote *L'incredulité savante et la credulité ignorante au sujet des magiciens et sorciers*, a work which opened the field to new ideas about a witch's hallucinatory experiences and psychosomatic illnesses. Many other voices were now raised denying the existence of witchcraft, while, at the same time, this 'revisionist' movement was still firmly resisted by the judges of some local tribunals who relentlessly continued to condemn women

56. Giovanni Bilivert, *Tempting Carlo and Ubaldo*, c. 1629-30,
oil on canvas, Giovanni Pratesi collection, Florence.

suspected of magic practices. This was the case in the small town of Louviers where, again in the first half of the century (1633), Sister Madeleine Bavent of the convent of the Hospitalers and St. Elizabeth, was discovered in a hallucinatory state in the throes of convulsions. During the course of the trial the guilt of the sister and of the curate Mathurin Picard, who had died ten years earlier, was established. In 1647 the nun's sentence was pronounced, together with that of the deceased cleric and of his vicar Thomas Boullé, guilty of carnal knowledge of Bavent (now a proven witch). Boullé was burnt alive along with the disinterred bones of Picard. The debate aroused by this amazing sentence strengthened the case of those who had no belief in diabolical possession (as shown by the enquiry conducted by Pierre Yvelin),[10] preferring the more logical solution of mental disturbance.

Another remarkable instance of merciless persecution concerned a milliner, Caterine Deshayes, wife of Montvoisin and thus known as 'La Voisin', a woman skilled in the preparation of salves and potions, as well as a practitioner of astrological predictions and abortions. According to the authorities, she was guilty of celebrating the 'Black Mass', during which she gave both her regular followers and more occasional worshippers sinister concoctions to drink made of menstrual blood and sperm. When this lurid affair came to light in 1680 the woman and a further thirty-five people were all tried and condemned to be burnt at the stake.[11]

Meanwhile, in 1671 and 1672 the 'Conseil des Dépêches' sanctioned numerous decrees aimed at finally bringing an end to witch hunts in Béarn, Guienes and in Normandy. These decrees were followed in 1682 by an edict on magicians and fortune-tellers which stipulated that those accused should only be condemned in the face of incontrovertible proof.

As the new era advanced, witchcraft continued to keep a foothold in the minds of the more credulous members of the population, while for others it was now no more than an idle superstition. Although it is difficult to establish when witch hunts officially came to an end there is no doubt that by the mid-seventeenth century there was finally a cessation of the large-scale and merciless persecution of the 'mistresses of Satan', and this was replaced by a more aware evaluation of the phenomenon of collective hysteria and of the kind of disorderly behaviour which was held to be immoral. This gradual positive shift towards a more rational view of human life and experience was encouraged by the establishment of scientific principles in the fields of physics and astronomy. A re-evaluation of the empirical question, or rather the observation and enumeration of phenomena, led to a better assessment and theoretical formulation of all forms of human activity, all worthy to be represented and studied as manifestations supported by firm evidence or convincing hypotheses. The birth of the new science, faith in Galileo's observations and the formulation of his theories concerning the universe which he recorded in mathematical formulae, his calculation of the distances between the sun and the planets, the discovery of the law of gravity and infinitesimal calculus, achieved by the work of Copernicus, Kepler, Newton and others, encouraged

57. Felice Ficherelli, *Carlo and Ubaldo in Armida's Garden*, oil on canvas, c. 1654, private collection.

complete revision of the more irrational beliefs. This revision led the phenomenon of magic to be at least partially resolved and it was no longer held to depend exclusively on supernatural forces. The witch was seen increasingly as a woman in the throes of severe mental disturbance. This new attitude encompassed the rules governing witch trials and the methods used to uncover the truth.

By 1620, the Holy Office had disseminated the *Instructio*, not published however until about 1650, a text which advised inquisitors to conduct their investigations with extreme caution.[12] No less a figure than Louis XIV signed two edicts prepared by his minister Colbert sanctioning the revocation of the crime of witchcraft. In Germany in 1631, a man of the Church,[13] the Jesuit Friedrich von Spee, published *Cautio Criminalis* which at least has the merit of describing accusations of witchcraft as mad, nothing more than the result of superstitions in which envious people of every kind took refuge, wreaking harm on poor ignorant women.[14]

On the strictly artistic side things took a different direction. Diabolical practices (which began to decline as a social phenomenon in 1650)[15] proved a successful subject for artistic expression, at least in their more sinful and scabrous aspects, production being further encouraged by expanding popular demand.

Many artists enjoyed painting these libidinous scenes which allowed them to give full rein to their fertile imaginations and some achieved great narrative and visual effect.

The painting by Frans Francken II (1581-1642) entitled *The Witches' Gathering* (1607, Kunsthistorisches Museum, Gemäldegalerie, Vienna) depicts a whole cluster of witches engaged in wicked practices and emphasizes the close link between women and sorcery. Many of the witches and devilish monsters are busy preparing various ointments and liniments. The young and the old, even children, are depicted living and working in some infernal region, rapt in ecstatic concentration as they gaze at the stars, study the cabala or brew their magic herbal concoctions. Each witch is engaged in a particular occupation and there are many different tasks to be performed. A truly detailed description would need an essay on its own, however: in the foreground skulls and

58. Salvator Rosa, *Witch*, oil on canvas, Capitoline Gallery, Rome.

shin-bones lie scattered on the floor and among these are toads, a chosen symbol of the devil, and the head of a black cat, a witch's traditional familiar. The witches in the scene are naked or clothed, old and haggard or young and beautiful, and even children. The aim of this painting, unlike the works of the previous century which we have just discussed, was not to present the witch as an enchanting creature, but as an artificer (a view that prevailed at all social levels) who could unleash wild mental energy which, when combined with the forces of nature, constituted the basis of her triumph over man.

The mental energy is illustrated in this painting by the irrational chaos produced by the busy display of reading, study and the interpretation of ancient diabolic texts, obvious-

59. Salvator Rosa, *Witch preparing the
cup of immortality*, c. 1646-1649,
oil on canvas, private collection, Milan.

ly reserved for the witches' eyes alone. The cerebral figure here clearly reigns supreme over the sensual one, in obedience to the accepted notions of witchcraft as elaborated by judges and doctors. This graphic illustration can obviously be interpreted as a response to the new views which were emerging during the second half of the century, and this whirl of frenzied movement and activity only thinly veils the true dilemma of these wretched women, mental illness, some hidden sickness or the demons lurking in the unconscious, and certainly not supernatural evil forces. The real subject of this painting is the nightmare of the human mind, since the demons and monsters in the scene play a secondary role while the true protagonist is the physical energy.

Thus, while maintaining both models, the Baroque seems in the end to have opted for Lamia alone, and just as intertwining, serpentine forms were carried to all imaginable extremes in paintings and sculptures of saints and angels, these forms were certainly not neglected for portraying witches too, and perhaps even more stressed. A perfect and highly interesting example of this is supplied by the illustration of Torquato Tasso's *Gerusalemme liberata*, a poem which quickly captured the attention and enthusiasm of painters in the early years of the century. An invaluable record is provided by this work of Tasso's, originally entitled *Goffredo* and completed in 1575 (later published as *Gerusalemme liberata*, 1581), because it confirms our conjectures about the image of the witch at the time of the Counter-Reformation and during the Baroque era, at the moment of the shift towards the seductive and voluptuous woman.

Tasso himself was representative of this new artistic direction which fluctuated between moments of impassioned spontaneity and rare instances of gloomy introspection and inner turmoil. His whole opus is such a succession of these archetypal moments that even the less obvious ones, inherent in the magical pathos, emerge as deeply troubled and charged with emotion. The episode with Rinaldo and the sorceress Armida is covered in three verses in *Gerusalemme liberata* and is highly sexually expressive throughout, full of fire and stirring passion. Armida is the sorceress who sets the stage for a game of love which causes Rinaldo to go astray; Armida is the goddess who creates the love-spell; she is the enchantress and lover and is consumed with passion for the dashing young Rinaldo, searching for fame, revenge and glory.

Armida is a perverse witch, meaning in this case that she carries the passion of physical love to its most extreme level, a level so wild and frenzied that Rinaldo briefly abandons himself to her and to her world, forgetting his mission as a crusader which consists in fighting to defeat the infidels, at a particularly delicate moment for the whole venture since Goffredo di Buglione is being hard pressed by his own men and, together with the bulk of the Christian forces, is assailed by drought and enfeebled by Ismeno's spells. It is Carlo and Ubaldo who, at Buglione's insistence, set off to guide the young soldier back to the true path and away from the witch's prison in the Fortunate islands, beyond the Pillars of Hercules.

The passage where Armida (XIV, 52-56) entices Rinaldo to the island in the Oronte river in order to kill him, is sexually highly charged. The exhausted hero is lured to the

island by a charming young maiden, but she suddenly vanishes and Armida appears in her place, ready to slay him. This episode, like others involving the two protagonists, is illustrated in a cycle of frescoes in the Careggi and Mezzomonte Medici villas. The success of the theme of *Gerusalemme liberata* in the Grand Duchy of Tuscany was due in part to the dynastic importance which the poem came to assume for the Medici family, following the marriage of Ferdinando I and Christine of Lorraine in 1589. The bride was descended from Goffredo di Buglione, the Christian *condottiero* celebrated by Torquato Tasso in his poem glorifying the House of Este (with particular reference to Alfonso II d'Este).[16] The principal theme which caused it to be so widely read was further encouraged by the fact that the liberation of the holy sites was also particularly dear to the Medici family, clearly more than ready to exploit the happy circumstance of being linked to a house so committed to the defence of Christianity.

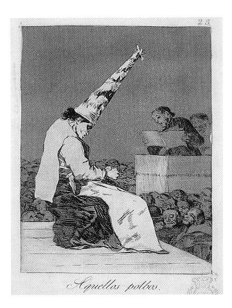

60. Francisco Goya,
"Aquellos Polbos",
etching of the series
Los Caprichos, 1797.

An early seventeenth-century canvas attributed to Giovan Battista Vanni[17] depicts *Armida attempting to kill Rinaldo* (Kunsthistorisches Museum, Vienna, depository), and shows the young crusader in a fairy-tale setting, surrounded by open meadows and hills in the distance; on the left looms a dark tree, almost like a stage set. The whole scene provides a perfect frame for the protagonists, *eros* and *thánatos*. The handsome, alabaster-skinned warrior lies stretched on his side, his head gently pillowed on some drapery and his right arm lying loosely across his sword. Beside him stands Armida and in her murderous rage, her passionate frenzy, she brandishes a dagger with the aim of bringing an end to the cause of her suffering. Armida is presented here as young noblewoman with delicate features, milk-white skin, generous sensual body and voluptuous heaving bosom. The witch we have so often seen portrayed, both young and old but always naked with a seductive body and an evil face, has been transformed into a lady

of court, a sorrowing Venus who is not just a fighter struggling to defend the superior powers conferred on her by Satan which enable her to alter the course of events, but also a battling spirit ready to fight to the death to protect the most fundamental expression of feminine power, that is, sexual passion.

The same may be said of another work painted in the first half of the same century, again for the Medici Grand Duchy. This episode depicts *Armida binding Rinaldo* (Florence, private collection) with a garland of flowers. The hero is shown sleeping in his suit of armour, leaning on his side, while the lovely maiden prepares to bind him with her enchanted garland. The sorceress is presented in profile and resembles a Classical nymph; she is clad in drapery and the cloak over her left shoulder lends a touch of the androgynous feeling which pervades the whole figure, although her hair is dressed in the style of a lady of the late Renaissance and drawn back onto the nape of her neck with a string of pearls.

We find a more still more abandoned image of unbridled of sensual passion, as conveyed by the generous yielding limbs of this new Baroque witch, in a painting by Girolamo Frilli Croci (active in Florence during the first quarter of the seventeenth century) entitled *Rinaldo in Armida's garden* (fig. 55). The painting was first published in 1983[18] and formed part of a series of three works commissioned in 1630 by Cardinal Carlo de' Medici for his *Casino* of San Marco in Florence; it offers a visual interpretation of Armida's garden (XVI, 9ff.). This is a famous episode and probably the most erotic in the whole poem. Sensuality plays the leading role here and is challenged by no other. The enchantress in this painting is in the full flush of womanhood, her limbs abandoned as she burns with desire for the handsome young warrior. The Classical figure of Lamia is now a Venus searching for her mirror-image, the beautiful 'other', her bodily and cerebral double. Like Rinaldo she too is a fighter, and like Rinaldo she fights for her love. The young man risks his life for the love of Christ, while the beautiful witch risks her life for love of the young man. She seeks to possess joy and energy in its Dionysian form, without, however, forgetting the hidden power of the emotions, since Armida does not represent sensuality alone. She embodies the supreme value of passionate emotion, the noblest expression of eros. Because Armida is in love with Rinaldo she is able to seduce him without the aid of magic potions, something she could very easily have procured.

The seduction she practices follows a perfectly traditional and ordinary pattern: the use of glances, followed by movements of the body. Armida loosens her hair and looks at her reflection in the mirror held by her beloved. She wants confirmation of her attractions, indeed she gazes at herself intently while the young man observes her admiring herself. Her partial nudity conveys an explicit message and the very interweaving of their bodies is expressive of ardent sexual desire. Rinaldo's right arm encircles her right leg while the left is slipped between her young thighs. In the background we see two turtle doves perched on their nest.

The painting would seem to emphasize the idea that this seventeenth-century witch is

a vehicle for the magic of beauty, which is none other than the harbinger of love, the meeting of two bodies is the real subject of the enchantment which is produced by a half-glimpsed idyllic setting, light years away from the gloom-filled landscapes of Dürer and Hans Baldung Grien. On the extreme left of the painting a lively cupid seems to set the seal on the enduring theme of magical inspiration illustrated in this amorous encounter.

We must not forget to mention some illustrations of the witches in Armida's retinue skilfully portrayed in an oil painting commissioned by Marchese Gabriello Riccardi and painted by Giovanni Bilivert in around 1630 (fig. 56). The work depicts Carlo and Ubaldo being tempted by two young girls (an episode drawn from Canto XV of *Gerusalemme liberata*), a subject which is illustrated in two other works on canvas in Paris (Musée du Louvre), and in Florence (private collection).[19]

Here too the body remains the principal means of enchantment, the prime instrument of seduction. The witches here, both reminiscent of Botticelli's Venus, are seeking a sexual encounter with Rinaldo's young friends. The sensual character of the young girls is not overplayed, their magic is a visual enticement, an invitation, and is not openly presented as the operation of a perverse and fiendish mind; their invitation is simply a request for physical love. These young girls, swathed only in their tresses and a few wisps of cloth, are shown in the grip of some Bacchanalian frenzy, their objective being a sexual union which will cause the young crusaders to stray from the true path. Besides being simply an illustration of Tasso's story, the images of these witches also reveal the tastes of an era which saw sensuality as a major path to success.

For the Lamia figure too success lay in an eruption of eros, a fateful course involving the 'nullification' of reason and the triumph of chaos. In this instance however, according to Tasso's poem, the venture did not prove successful. But quite independently of the story of *Gerusalemme liberata*, the most important point for this study concerns the changing image of the witch who, in the guise of the seductive and voluptuous Lamia, became the protagonist and female prototype *par excellence* during the seventeenth century.

Another painting on canvas by Felice Ficherelli (fig. 57)[20] depicting two young girls enticing the two crusaders has this same voluptuous quality – Eve the Temptress. This is an illustration of verses in Chapters XV-XVI, and the two witches in the foreground on the left are little more than images of bathing nymphs; one is depicted standing in profile with her knee pressed against the trunk of a tree, while the second is seated, observing the charming scene of Armida and Rinaldo. On the right are Carlo and Ubaldo, who philander like innocent young lovers. The atmosphere of the whole picture is of utter normality and the appearance of the two young witches is one of virginal purity, but also acceptance of their failure to be welcomed as a source of pleasure. Both Tasso and the painters who have interpreted his text make it clear that the witch is now to be to both seen and felt by the senses which, if well deployed, will destroy the sanctity of their holy mission.

A painting attributed to the circle of Cornelis Metsys (o Massys, 1510-1556/57) entitled *The Temptation of St. Anthony* (Musées royaux des Beaux-Arts, Brussels and datable to the early 17th century, has the same sensuality and gently seductive quality as the witches illustrating Tasso's work. Although the subject is embedded in an iconographic tradition which envisages the hermit, St. Anthony, being tempted by Satan with the objects of desire, it is interesting to note how the main feature of these enchantresses is their loveliness, the beauty of their slender yielding bodies, their gentleness, all part of the new belief which held that the witch tempted the hermit less with her mental powers than with the beguiling charms of the body, in this instance of a young girl, emphasizing the contrast between the wrinkled old man and their youthful freshness. We should mention the dressing of the hair, which we have described in other works. During the Renaissance the Lamia type of witch was always shown with loose or undressed hair, disordered and unruly locks which echoed her true nature. In almost all the paintings studied here, and especially in this one, the hair is dressed in a neat and ordered fashion, drawn back onto the nape of the neck with a twist of pearls or, as here, gathered together in an elegant and becoming tight plait. The sorceress is no more than a wily lady tempting the saint with the forbidden fruit; she is a new Venus, less remarkable for her perfect beauty than for her the pleasing smoothness of her limbs. The nymph, the grand lady and Venus are all variations of the witch, lurking behind the respectable façade of the lady of court and waiting to burst forth in all her brazenly disturbing nudity. In this case too, as with Tasso's Armida, we see the introduction of the new Eve, able to ensnare with her body language alone.

The solitary witch painted by Salvator Rosa (1615-1673, fig. 58), in the Capitoline Gallery in Rome, is quite a different figure. She is shown consulting a book of magic in order to brew her lethal potions and is portrayed sitting on a rocky outcrop in a night scene which is full of gloomy foreboding. Her great age is startling and distressing and her nudity is an added illustration of the fact it was modish to present her as poverty-stricken. This painting has a typically Baroque flavour and a grimly macabre atmosphere, following the anti-Renaissance and anti-Classical movement espoused by the painter. Unlike the images discussed above, this figure conveys the theatrical whimsy of a past era. It represents a nostalgic harking back to a previous period, full of darkly sinister tones which, furthermore, were be readopted during the nineteenth century to form the basis of the 'sublime' painting of the Romantic age. Salvator Rosa is a painter of paradox and his style reflects his typically imaginative vision. In this instance he does not fail to highlight the important influence that fantasy exercises on the intellect,[21] and thus this aged crone is portrayed as monstrously ugly, while in her claw-like hands she holds a book of charms and magic, searching for some mortal incantation (note the smoking candles encircling her feet, which are resting on a written sheet). This painting is a typical expression of the personal style of the artist who chose to reflect a much earlier popular taste, based on past traditions and simple local customs.

61. Francisco Goya, *Night scene with witches*, oil on canvas, 1797-1798, Lázaro Galdiano Museum, Madrid.

114

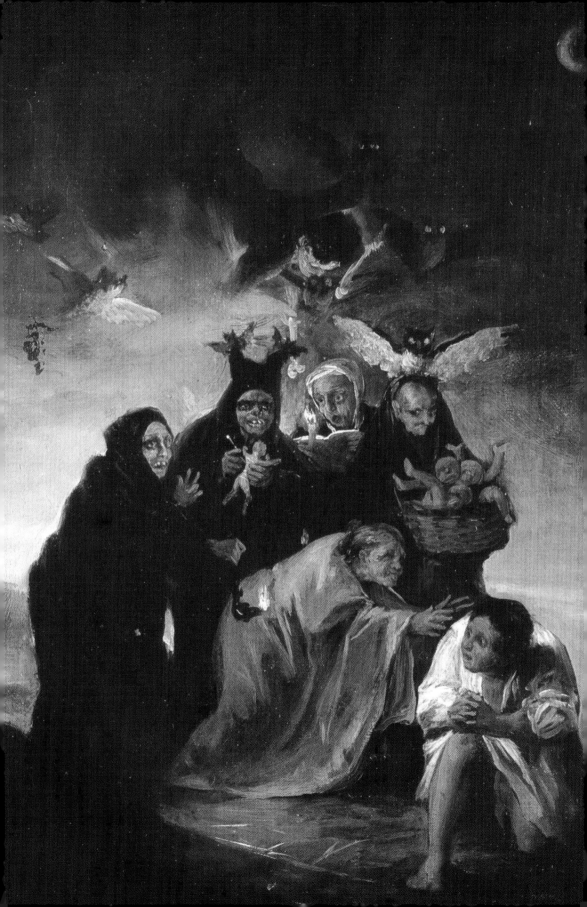

However, the scene from Tasso painted by François Boucher in 1734 adopts the new iconography. The painting depicts *Armida and Rinaldo* (Musée du Louvre, Paris) and portrays a witch who seduces with her physical charms alone. The beautiful young woman, her breast uncovered, occupies the centre of the scene and displays her charms to Rinaldo, who seems suitably enthralled. Despite the fact that Tasso's epic poem leaves little room for invention in terms of iconography the painter could have given a more psychological cast to his interpretation of the image of Armida, highlighting the fact that she was capable of enticing the knight with the force of her gaze, the essence of her psychic powers. Instead, Boucher limits the witch's gifts to her physical beauty, while her expression hovers between pleasure and reluctance. The sole source of attraction is Armida's body, the latent sexuality of which is revealed by the generous curve of her thighs and her position as she reclines on the couch, legs parted, surrounded by a quantity of swirling drapery through which peep plump wicked-looking little cherubs. The greyish colour too, sometimes sombre in tone, with a few vague touches of sky-blue, emphasizes the atmosphere of sensuality which now prevails over mental forces and the direct intervention and control of the devil and his supernatural powers.

We owe the original creation of the lascivious sorceress or witch to the courtly literature of Matteo Maria Boiardo, which was later perfected by Ariosto and Tasso. For example, the sorceress Alcina, the epitome of lust and vice, appears in the poem *Orlando innamorato*, and Ariosto tells us that it is with physical and sentimental pleasures that Alcina lures Ruggiero in *Orlando furioso* (VII, 29, 7-8). Alcina entices, bewitches and seduces Ruggiero (see the painting by Dosso Dossi,[22] c. 1525, in the National Gallery in London) who then learns from Bradamante the value of true beauty and realizes that this charmed seduction is an illusion which conceals what is most hideous, and indeed, it is only after Bradamante's intervention that Ruggiero sees the lovely witch as her real self, an unpleasant toothless old hag.[23]

The Enlightenment brought an end to any surviving doubts concerning belief in the daughters of Satan with studies and essays which led phenomena once regarded as supernatural to be looked on in terms of mental disturbance or sickness. A forerunner in this field was Lodovico Antonio Muratori who, in 1745, published a work entitled *La forza della fantasia umana* (The Power of Human Fantasy) in which he discourses on the imaginative power capable of creating grandiose illusions and superstitions. Credulity and simplicity, moral codes and eccentric behaviour had all contributed to creating the picture of an unfortunate woman, guilty solely of failing to restrain her overwhelming physical urges. If the term deviation was used at all it was now understood as a deviation provoked by purely human, earthly causes and not by supernatural powers.[24]

Girolamo Tartarotti makes an even sharper attack on the shallow nature of the human mind in his treatise *Congresso notturno delle Lammie* (Nocturnal conclave of witches), published in 1749 though ready for printing by 1747. For Tartarotti the whole witch phenomenon and the idea that they created spectres of all kinds, hallucinations, dia-

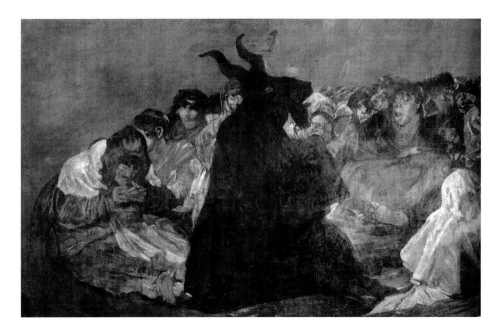

62. Francisco Goya, *The Great Goat*, or *The Witches'*
Sabbath, 1821-1823, Prado Museum, Madrid.

bolical covens and terrible human disasters was pure imagination. The writer states that the witch is a supreme example of a woman who is dissatisfied, needy, frustrated or unhappy, besides being little versed in employing her powers of reason. Witches, according to Tartarotti, are "…carried away by powerful emotions, such as rage, love and envy, which they find difficult to curb; thus they easily accept them as real and … they are shy, mischievous, unstable, curious, weak and credulous and in consequence they are easily deceived…"[25] Tartarotti supports his views on witches with reasoned observations which stress the weakness of human nature and its propensity to make a mystery out of what it cannot explain in order to make it conform to common moraes. Muratori's speculations, and Tartarotti's more thoughtful arguments, would suggest that the witch's only guilt lay in her fragility, in her emotional and sensitive nature, in her ability to enjoy life to the full, or to scorn it when troubled with black moods. There is nothing superhuman about this woman we are told and her only vice is referred to either as a sickness or a form of social disturbance which should be studied, understood and cured. Torture was now considered less acceptable than a witch's anti-social behaviour.

Only the work of a great master like Francisco Goya (1746-1828) could so perfectly express the rational and logical reaction to the concept which had held sway for so long during the *Ancien Régime*. The series *Los Caprichos* published in 1797, originally conceived of as *Dreams*, are a series of etchings illustrating some of the darker aspects of human existence (death, war, old age and sickness, real and imaginary monsters, the

Sabbath, witches, etc.) and they clearly express the disgrace and shame which form the basis of prejudice and superstition, both sparked off by the weight of an age-old religious and political tradition, the despotism and obscurantism of the Catholic Church.[26] These are scenes which illustrate dark events, not observed and studied with the eye of a scientist but by a man of traditional culture whose learning was based on the Bible, albeit without the close attention involved in strict religious observance.

In these scenes Goya depicts the vagaries of the imagination and its tendency to generate misunderstandings rather than certainties. The artist sought to denounce the spiritual anti-world which, in the absence of logic, becomes an impassioned concrete reality. The first image in the dream series must be the etching entitled *Monsters are generated when reason sleeps* (now n. 43) which, as we have just said, illustrates the idea that in the absence of a system of reason, dream and fantasy become irreal disquieting presences to which their sleeping creator falls unconscious victim. Scenes involving witchcraft and the supernatural appear more frequently after Folio 43 and take the form of an attack on the clergy, which remained blind to the purely natural character of the phenomenon.

One of these scenes depicts a victim of the Inquisition (fig. 60) wearing the pointed hat of the condemned, in this instance for the practice of magic. The figure is depicted seated awaiting the sentence of death, while along the bottom runs the inscription: "Aquellos polbos" (that dust) which comes from the popular Spanish saying "From that dust comes this mud". With this image Goya aimed, on the one hand, to show his disdain for the whole activity of the Inquisition as a reflection of ignorant superstition (fig. 61), and, on the other, to refer to a specific event which took place in 1784 when some witches accused of selling magic potions were exposed to public ridicule before being imprisoned.

A painting which provides an even better example of what we have described above is entitled *The Great Goat* (fig. 62). The enormous beast is surrounded by a group of haggard old women, entranced by this manifestation of evil which, in obedience to the new spirit of the Enlightenment which extolled reason as expressed by the *philosophes*, is shown entertaining the witches not with eros but with the power of the word.[27] As with the etchings forming *Los Caprichos*, for Goya this work reflected the deep-rooted superstitions which were still widespread in Spain in the mid-eighteenth century, together with the commonly held view of women as embodiments of seduction, carnality and magic practices. In the Basque countryside women were considered the very essence of deception, perfect examples of the enchantress, a lower species of witch capable of leading man to perdition, if not of actually joining forces with the devil. Goya was bold enough to paint this image of a woman when, in 1800, he produced a work full of openly perverse and disquieting sensuality, provoking a scandal and the censure of the Inquisition: the staggering *Maja desnuda*, now in the Prado Museum in Madrid.

1) The 'trial by water' consisted in putting a noose attached to a large stone around the neck of a presumed witch. If she floated when put in the water this was proof of the presence of Satan; otherwise, by drowning, the woman's soul was shown to be free of any form of Satanic possession.

2) J.-M. Sallmann, *Le streghe amanti di Satana* [Paris 1987], Milan 1995, pp. 107 108.

3) In 1586 a Bull condemning all forms of astrological prediction was promulgated by Pope Sixtus V.

4) Johann Weyer published the volume *De praestigis daemonum ac incantartionibus ac veneficiis* in Basel, which describes those suspected of witchcraft as nothing but sick women in need of medical care (cf. J.-M. Sallmann, *Le streghe*, cit., p. 109).

5) We know little of his life. Born in Milan at the end of the sixteenth century he became a monk in the Order of Sant'Ambrogio ad Nemus and, as an expert on witchcraft, was summoned to Clèves in 1605 for the trial of Duke Willliam III. He died in 1640, probably in Milan.

6) S. Abbiati, *Francesco Maria Guazzo*, in A. Abbiati et al., *La stregoneria*, cit., p. 270.

7) *Ibidem*, p. 271.

8) *Ibidem*. The passage from *Compendium maleficarum in tres libros distinctum ex pluribus per fratrem Franciscum Mariam Guaccium, mediolani apud haeredes August* is taken from the second edition, published in Milan in *Arsario: angelo ribelle, principe delle tenebre, seduttore...*, edited by A. Cerinotti, D. Sala, Colognano ai Colli 2000, p. 80.

9) *Ibidem*, p. 272.

10) The doctor in question was under the protection of the ruling Anne of Austria. Moreover, after the minister Colbert's reform of the penal code (begun in 1665 and brought to completion in 1670 with the grand decree on penal procedure) witchcraft no longer featured in the penal code.

11) The story of Catherine Deshayes is summarised in *Il diavolo. L'avversario: angelo ribelle, principe delle tenebre, seduttore...*, edited by A. Cerinotti, D. Sala, Colognano ai Colli 2000, p. 80.

12) M. Centini, *La stregoneria*, Milan 1995, p. 104.

13) *Ibidem*, p. 105.

14) *Ibidem*, p. 107.

15) G. Dall'Olio, *La caccia alle streghe: tre secoli di roghi*, in 'La civiltà del Rinascimento', II, n. 6, June 2000, p. 30.

16) R. Spinelli, *Filologia e 'licenze' nella traduzione figurativa della* Gerusalemme liberata: *il caso fiorentino*, in *L'arme e gli amori. La poesia di Ariosto, Tasso e Guarini nell'arte fiorentina del Seicento*, edited by E. Fumagalli, M. Rossi, R. Spinelli, Livorno 2000, pp. 53-55ff.

17) On the artistic merit of the work of Vanni and others who depicted the sorceress Armida see: R. Spinelli, *Filologia e 'licenze' nella traduzione figurativa della* Gerusalemme liberata: il caso fiorentino, in *L'arme e gli amori*, cit., pp. 64ff.

18) On the critical and historical background to this work see the entry by E. Fumagalli, in *ibidem*, pp. 195-196.

19) Here also, for critical and historical information see R. Spinelli, in *ibidem*, p. 190.

20) For all other information cf. F. Baldassare, in *ibidem*, p. 194.

21) G. C. Argan, *Storia dell'arte italiana, 3. Da Michelangelo al Futurismo* (1968), Florence 1989, pp. 315-316.

22) We should mention another fine image of Circe-Alcina by the same artist in the Borghese Gallery in Rome.

23) P. Castelli, *Circe e le altre*, 'Art e Dossier', IX (1994), n. 89, p. 24.

24) S. Abbiati, *Lodovico Antonio Muratori*, in A. Abbiati et al., *La stregoneria*, cit., pp. 280-281. For biographical details on this author see pp. 369-370.

25) An extract of Tartarotti's work appears in S. Abbiati, *Girolamo Tartarotti*, in *ibidem*, p. 309. For information on the writer see pp. 370-371.

26) J. Batiele, *Goya, il sangue e l'oro*, Milan 1993, pp. 136-138.

27) This interesting interpretation is proposed by F. Jiménez Del Oso in his book entitled *Streghe. Le amanti del diavolo*, Milan 1995, pp. 138-139.

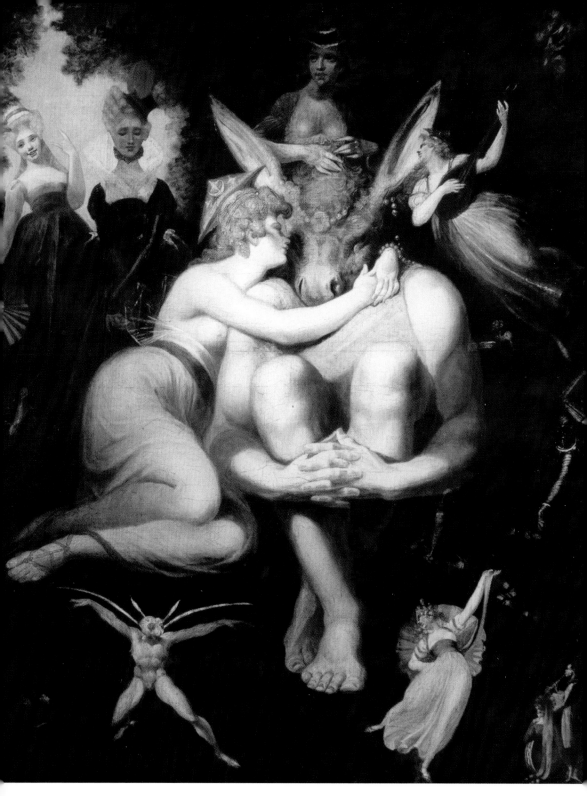

63. Heinrich Füssli (Henry Fuseli), *Titania awakes surrounded by the fairies in her retinue, and tenderly embraces Bottom*, 1793-1794, Kuntshaus, Zurich.

The Nineteenth Century and the Return of Medusa

In contrast to what had transpired in the previous century, Romanticism now revived the image of a witch based on the Medusa model. Throughout northern Europe, especially in Germany, this particular iconographic prototype was to re-emerge in major works which are reminiscent of the figurative scenes appearing in Medieval art, restored to life by the love of the 'sublime' (horrific and fantastical) which was enjoying renewed success and influence as a reaction to the Enlightenment.

A reassessment of the historical and iconographic fabric of the 'Dark Ages' led to the reintroduction of the successful stereotype of the ugly, skinny crone, sometimes old, dirty, and threadbare to boot (on the pattern of the works of Bosch, Bruegel, Memling, Van der Weyden, Metsys, and others), who terrified all who spoke to her or even simply encountered her. This figure of Medusa seems undoubtedly to have held the stage in the artistic world, even if the Lamia model continued to survive alongside her, and she recovered the compelling allure which made such a strong impression on the viewer towards the end of the nineteenth century with the advent of Art Nouveau, and she remained firmly ensconced through the twentieth century and up to the present day. The only exception occurred during the 1970s when she had a consolidating effect on the established feminist movement.

The reasons for this iconographic *volte face* lie in the political and historical pattern which was emerging throughout western Europe, a pattern which made a clean break with the social and ideological ideas of the Enlightenment. The Congress of Vienna, the concomitant defeat of Napoleon at the battle of Waterloo, the restoration of the monarchy, the Holy Alliance and the spread of religious fervour, a natural outcome of resistance to eighteenth-century rationalism, all had their effect on the onset of the new era, which was also marked by the recognition of the old sovereign states, giving rise to a search for popular early models which formed part of more recent history.[1] This led to a revival of interest in the Medieval period, and a re-evaluation of the myths which formed part of the original baggage of German folklore, including elves, witches and sorcerers, goblins, cunning woodland demons and fairy-tale wonders of all kinds. A perfect example is offered by the Grimm brothers whose tireless research resulted in a vast collection of fairy tales, with the scope of establishing the first dawnings of German history.

Germany was the birthplace of the Romantic movement, which upheld the value of sentiment over reason, along a path already explored by Rousseau at the end of the eighteenth century. *La Nouvelle Heloise* is an epistolary romance in which the sentiment of love covers a whole world of hidden meanings of great cognitive significance, the lat-

ter entangled in the dead zone of what we call instinct, within which reside, and explode, the finer subtleties of passion, energy, insight, illumination and love. At almost the same time the Gothic novel appeared, full of ghosts and hauntings, supernatural events and generally disquieting occurrences. These include the works of Horace Walpole (*The Castle of Otranto*, 1764) and Anne Radcliffe (*The Mysteries of Udolpho*, 1794, *The Italian*, 1797). In Germany, the circle in Jena (composed of Friedrich Schlegel, August Wilhelm Schlegel, Karoline Michaelis, and Friedrich von Hardenberg, known as Novalis) elaborated a theory which concerned the sentiments, art, the absolute and the infinite. Germany gave birth to Idealism, a philosophical school which held the idea to be superior to the reality on which it is dependent as its rightful and inevitable consequence. The father of this movement was Johann Gottlieb Fichte, who stated that the absolute, abstract and consciously thinking Ego created the Non-Ego, the world, beings, inhabited by finite Egos which operate in the earthly sphere creating other Non-Egos in order to confront them,[2] a kind of antithesis between perfection and imperfection, a clash between good and evil, a desire to approach the absolute as a consuming longing for eternity, beyond known time and space. These ideas provided the necessary stimulus for those who were to continue to explore the various channels of this subject, the unconscious and the emotions, forces capable of immense aesthetic creations, organs of consciousness. These new views led to the emergence of a new literary genre which included: *Frankenstein* (1818) by Mary Shelley, *Dracula* (1897) by Bram Stoker, the tales of E. T. W. Hoffmann and the horror stories of Edgar Allan Poe, full of ghouls, ghosts and blood-sucking vampires from some terrifying mysterious other world, come to bring torment to the lives of men.[3]

In this cultural climate it was inevitable that the image of the witch also changed, and in particular the lovely Venus who prevailed in neo-Classical times. Indeed, she re-emerged as a creature of commanding, superhuman psychic force. During the nineteenth century the lovely Lamia ceased to exist and her ashes gave birth to the terrifying Medusa. The eighteenth century marked the official end of the persecution of witches as a social evil that had to be extirpated (hence the reduction in number and importance of treatises written *contra striges*). However, this did not mean that images of witches ceased to intrigue and, indeed, in a resurgence of taste for the Medieval and the various streams of neo-Gothic art, a new aesthetic emerged, derived exclusively from the fantasies of the past.

Before investigating the reason for some cornerstones of this new image, we should mention the prevailing taste for commanding, ghostly and supernatural beings. The theory of the being as a thinking and creative ego, as asserted by the philosophy of Idealism, encouraged the taste for the supernatural in the arts, and indeed superhuman power became a condition of beauty. This interpretation was in itself a reality in the previous century, although relegated to the love of the sublime. In the late sixteenth century a process of re-evaluation had already begun in the wake of the pseudo-Longinus's treatise, and during the eighteenth century this was to be taken up again and

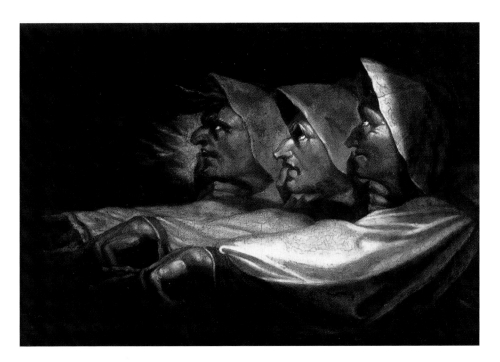

64. Heinrich Füssli (Henry Fuseli), *The Three Witches who appeared to Macbeth and Banquo*, 1783, Kunsthaus, Zurich.

reconsidered in depth in the remarkable essays of Edmund Burke and Immanuel Kant. Burke's (1729-1797) analysis in his 1756 essay entitled *A Philosophical Enquiry into the Origin of our Ideas of the Sublime and the Beautiful* (expanded and updated in 1759) sets out to discover the principles which are common to all mankind, principles which lead to judgements of taste, goodness or otherwise, concerning the object under examination. Beyond the ideas supplied by the senses, the mind has imagination, the ability to represent images of things in the order and manner in which they are perceived by the senses, or according to a different pattern conceived by the imagination itself.[4] The imagination is the sphere of pleasure and pain and this effects all men equally. After perception of the exterior object (whether man-made or natural beauty), the shaping of the immutable concepts of perfection, usefulness, arrangement and ornament make any hasty judgement (immediate and related to impulse) a complete theoretical-aesthetic judgement. In discussing why a subject prefers one thing to another, Burke's study seeks to make a strict definition of the distance that exists between pleasure and pain, both being accorded a positive character. The former is neither connected nor inspired by the disappearance of the latter since, for this philosopher, the passing of pain does not necessarily lead to a feeling of pleasure. Instead, pleasure is dependent on admiration of something which fills us with wonder, and only love (freed of mere desire) can amaze, stun and lead the subject to serene admiration.

Burke uses the word 'delight' to describe the sensation which accompanies the passing

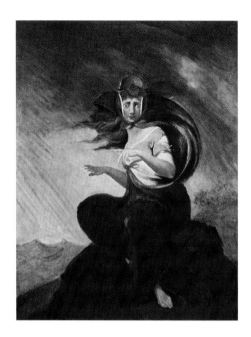

65. Heinrich Füssli (Henry Fuseli), *The Madness of Kate*, 1806-1807, Goethe Museum, Frankfurt.

of pain, and 'pleasure' to describe the kind of physical well-being (expressed by relaxation of the muscles, slow breathing, half-closed eyes, parted lips, drooping head and languorous gaze) which is the result of love, understood as a forceful movement towards what is attractive and beautiful.[5] On the other hand, everything that gives rise to feelings of terror, danger or the idea of pain is a source of the sublime (this argument emerged particularly strongly following the seventeenth-century translations of the treatise by the pseudo-Longinus), one of the strongest emotions experienced by man when confronted by uncontrollable forces, or vast open spaces which stun the imagination.[6] Beauty, on the other hand, is born from the vision of what is measured; it lies in the formal synthesis of things which are elegant, charming and finely polished. These categories are obviously are very different from the Classical views on beauty of the Platonic and scholastic school.[7] However, consideration of Burke's 'delight' forms a link with the images of the ghostly witch we are about to examine. Indeed, these disquieting figures delighted a public that was increasingly willing to be shocked and horrified in the hope of experiencing the extreme emotion of catharsis. The discovery of a new art form, no longer obedient to the rules of Classical proportion or symmetry, led the more daring fringe of artists and intellectuals towards outlandish forms of expression and favoured caricature and stylistic exaggeration. The handsome limbs of the neo-Classical style were replaced by more abstract representations, 'diachronic', and therefore sublime, or, in truth, startling, disturbing, excessive and sometimes horrifying.

Immanuel Kant (1724-1804) saw the experience of beauty as a purely subjective pleasure, a free and natural activity sparked off by the play between the imagination and the

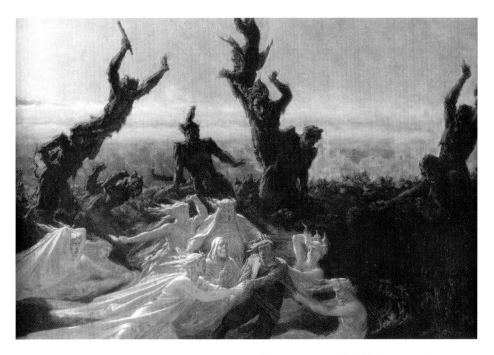

66. Yann Dargent, *The Night Laundresses*, 1861, detail, Musée des Beaux Arts, Quimper.

intellect. In his *Critique of Judgement* (1790) he explores sentiment as the faculty with which man portrays the world in finite terms. In this work Kant does not examine beauty alone as an aesthetic category, he also devotes some space to an analysis of the 'sublime' as the outcome of the perception of what is excessive and immeasurable in various ways, the horrific, solemn, terrible or tragic. The sublime is born of the representation of what is without limit or measure and is revealed in two modalities: the 'mathematical sublime' and the 'dynamic sublime'.[8] The former concerns the sentiment which emerges when the subject is faced with disproportionately large and powerful works or natural forces which cause him to experience two distinct states of mind: the displeasure of the imagination and the pleasure of reason. Kant cites the examples of the nebula, the galaxies and the Milky Way. Faced with such infinity the subject feels regret because his imagination is held in check, unable to equal or grasp what is before him; at the same time, great pleasure is created by the fact that reason succeeds in rising above simple physical perception to the concept of the infinite. Hence, infinite dimensions appear finite and small by comparison with the spiritual grandeur of our powers of reason; this in itself contains the idea of the infinite (superior to any perceptible reality) reawakened by the vision of perceived infinity.[9] On the other hand, the dynamic sublime is a sentiment created by the perception of natural forces, seen by us as warring, perpetually indomitable and obsessionally combative. When faced with devastating storms or disastrous volcanic eruptions the individual, being too small,

experiences displeasure, followed almost immediately by pleasure at the extraordinary natural spectacle.[10] To the philosophical mind the 'extraordinary' acquired a highly stimulating value. Indeed, after this period European culture showed a preference for all that was concerned with the accidental, the artistic *unicum*, which found expression in depictions of miraculous events, spiritual symbolism, or dark images of evil.

The ideas of Burke and Kant undoubtedly influenced the work of those artists who were most *au fait* with the new demands of modernity and the growing taste for the irrational. One example was the painter Johann Heinrich Füssli (later Henry Fuseli, 1741-1825) who was strongly influenced by Burke's essay concerning the question of the power of emotions aroused by danger and fear, or by any emotional response sparked off by terrifying imagery. As Orietta Rossi Pinelli[11] rightly points out, as early as 1764, before leaving Germany to settle in London, Füssli was a follower of the pre-Romantic 'Storm und Drang' (Storm and Stress) movement, the objective of which, by 1776, was to counter Kant's finite reason with infinite faith, a means of gathering what remains inaccessible, the experiential beyond.

Between 1793 and 1794 Füssli painted *Titania awakens surrounded by the fairies in her Retinue*. This painting, in the Kunsthaus in Zurich (fig. 63), depicts Titania warmly embracing the figure of Bottom, portrayed with the head of an ass. This slightly disturbing image is in perfect accord with the sentiment of the sublime and the viewer is struck by the animalesque, almost gloomy atmosphere which is conveyed by this gentle display of passion. The central pair of figures, consisting of a glamorous scantily clad woman fondly embracing a friendly giant, half man and half ass, has a startling effect. The artist has portrayed Bottom as a gentle lovable monster who is even fondled by the fairies which encircle the central pair. The fairies are not half-clad like Titania but elegantly attired like ladies going to a ball: they no longer have to flaunt their naked bodies to be exciting and charismatic for now it is simply their spiritual and ethereal forces which prevail. Their appeal lies in their lithe and charming forms and their strong but delicate features. This is exemplified by the fairy appearing over Bottom's head whose keen and penetrating gaze is an expression of her psychic powers, and certainly suggests nothing of a voluptuous nature.

The painter's desire to give form and expression to a woman's psyche (whether witch or fairy) can also be seen in a drawing in sanguine entitled *The Fairie Queen appearing to Prince Arthur* (c. 1769), from Edmund Spenser's poem *The Fairie Queen*. Indeed, we notice that the woman who appears to the protagonist in a dream has no sensual overtones, although she is portrayed as an attractive young girl. The scene's dramatic intensity evolves inside the circle created by the woman's swirling cloak and is a force, as we are made aware, created by the power of her mind. Moreover, it is obvious that this painter liked to depict the more typically cerebral aspects of his female characters. We have only to look at a work he painted in 1783 entitled *The Three Witches Appearing to*

67. William Holman Hunt, *The Lady of Shalott*, 1886-1905, Wadsworth Athenaeum, Hartford.

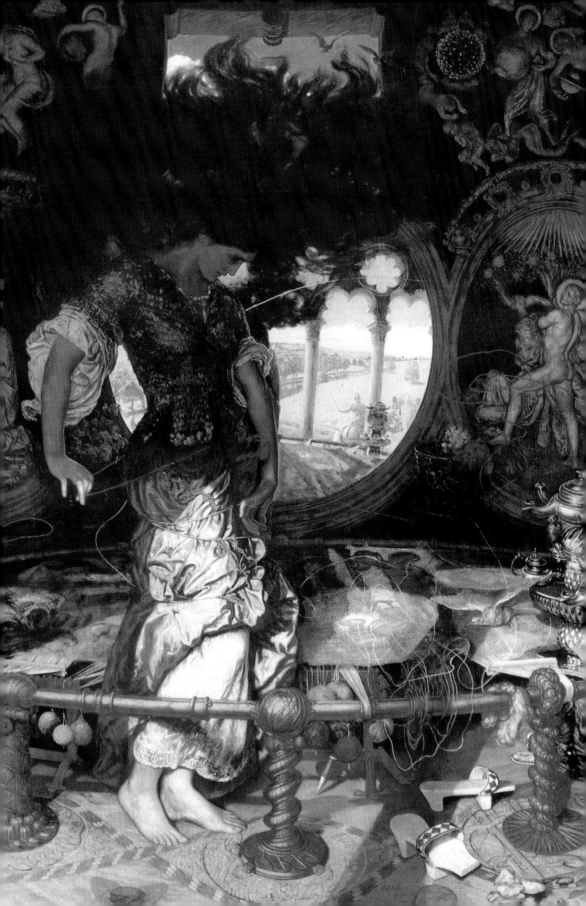

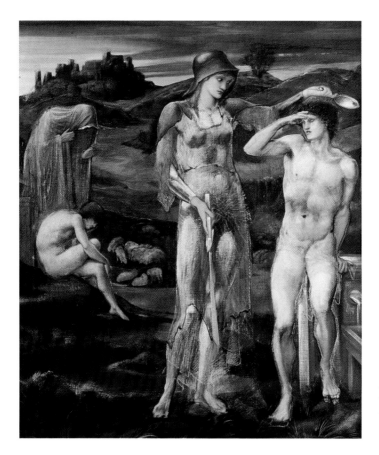

68. Edward Burne-Jones, *Perseus is Appointed*, from *The Perseus Cycle*, 1885-1898, Staatsgalerie, Stuttgart.

Macbeth and Banquo (fig. 64) portraying three startling old witches of the Medusa type, with frightening sullen gazes, gaping mouths and pendulous tongues. Another example is his 1783 painting *Lady Constance, Arthur and Salisbury* (Smith College Museum of Art, Northampton, Mass.)[12] which shows the woman, obviously the protagonist of the scene, in a mood of thoughtful concentration, while the other two figures are portrayed as absent and relaxed. In contrast to this pensive young woman is the beautiful whirling figure of *The Madness of Kate* (fig. 65) whose haunted expression makes her stand out with startling effect and, on close observation, gives the viewer the impression that her eyes communicate all the impassioned torment of her mental turmoil.

The space devoted to scenes of witchcraft in *Macbeth* reflects the importance of the earlier Medieval beliefs in diabolical practices which were to continue to influence a sizeable body of works of art. One example is the work of the French painter Théodore Chassériau (1819-1856) and what is of particular interest here is his painting of the witches appearing to Macbeth and Banquo, who asks: "…What are these, / So withered, and so wild in their attire, / That look not like the inhabitants o' the earth, / And yet are on't?…". [13] Chassériau's painting of the three witches (Musée d'Orsay, Paris), apart from faithfully abiding by the text, reveals the particular iconographic fashion of

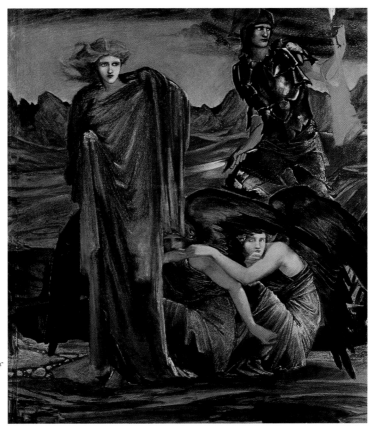

69. Edward Burne-Jones, *The Discovery of Medusa*, from *The Perseus Cycle*, 1885-1898, Staatsgalerie, Stuttgart.

the period, the witch being presented as a powerful and wicked supernatural being and the ugliness of her body being a formal expression of this. We see the re-emergence of Medusa even more strongly in these three women and she is presented in three outstanding and truly unique variations. Once again, it is the mixture of the fairy-tale and the ghostly which provides further confirmation of the new character of the witch's iconography. Apart from startling the viewer, this image awakens feelings of fear and consternation, in accord with theories of the sublime which also found literary expression in the form of fairy stories and imaginative tales with a Medieval flavour.

Yann Dargent's painting in the Musée des Beaux-Arts in Quimper (fig. 66), *The Night Laundresses*, portrays a group of witches devoid of all physical attributes except for the haunting gaze of their wild staring eyes. These ghostly figures are evil spirits and thus their powers are concentrated in their wicked minds, which are powerful enough to lead men astray. Any physical detail is hidden behind a barely defined cloak and their faces, if not ugly, are fleshless and all that emerges of the Medusa model is the skull housing the eyes which can corrupt and bewitch, torture and kill.

We will draw an end to this brief survey with some late nineteenth-century works which are of interest from an iconographic point of view, produced by the Pre-

Raphaelites, the school of painters formed in London in 1848,[14] whose manifesto for their artistic activities declared their opposition to academic art, in particular the works of the mature Raphael, and advocated a return, in terms of morality and subject matter, to the more naturalistic art of the 'primitive' painters, with subject matter frequently derived from Classical or Biblical sources and coloured with impassioned and amorous elements.

In the case of some artists, the symbolist and introspective character of their paintings favoured a choice of themes derived from literary sources or from Medieval history. One of these was William Holman Hunt (1827-1910) with his *Lady of Shalott*, painted between 1886 and 1905 (fig. 67), which is reminiscent of the romantic atmosphere of the 1857 illustrations to Tennyson's *Poems*. In this painting, a magical witch-like quality is well conveyed by the phantasmagoric nature of the lady's hair, which, according to long-established tradition, took the painter three years to complete. This is a woman in the Medusa mode with flowing locks and, though depicted in profile, a keen gaze. She expresses a woman's strength of purpose, nicely combined with the pleasing sensuality of her Bacchic dance which reveals that she uses her body as a vehicle of attraction, coercion and passion. The warm sensuality of her form is enhanced by her gleaming silken garments which are drawn back over her hips with impressive effect, lending a strongly erotic charge. Skeins and threads, bobbins and yarns and pieces of tapestry are scattered all around the room like evil charms.

This turn-of-the-century Medusa leans towards the Lamia model but a only few years earlier Edward Burne-Jones (1833-1898), whose work is an example of Classicism blended with the irrational Medievalist revival, had produced (between 1885 and 1898) the *Perseus* series (figs. 68, 69) in which Medusa, the prime exemplar of the enchantress who conquers with the power of her gaze, as controlled by her mind, is portrayed on traditional lines as a woman who offers no winning sensual charms but is instead full of great psychic charge. In the scene *The Discovery of Medusa* (fig. 69) what captures the attention is not just her lean body, clad in a grey tunic of drapery, but her cool waxen face with large encircled eyes, fair hair ruffled by the wind and fierce evil gaze. This is also true of another scene in this cycle entitled *The Fateful Head* (fig. 70), the staging of which enabled the painter to avoid depicting the true horror of her terrible features. Once her head has been cut off, her life brought to an end, her power to do harm dies with her. Indeed, we see here how the painter depicted the now lifeless face with the gentle seductive expression of someone asleep who, on waking, might give birth to the voluptuous and passionate Lamia, full of sensuality and physical charms. In her charmed and peaceful death this Medusa would seem to herald this rebirth since at the death of one the other rises from the ashes like a reflection or a phoenix, no less terrible a figure but undoubtedly outwardly sensual and captivating.

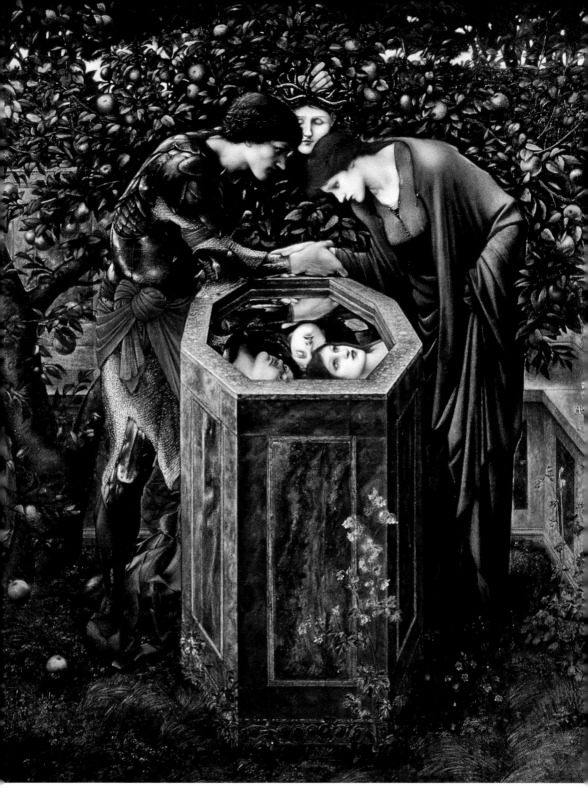

70. Edward Burne-Jones, *The Fateful Head*, from *The Perseus Cycle*, 1885-1898, Staatsgalerie, Stuttgart.

1) E. Renan, *Che cos'è una nazione?*, Milan 1919; R. Romeo, *Italia mille anni. Dall'Italia Feudale all'Italia moderna ed europea*, Florence, 1981; J. G. Fichte, *Reden an die deutsche Nation*, 1807-08 (*Addresses to the German Nation*)

2) On Fichte's 'absolute Ego' see: M. Ivaldo, *Fichte. L'assoluto e l'immagine*, Rome 1983; C. Cesa, *Fichte e l'idealismo trascendentale*, Bologna 1992; G. Rotta, *L'idea di Dio'. Il pensiero religioso di Fichte*, Genoa 1995.

3) Other works which were influential on the idealistic stream of the Romantic movement include: *The Sorrows of Young Werther*, by Johann Wolfgang von Goethe, (*Die Leiden des jungen Werthers*, 1774), and *René* by F. R. de Chateaubriand, published in 1802.

4) Edmund Burke, *Philosophical Enquiry into the Origin of Our Ideas of the Sublime and Beautiful*, first published 1756.

5) *Ibidem.*

6) *Ibidem.*

7) *Ibidem.*

8) Immanuel Kant, *Kritik der Urteilskraft*, 1790 (*Critique of Judgement*).

9) *Ibidem.*

10) *Ibidem.*

11) O. Rossi Pinelli, *Füssli*, 'Dossier Art', n. 126, Florence 1997, pp. 16-17.

12) *Ibidem*, p. 32.

13) William Shakespeare, *Macbeth*, Act I, Scene 3.

14) For a concise account of the work of the Pre-Raphaelites see: M. T. Benedetti, *I Preraffaelliti*, 'Dossier Art', n. 5, Florence 1986.

15) *Ibidem*, p. 38.

Bibliography

SOURCES

Ader G., *Enarrationes de aegrotis et morbis in Evangelio*, Tolosa 1623

Agobardi lugdunensis opera omnia, Turnholt 1981

Agostino, *Opera Omnia*, Roma 1965

Albertino A., *Malleus daemonum*, Verona 1620

Albizzi F., *Risposta all'Historia della Sacra Inquisizione composta già dal R. P. Paolo Servita*, s.l. 1639

Alciato A., *Parergon iuris libri XIII*, Lyons 1544

Alessio Piemontese, *De' secreti*, Venezia 1683

Alighieri D., *Inferno*

Anania G. L., *De natura daemonum*, Venezia 1589

Apuleius, *Metamorphoses*

Aristotle, *De Anima*

Arnaldo da Villanova, *De Maleficiis*, Lyons 1509

Baluze E., *Capitularia regum francorum*, Paris 1677

Baroni C., *L'impotenza del demonio di trasportare a Talento per l'aria da un luogo all'altro i corpi umani*, Rovereto 1753

Benvenuti G., *De daemoniacis dissertatio*, Lucca 1776

Bernardino of Siena, *De idolatriae cultu*

Id., *Le prediche volgari*

Binsfeld P., *Tractatus de confessionibus maleficurum et sogarum*, Trier 1591

Bodin J., *De la démonomanie des sorciers*, Paris 1581

Id., *De magorum Demonomania seu Detestando Lamiarum ac Magorum cum Satana commercio*, Frankfurt a. M. 1603

Bonelli B., *Animavversioni critiche sopra il notturno congresso delle Lammie, per modo di lettura indiritte ad un letterato.S'aggiunge il discorso di P. Gaar sulla strega di Salisburgo e il compendio storico della stregoneria*, Venezia 1571.

Bonifacio di Magonza, *De abrenuntiatione in baptismate*, in J. P. Migne, *Patrologia Latina*, Paris 1888

Borromeo F., *De pestilentia quae Mediolani anno 1630 magnam stragem adidit*, 'Archivio storico lombardo', Milano 1903

Bouget H., *Discours des sorcières*, Paris 1603

Brognolo C., *Alexiacon, hoc est opus de maleficiis*, Venezia 1714

Id., *Manuale exorcistarum et parochorum*, Venezia 1714

Burchard of Worms, *Corrector et medicus*, in J. P. Migne, *Patrologia Latina*, CXL, 973-976

Id., *Liber decretorum (Decretum)*, in J.P. Migne, *Patrologia Latina*, CXL, 831-854

Burke E., *Philosophical Inquiry into the Origin of Our Ideas of the Sublime and Beautiful*, London 1756

Campanella T., *Del senso della cose e della magia*, Frankfurt a. M. 1620

Canale F., *De' secreti universali*, Venezia 1613

Id., *Del modo di conoscere et sanare i maleficiati*, Brescia 1622

Cardano G., *De rerum varietate*, Basel 1545

Carena C., *Tractatus de Officio Sanctissimae Inquisitionis*, Cremona 1655

Carli G.R., *Intorno all'origine e falsità della dottrina de' maghi e delle streghe*, Rovereto 1749

Cattani da Diacceto F., *Discorso sopra la superstizione dell'arte magica*, Firenze 1567

Cesalpino A., *Investigatio peripatetica o daemonum investigatio*, Florence 1567

Ciardi P. M., *Ritualis romani documenta de exorcizandis obsessis a daemonio*, Venezia 1733

Codronchi G. B., *De morbis veneficis ac veneficiis*, Venezia 1595

Dante, *Inferno*.

De Becchi G., *De potestate spiritum*, Venezia 1450

De Casini S., *Quaestio lamiarum*, s. l. 1505

De la Torre R., *Tractatus de potestate Ecclesiae coercendi daemones circa absessos et maleficiatos*, Köln 1629

De Lancre P., *L'incredulité et méscréance du sortilège plainement convaincue*, Paris 1622

De Lille A., *Contra haereticos sui temporis, in Migne*, Patrologia Latina, ccx, 366

Del Rio M., *Disquisitiones magicarum libri sex*, Köln 1720

Della Porta G. B., *Magiae naturalis, sive De miraculis rerum naturalium libri III*, Napoli 1558

Ebendorfer von Haselbach T., *De decem praeceptis*, s. l. 1439

Erasto T., *Dialogi de potestate maleficarum*, Genève 1579

Eymerich N., *Directorium inquisitorium*, s. l. 1503

Fichte J. G., *Discorsi alla nazione tedesca*, 1808, Torino 1965

Gambiglioni A., *Tractatus de maleficiis*, Köln 1599

Garzoni T., *La piazza universale di tutte le professioni del mondo*, Venezia 1592

Giordano da Bergamo, *Quaestio de strigis*, s. l. 1470

Gómez D., *Iugum ferreum Luciferi*, Valentia 1676

Grillando P., *De sortilegiis eorumque poenis*, Venezia 1556

Grimaldi C., *Dissertazione in cui s'investiga quali siano le operazioni che dependono dalla malia diabolica e quali quelle che derivano dalla magia artificiale e naturale*, Roma 1751

Guazzo F. M., *Compendium maleficarum*, Milano 1608

Gui B., *Pratica inquisitionis haereticae pravitatis*, Venezia 1321

Jacquer N., *Flagellum haereticorum fascinariorum, auctore F. Nicolao Iacquerio, et olim haereticae pravitatis Inquisitore*, Frankfurt a. M. 1581.

John of Salisbury, *Policraticus, sive de nugis curialum et vestigium philosophorum*, ed. V. V. Webb, Oxford 1909, 2 vols.

Kant I., *Critica del giudizio* (1790), edited by V. Verra, Bari 1997

Maffei S., *L'arte magica annichilita*, Verona 1754

Id., *L'arte magica dileguata*, Verona 1749

Masini P. E., *Sacro Arsenale overo Prattica dell'Officio della S. Inquisitione*, Genova 1625

Marmus J. H., *Dissertatio physica de virgula divinatoria*, München 1693

Mazzolini S., *Summa Sylvestrina*, Bologna 1514

Menghi G., *Compendio dell'arte essorcistica*, Bologna 1582

Id., *Eversio daemonum e corporibus oppressis*, Bologna 1576

Id., *Flagellum daemonum seu Exorcismi terribiles potentissimi & efficaces*, Bologna 1577

Mercuri S., *De gli errori popolari d'Italia*, Padova 1645

Migne J. P., *Patrologiae cursus completus*. Series graeca, Paris 1857

Id., *Patrologiae cursus completus*. Series latina, Paris 1844

Molitor U., *De lamiis et pythonicis mulierubus*, Reitlingen 1489

Muratori L. A., *Antiquitates Italicae Medii Aevi*, Milano 1738

Id., *Della forza della fantasia umana*, Venezia 1745

Nider J., *Formicarius in quinque libros divisus*, Köln 1443

Id., *Praeceptorium divini legis*, Basel 1481

Nietzsche F., *La nascita della tragedia ovvero grecità e pessimismo*, a cura di P. Chiarini, Bari 1992

Olaus Magnus, *Historia de Gentibus Septentrionalibus*, Roma 1555

Oliveri C., *Baculus daemonum*, Perugia 1618

Paracelsus, *De praesagiis, vaticinijs & diuinationibus sanctae, astronomica item, et astrologica fragmenta*, Basel 1569

Passavanti J., *Specchi di vera Penitentia compilato da Frate Jacopo Passavanti dell'ordine de' frati predicatori*, Firenze 1495

Passi G., *Della magica arte*, Venezia 1614

Id., *I donneschi difetti*, Venezia 1599

Pico della Mirandola G., *Strix sive de ludificatione daemonum*, Venezia 1523

Pistacchi Castelli A., *Tractatus de superstitione reorumque iudicis*, Napoli 1678

Pomponazzi P., *De naturalium effectum admirandorum causis, sive de incantationibus liber*, Bologna 1520

Ponzinibio G. F., *De lamiis*, Frankfurt, 1592.

Porri A., *L'antiodotario contro li demoni*, Venezia 1601.

Prierias S., *Summa Sylvestrina*, s.l. 1498

Prieur C., *Dialogue de la lycanthropie ou transformation d'hommes en loupes vulgairement dit loups-garous et si telle se peut faire*, Louvain 1596

Pseudo Eligio, *Indiculus superstitionum et paganiarum*, s.l. 1427

Rabano Mauro, *De Universo, in J. P. Migne, Patrologia Latina*, CXI, Paris 1852

Rategno B. da Como, *De strigibus*, Milano 1566

Raterio di Liegi, *Praeloquiorum libri, in J.P. Migne, Patrologia Latina*, CXXXVI, 157

Reginon of Prüm, *Libri duo de synodalis causis et*

disciplinis ecclesiaticis, Leipzig 1840

Samuele Da Cassine, Questione de le strie, s.l. [Pavia] 1505

Schedel H., Liber chronicarum, Basel 1493

Sinistrari L.M., Daemonialitatis expensa, Venezia 1701

Sozzini M., Tractatus de sortilegiis, Roma 1443

Spee F. von, Cautio criminalis, Köln-Frankfurt a. M. 1630

Spina B., Quaestio de strigibus, Venezia 1523

Sprenger J., Institoris H., Malleus maleficarum, Köln 1486

Tartarotti G., Del congresso notturno della Lammie, Rovereto-Venezia 1749

Torquemada A., Jardín de flores curiosas, Salamanca 1570

Tostato A., An Homines aliquando portentur a diabolo per diversa loca, in Commentaria in primam partem Matthaei, quaest. XLVII, cap. VI, Venezia 1615

Vairo R., De fascino, Paris 1583

Vespoorten G., De daemonum exixtentia, Gedani 1779

Vicecomes Z., Complentum artis exorcisticae, in Ars exorcistica, s. l. 1606

Vincenti G. M., Il mondo infestato dagli spiriti, cioè di molti effetti che cagionano i demoni nel mondo e de' suoi remedi, opera utile a tutti, Roma 1607

Vincenzo de Beauvais, Speculum historiale, Venezia 1494

Vineti J., Tractatus contra daemonum invocatores compilatus per sacrae theologiae professorem fratrem Johannem Vineti oridinis Praedicatorum inquisitorem apotolicum Carcassonae, Paris 1483

Visconti G., Lamiarum sive striarum opusculum, Milano 1490

Wecker, J. J., De secretis libri XVII, Basel 1598

Weyer J., De lamiis liber, Basel 1577

Id., De praestigiis daemonum et incantationibus ac veneficiis, Basel 1573

ESSAYS

Abbiati S., Agnoletto A., Lazzati M. R., La stregoneria. Diavoli, streghe, inquisitori dal Trecento al Settecento, Milano 1984

Adriani M., Italia magica, Roma 1970

Alaimo G., Diavoli, diavolesse e streghe, demoni e inquisitori, Ancona 1979

Albaret L., L'Inquisizione baluardo della fede? (Paris 1998), Milano 1999

Albèrgamo F., Mito e magia, Napoli 1970

Albicci G., 'Lo stregozzo' di Agostino Veneziano, 'Arte Veneta', 36, 1982, pp. 55-61

Altieri A. C., Le streghe a Benevento, Napoli 1940

Alzona M., La strega, Milano 1964

Amalfi G., Delitti de superstizione, Pisa 1911

Andersen J., The Witch on the Wall, Copenhagen-London 1957

Anglo S., Melancholia and Witchcraft, in Folie et déraison à la Renaissance, Bruxelles 1976

Ariès Ph., Duby G., La vita privata dall'Impero romano all'anno Mille, Roma-Bari 1986

Argan G. C., Storia dell'arte italiana 3. Da Michelangelo al Futurismo [1968], Firenze 1989

L'arme e gli amori. La poesia di Ariosto, Tasso e Guarini nell'arte fiorentina del Seicento, edited by E. Fumagalli, M. Rossi, R. Spinelli, Livorno 2000

Astrologia, magia e alchimia nel Rinascimento fiorentino ed europeo, in Firenze e la Toscana dei Medici nell'Europa del Cinquecento. La corte, il mare, i mercati, Firenze 1980, pp. 309-434

L'autunno del diavolo, edited by E. Corsini, Milano 1990

Bachtin M., L'opera di Rabelais e la cultura popolare del riso, carnevale e festa della tradizione medievale e rinascimentale, Torino 1979

Batiele J., Goya. Il sangue e l'oro, Milano 1993

Battisti E., L'antirinascimento, Milano 1962

Id., La civiltà delle streghe, Milano 1964

Belloni G. A., I processi stregoneschi: superstizioni e realtà, Roma 1941

Bernardelli Curuz M., Streghe bresciane, Brescia 1988

Benedetti M. T., I Preraffaelliti, 'Dossier Art', n. 5, Firenze 1986

Bernheim R., Wild Man in the Middle Ages, Cambridge 1952

Berti L., Pontormo e il suo tempo, Firenze 1993

Biblioteca magica. Dalle opere a stampa della biblioteca Casanatese di Roma (secc. XV-XVIII), Firenze 1985

Bibliotheca lamiarum. Documenti e immagini della stregoneria dal medioevo all'età moderna, Firenze 1994

Bocca C., Gli dèi della montagna, Torino 1981

Id., Processo al diavolo: esorcismo, satanismo e superstizioni nelle Alpi del XVII secolo, Torino 1993

Bolzoni F., *Le streghe in Italia*, [Bologna] 1963

Bonomo G., *Caccia alle streghe*, Palermo 1959

Bormetti M., *Al tempo delle streghe*, Milano 1964

Bortolotti A., *Streghe, sortieri e maliardi nel secolo XVI in Roma*, Firenze 1883

Bosi C., *Alfonso Tostato. Vita e opere*, Roma 1951

Boyer P., Nissenbaum S., *La città indemoniata*, Torino 1986

Brooke R. C., *La religione popolare nell'Europa medievale*, Bologna 1989

Butler W. E., *La magia. Rituali e poteri magici*, Roma 1983

Campari F. L., *Un processo di streghe in Piacenza (1611-1615)*, Piacenza s. d.

Canosa R., Colonnello I., *Gli ultimi roghi, la fine della caccia alle streghe in Italia*, Roma 1983

Id., *Storia dell'Inquisizione in Italia*, Roma 1987

Cantù C., *Gli eretici in Italia*, Torino 1867

Capitani O., *Medioevo eretico*, Bologna 1977

Carassiti A. M., *Dizionario mitologico. Le figure mitologiche della civiltà greco-romana*, Genova 1996

Cardini F., *La strega nel medioevo. Resistenza pagana al cristianesimo, condizione femminile, emancipazione sociale. Le basi del problema*, Firenze 1977

Caro Baroja J., *Le streghe e il loro mondo*, Parma 1994

Cassirer E., *Individuo e cosmo nella filosofia del Rinascimento*, Firenze 1935

Castellani C., *Le donne e il diavolo*, Milano 1963

Castelli E., *Il demoniaco nell'arte*, Milano-Firenze 1952

Castelli P., *'Donnaiole, amiche de li sogni' ovvero i sogni delle streghe*, in *Bibliotheca lamiarum* cit., pp. 35-85

Castelli P., *Circe e le altre*, 'Art e Dossier', n. 89, IX (1994), pp. 24-30

Id., *Il doppio significato. L'ostensione della vulva nel medioevo*, 'Il Gesto: quaderni di Gargonza', a cura di S. Bertelli, M. Centanni, Firenze 1995

Id., *L'immagine della strega. L'antichità classica. Le antenate di malefica*, in 'Art e Dossier', n. 85, VIII (1993), pp. 28-32

Id., *L'immagine della strega. Il medioevo. A cavallo di una scopa*, 'Art e Dossier', n. 86, IX (1994), pp. 30-34

Id., *L'immagine della strega. Il Rinascimento. Malefici da Manuale*, 'Art e Dossier', n. 87, IX (1994), pp. 26-31

Id., *Quelle immagini ambigue. L'ostensione dei genitali nella scultura romanica*, 'Art e Dossier', n. 125, XII (1997), pp. 39-42

Castiglioni A., *Incantesimo e magia*, Milano 1934

Centini M., *Animali, uomini, leggende. Il bestiario del mito*, Milano 1990

Id., *Demoni e magia nel Piemonte medievale*, Torino 1992

Id., *Il sapiente nel bosco. Il mito dell'uomo selvatico nelle Alpi*, Milano 1989

Id., *La stregoneria*, Milano 1995

Id., *Le schiave di Diana. Stregoneria e sciamanesimo tra superstizione e demonizzazione*, Genova 1994

Cesa C., *Fichte e l'idealismo trascendentale*, Bologna 1992

Clair J., *Medusa. L'orrido e il sublime nell'arte*, Milano 1989

Cittadini A., *Il costume nella storia dei popoli*, Bagnacavallo (Ravenna) 1938

Cocchiara G., *Il diavolo nella tradizione popolare italiana. Saggi e ricerche*, Palermo 1945

Cohn N., *I demoni dentro. Le origini del sabba e la grande caccia alle streghe*, Milano 1994

Coletti V., *Parole dal pulpito. Chiesa e movimenti religiosi tra latino e volgare*, Casale Monferrato 1983

Collin de Plancy J., *Dizionario infernale*, Milano 1988

Corsi D., *Dal sacrificio al maleficio. La donna e il sacro nell'eresia e nelle stregoneria*, 'Quaderni medievali' 30, 1990, pp. 297-330

Corte N., *Satana. L'avversario*, Torino 1928

Corvino C., *La grande caccia*, 'Medioevo', V, n. 2, 2001, pp. 89-113

Id., Petoia E., *Storia e leggende di Babbo Natale e della Befana. Origini, credenze e tradizioni di due mitici portatori di doni*, Roma 1999

Cosimo A. A., *Le streghe a Benevento*, Napoli 1940

Craveri M., *Sante e streghe. Biografie e documenti dal XIV al XVII secolo*, Milano 1980

Cremonesi C. B., *Le streghe*, Milano 1840

Cuccu M., Rossi P. A., *La strega, il teologo e lo scienziato*, Genova 1989

D'Alatri M., *Eretici e inquisitori in Italia*, Roma 1986

Dall'Olio G., *La caccia alle streghe: tre secoli di roghi*, 'La civiltà del Rinascimento', II, n. 6, giugno 2000

Dandolo T., *La signora di Monza e le streghe del Tirolo*, Novate Milanese 1967

Davari S., *Cenni storici intorno al Tribunale dell'Inquisizione in Mantova*, Mantova 1973

De Blasio A., *Inciarmatori, maghi e streghe di Benevento*, Bologna 1976

De Lucia S., *Streghe e diavoli a convegno*, Benevento 1952

De Maio R., *Donna e Rinascimento*, Milano 1984

Delumeau J., *La peur en Occident (XIV-XVIII siècles)*, Paris 1978

Delort I., *La vita quotidiana nel medioevo*, Roma-Bari 1989

Diables et diableries. La représentation du diable dans la gravure des XV et XVI siècles, Genève 1977

Il diavolo in pulpito. Spettri e demoni nelle prediche medievali, a cura di V. Dornetti, Milano 1991

Il diavolo. L'avversario: angelo ribelle, principe delle tenebre, seduttore, a cura di A. Cerinotti, D. Sala, Colognola ai Colli 2000

Di Gesaro P., Streghe. *L'ossessione del diavolo, il repertorio dei malefizi, la repressione*, Bolzano 1988

Id., *I processi delle streghe: stregonerie confessate nei processi del Cinquecento e Seicento e convalidate dai massimi demonologi*, Bolzano 1995

Di Nola A. M., *Il diavolo. La sindrome demoniaca sovrasta l'umanità*, Roma 1980

Id., voce *Stregoneria* in *Enciclopedia delle religioni*, Firenze 1973

Dizionario infernale, ossia esposizione della magia, dell'alchimia, della divinazione, del magnetismo e..., Milano 1985

Doni M., *Il 'De incantationibus' di P. Pomponazzi e l'edizione di Guglielmo Grataroli*, 'Rinascimento', II s., 15, 1975, pp. 180-230

Duby G., *Il cavaliere, la donna, il prete*, Roma-Bari 1982

Durand G., *Le strutture antropologiche dell'immaginario*, Bari 1972

Eliade M., *Occultismo, stregoneria e mode culturali*, Firenze 1982

Id., *Storia delle credenze e delle idee religiose*, Firenze 1980

L'erba delle donne. Maghe, streghe, guaritrici: la riscoperta di un'altra medicina, edited by N. Fedrigotti, Roma 1979

Ernst G., *I poteri delle streghe tra cause materiali e interventi diabolici*, in *Giovan Battista Della Porta nell'Europa del suo tempo*, Napoli 1990, pp. 167-197

Farinelli G., Pacagnini E., *Processo per stregoneria a Caterina de' Medici 1613-1617*, Milano 1989

Farrar S., *What Witches Do*, New York 1971

Ferraroni F., *Le streghe e l'Inquisizione. Superstizioni e realtà*, Roma 1955

Id., *Streghe o maliarde*, Ventimiglia 1973

Fiorelli P., *La tortura giudiziaria nel diritto comune*, Milano 1953

Fischer O., *Hans Baldung Grien*, München 1930

Foa A., *La stregoneria in Europa*, Torino 1980

Foglia S., *Il libro delle streghe*, Milano 1981

Id., *Streghe*, Milano 1989

Foucault M., *Storia della follia*, Milano 1980

Français J., *L'Eglise et la sorcellerie*, Paris 1910

Fumi L., *L'inquisizione romana e lo stato di Milano*, 'Archivio storico lombardo', 1910

Gabotto F., *Roghi e vendette*, Pinerolo 1898

Galli G., *Occidente misterioso*, Milano 1987

Gallini C., *La sonnambula meravigliosa. Magnetismo e ipnotismo nell'Ottocento italiano*, Milano 1983

Ganci Battaglia G., *Streghe, stregoni e stregonerie in Sicilia*, Palermo 1972

Gatto Chanu T., *Streghe. Storie e segreti*, Roma 2001

Gatto-Trocchi C., *Magia e medicina popolare in Italia*, Roma 1963

Gennep A. van, *Le origini delle leggende*, Milano 1992

Ginzburg C., *Folklore, magia e religione*, in *Storia d'Italia*, vol. I, Torino 1974

Id., *I Benandanti. Ricerche sulla stregoneria e sui culti agrari tra Cinquecento e Seicento*, Torino 1966

Id., *Il formaggio e i vermi*, Torino 1976

Id., *Storia notturna. Una decifrazione del sabba*, Torino 1989

Gollino Bontempi A., *Storia della stregoneria e dei processi alle streghe*, Milano 1972

Gostanza. La strega di San Miniato. Processo ad una guaritrice nella Toscana medicea, a cura di Franco Cardini, Roma-Bari 1989

Goya y el espíritu de la ilustración, exhibition catalogue, Madrid 1988

Graf A., *Miti, leggende e superstizioni del medioevo*, (Torino 1892-93) Milano 1986

Grafica tedesca al tempo di Albrecht Dürer, exhibition catalogue, Venezia 1964

Le grandi madri, Milano 1989

Gremmo R., *Le donne del diavolo*, Grugliasco 1978

Grignola A., *Egitto. Una grande civiltà*, Colognola (Verona) 1997

Grillot de Givry E., *Il tesoro delle scienze occulte*, Milano 1968

Grundmann H., *Movimenti religiosi nel medioevo*, Bologna 1974

Guerrini P., *Le cronache bresciane dei secoli XV-XIX*, Brescia 1922

Guiedham A., *L'ossessione diabolica*, Roma 1974

Haag H., *La credenza nel diavolo*, Milano 1976

Hans Baldung Grien, exhibition catalogue, Karlsruhe 1959

Hansen J., *Der Malleus maleficarum, seine Druckausgaben und die gefälschte Kölner Approbation von J. 1487*, 'Westdeutsche Zeitschrift für Geschichte und Kunst', 17, 1988, pp. 119-168

Harris T., *Goya, Engravings and Lithographs*, vol. II, Oxford 1964

Henningsen G., *L'avvocato delle streghe*, Milano 1990

Hertz R., *Sociologie religiose e folklore*, Paris 1928

Hind A. M., *Early Italian Engraving. A Critical Catalogue with Complete Reproduction of the Prints Described*, London 1938

Hole C., *A Mirror of Witchcraft*, London 1957

Huizinga J., *L'autunno del medioevo*, Firenze 1978

Ivaldo M., Fichte. *L'assoluto e l'immagine*, Roma 1983

Jiménez Del Oso F., *Streghe. Le amanti del diavolo*, Milano 1995

Jong E., *Streghe*, Milano 1983

Knight R. P., *An Account of the Remains of the Worship of Priapus*, London 1786

Lea H. C., *Storia dell'Inquisizione*, Milano 1974

Leproux M., *Médicine, magie et sorcellerie*, Paris 1956

Levack B. P., *The Witch-hunt in Early Modern Europe*, London-New York 1987 (trad. it. Roma-Bari 1988)

Id., *The Literature of Witchcraft*, Handen 1993

Levron I., *Le diable dans l'art*, Paris 1935

Lewis J. M., *Possessione, stregoneria, sciamanismo*, Napoli 1993

Link L., *Il diavolo nell'arte*, Milano 2001

López Rey J., *Goya's Caprichos. Beauty, Reason & Caricature*, Princeton 1953

Lorenzi L., *Devils in art. From the Middle Age to the Renaissance*, Firenze 1997

Id., *L'iconografia del diavolo: In compagnia di Lucifero*, 'Medioevo', 1, 60, 20, 1993-96, pp. 67-72

Id., *L'immagine del diavolo nella miniatura di Attavante degli Attavanti*, 'Miniatura', 5-6, 1996, pp. 67-72

Id., *Inferni e diavoli nell'arte gotica a Firenze*, 'Città di Vita', 56, 1, 2001, pp. 45-62

Id., *I mostri del lavabo di Andrea del Verrocchio*, 'Antichità Viva', XXXII, 4, 1994, pp. 43-52

Id., *La pittura di morte a Firenze al tempo dei terribili fatti del 1348*, 'Città di Vita', 50, 2, 1996, pp. 141-150

Id., *La presenza del Maligno nell'Oreficeria fiorentina del Quattrocento*, 'Antichità Viva', XXXII, 3-4, 1993, pp. 65-72

Magia nera, satanismo e stregoneria, Milano 1984.

Magia, stregoneria, superstizioni nell'Occidente medievale, edited by Franco Cardini, Firenze 1979

Mair L., *La stregoneria*, Milano 1969

Mandrou R., *Magistrati e streghe nella Francia del Seicento: un'analisi di psicologia storica*, Bari 1971

Manselli R., *L'eresia del male*, Napoli 1980

Id., *Due fenomeni di devianza nel medioevo*, Milano 1972

Id., *Magia e stregoneria nel medioevo*, Torino 1976

Maple E., *The dark world of witches*, London 1962

Martinis B., *La stregoneria*, Carnago 1995

McCall A., *I reietti del medioevo*, Milano 1987

Mende M., *Holzschnitte Hans Baldung Grien 1484/85-1545*, Nürnberg 1977

Mereu I., *Storia dell'intolleranza in Europa. Sospettare e punire*, Milano 1979

Michelet J., *La sorcière*, Paris 1862 (trad. it. Milano 1977)

Mondini A., *Girolamo Cardano, matematico, medico e filosofo naturale*, Roma 1962

Monge M., *Straordinarie avventure di dèi e di eroi*, Torino 1988

Morelli A., *Dei e miti. Enciclopedia di mitologia universale*, s.l. [Verona] 1989

Muraro L., *La signora del gioco: episodi della caccia alle streghe*, Milano 1977

Murray M. A., *Female Fertility Figures*, 'The Journal of the Royal Anthropological Institute', n. 64, 1933, pp. 93-100

Murray M. A., *The Witch-Cult in Western Europe*, Oxford 1922

Nageroni A., *Il diavolo*, Milano 1996

Nulli S. A., *I processi delle streghe*, Torino 1939

Odorici F., *Le streghe della Valtellina e la Santa Inquisizione*, Milano-Venezia-Verona 1862

Olgiati G., *Lo sterminio delle streghe nella Valle Poschiavina*, Poschiavo 1979

Panaro T., Prumeti L., *Opposizione religiosa nel medioevo*, Messina-Firenze 1976

Panizza A., *I processi contro le streghe nel Trentino*, Trento 1888

Panofsky E., *La vita e le opera di Albrecht Dürer* [1943], Milano 1967

Id., Saxl F., *Dürer 'Melancholia' I*, Leipzig-Berlin 1923

Parinetto L., *Magia e ragione: una polemica sulle streghe in Italia intorno al 1780*, Firenze 1974

Parinetto L., *Materiali sul sabba*, Milano 1990

Id., *Solilunio. Erano donne le streghe?*, Roma 1996

Id., *Streghe e politica*, Milano 1983

Pascal C., *Dèi e diavoli*, Firenze 1904

Paschetto E., *Demoni e prodigi*, Torino 1978

Pazzini A., *Demoni, streghe, guaritori*, Milano 1951

Id., *Il reale significato del concetto di stregoneria*, 'Pagine di storia della medicina', XVI, 1972

Pellegrinelli C., Lorenzi R. A., *Donne e inquisitori tra realtà e leggenda*, 'Periferia', 4, 1980

Pericoli M., *The Record of the Trial and Condemnation of a Witch*, 'Medicina nei secoli', IX, 1972, pp. 54-58

Peruzzi C., *Un processo di stregoneria a Todi nel Quattrocento*, 'Lares', XXI, 1955, pp. 1-17

Petrioli Tofani A. M., *Omaggio a Dürer. Mostra di stampe e disegni*, Firenze 1971

Petrocchi M., *Esorcismi e magia nell'Italia del Cinquecento e del Seicento*, Napoli 1957

Picca P., *Erotismo e stregoneria*, Roma 1937

Plongeron B., Pannet R., *Le christianisme populaire*, Paris 1976

Poesch J., *Sources for two Dürer enigmas*, 'The Art Bulletin', 46, 1964, pp. 82-86

Portone P., *Il noce di Benevento. La stregoneria e l'Italia del sud*, Milano 1990

Power E., *Donne del medioevo*, Milano 1978

Prandi C., *Religione e classi subalterne*, Roma 1977

Praz M., *La carne, la morte e il diavolo*, Firenze 1976

Prevideprato M., *Le streghe del Tonale*, Cividate Camuno 1976

Id., *Tu hai renegà la fede. Stregoneria e Inquisizione in Valcamonica e nelle Prealpi lombarde dal XV al XVII secolo*, Brescia 1992

Prosperi A., *Credere alle streghe: inquisitori e confessori davanti alla 'superstizione'*, in *Bibliotheca lamiarum* cit., pp. 17-33

Id., *Tribunali della coscienza. Inquisitori, confessori, missionari*, Torino 1996

Randall L., *Images in the Margins of Gothic Manuscripts*, Berkeley-Los Angeles 1966

Remotti F., *Noi, primitivi*, Torino 1990

Renan E., *Che cos'è una nazione?*, Milano 1919

Reviglio della Veneria C., *L'inquisizione medievale e il processo inquisitorio*, Torino 1951

Ribaleua Dumas F., *Dossier segreti di stregoneria e di magia nera*, Milano 1973

Rigoli A., *Magia e etnostoria*, Torino 1978

Rivera A., *Il mago, il santo, la morte, la festa. Forme religiose nella cultura popolare*, Bari 1988

Robbins R.H., *The Encyclopedia of Witchcraft and Demonology*, New York 1959

Romeo G., *Inquisitori, esorcisti e streghe nell'Italia della Controriforma*, Firenze 1990

Romeo G., *L'Inquisizione nell'Italia moderna*, Roma 2002

Rosa G., *Stregoneria: ricerche storiche intorno le streghe*, Bergamo 1880

Rossi C., *Superstizioni e pregiudizi*, Milano 1870

Rossi Pinelli O., *Füssli*, 'Dossier Art' n. 126, Firenze 1997, pp. 16-17

Rotta G., *L' 'idea di Dio'. Il pensiero religioso di Fichte*, [s. l.] 1995

Runeberg A., *Witches, Demons and Fertility Magic*, Helsinki 1947

Russel J. B., *Il diavolo nel medioevo*, Roma-Bari 1987

Id., *Il diavolo nel mondo antico*, Roma-Bari 1989

Id., *Il diavolo nel mondo moderno*, Roma-Bari 1988

Id., *Il principe delle tenebre*, Roma-Bari 1990

Id., *Satana. Il diavolo e l'inferno tra il I e il V*

secolo, Milano 1986

Id., *Witchcraft in the Middle Ages*, Ithaca-London 1972

La sagra degli ossessi, il patrimonio delle tradizioni popolari nelle società settentrionali, a cura di C. T. Altan, Firenze 1972

Salimbeni F., *La stregoneria nel tardo Rinascimento*, 'Nuova rivista storica', vol. LX, III-IV, 1976, pp. 269-334

Sallmann J.-M., *Le streghe amanti di Satana*, Milano 1995

Sambenazzi L., *La confessione di una strega. Un frammento di storia della Controriforma*, Roma 1989

Santi, streghe e diavoli, edited by L. M. Lombardi Satriani, Firenze 1971

Satana, Milano 1954

Savio F., *I papi e le tradizioni religiose popolari*, Monza 1909

Schmitt J. C., *Medioevo superstizioso*, Roma 1992

Id., *Religione, folklore e società nell'Occidente medievale*, Bari 1992

Sebillot P., *Riti precristiani nel folklore europeo*, Milano 1980

Sertoli Salis R., *La strega di Bianzone*, Milano 1961

Spee F. von, *Cautio criminalis, ovvero dei processi contro le streghe*, Roma 1986

Stiglamayr E., *Die Religion in Geschichte und Gegenwart*, Tübingen 1959

Storia universale dell'arte. Il Basso medioevo. Il Romanico. Il Gotico, Novara 1990

Streghe, diavoli e morte. Incisioni e libri dei secoli XV-XX, exhibition catalogue, Museo del Sannio, Benevento 1988

La stregoneria, edited by M. Douglas, Torino 1980

Stregoneria e streghe nell'Europa moderna, edited by G. Bosco, P. Castelli, Pisa 1996

La stregoneria in Europa (1450-1650), edited by R. Romanello, Bologna 1975

Summers M., *The Geography of Witchcraft*, London 1927

Id., *The History of Witchcraft and Demonology*, London 1926

Szasz T., *I manipolatori della pazzia*, Milano 1972

Tabacco G., Merlo G.G., *Medioevo*, Bologna 1981

Tarducci F., *Le streghe, l'astrologo e il mago*, Milano 1886

Tenenti A., *Il senso della morte e l'amore della vita nel Rinascimento*, Torino 1927

Thomas K., *La religione e il declino della magia*, Milano 1983

Tietze-Conrat E., *Der Stregozzo (Ein Deutungsversuch)*, 'Graphischen Künste. Neue Folge', I, 3, 1936, pp. 57-59

Trevor-Roper H.R., *La caccia alle streghe nell'Europa nel Cinquecento*, in *Protestantesimo e trasformazione sociale*, Bari 1972, pp. 133-240

Troncarelli F., *Le streghe. Tra superstizione e realtà. Storia segrete e documenti inediti di un fenomeno tra i più inquietanti della società europea*, Roma 1983

Vasoli C., *Magia e scienza nella civiltà umanistica*, Milano 1984

Vazeilles D., *Gli sciamani e i loro poteri*, Cinisello Balsamo 1993

Venturi F., *Settecento riformatore*, Torino 1969

Verdiglione A., *Introduzione* a H. Institor-J. Sprenger, *Il martello delle streghe. La sessualità femminile nel transfert degli inquisitori*, Venezia 1977, pp. 9-27

Verga E., *Intorno a due inediti documenti di stregheria milanese del secolo XIV*, in *Rendiconti del Regio Istituto storico lombardo di scienze e lettere*, s. II, 32, 1890, pp. 170-171

Vovelle M., *La morte e l'Occidente*, Roma-Bari 1986

Webster C., *Magia e scienza da Paracelso a Newton*, Bologna 1984

William C., *Witchcraft*, London 1941

Wright T., *The Worship of the Generative Powers during the Middle Age of Western Europe (1866)*, in R. P. Knight and T. Wright, *Sexual Symbolism. A History of Phallic Worship*, New York 1957

Zangolini A., *Il diavolo e le streghe ossia pregiudizio della malia*, Livorno 1864

Zellan F., *Il sabba delle streghe*, Roma 1886

Zemon Davis N., *Le culture del popolo. Sapere, rituali e resistenze nella Francia del Cinquecento*, Torino 1980

Index of names

Acknowledgements:

Elisabetta Bacchetta, Alberto Bartolomeo, Francesca
Bianchi, Andrea Ciaroni, Gino di Paolo, Ginevra
Marchi, Massimiliano Milone, Giovanni Pratesi,
Biblioteca dell'Accademia Carrara di Bergamo,
Biblioteca Berenson di Villa I Tatti (Harvard
University) di Firenze, Civica Raccolta Bertarelli di
Milano, Gabinetto dei disegni e delle stampe della
Galleria degli Uffizi di Firenze, Istituto Tedesco di
Storia dell'Arte di Firenze.

Cover:
Pieter Huys, *The temptation of St. Anthony*, 1547,
detail, Musée du Louvre, Paris.